ALGONQUIN

THE PARK AND ITS PEOPLE

A Canadian book on this scale faces many difficulties if it is not to be prohibitively expensive. This book is available to readers at its current price only because several organizations generously agreed to assist in the book's creation.

These organizations are:

Algonquin Outfitters, who have been serving travellers in the park for thirty-five years;

The Friends of Algonquin Park, an organization whose name bespeaks its pride in the park;

and the Ontario Ministry of Natural Resources, which recognizes the importance of Algonquin as the province's oldest and most famous park.

The authors and publishers thank them for their generosity.

 Ministry of Ministère des
Natural Richesses
Resources naturelles
Ontario

 ALGONQUIN OUTFITTERS

The Friends of Algonquin Park

THE PARK AND ITS PEOPLE
ALGONQUIN

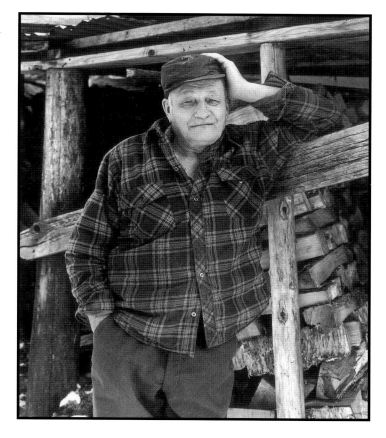

PHOTOGRAPHS BY
DONALD STANDFIELD

TEXT BY
LIZ LUNDELL

FOREWORD BY
ROY MACGREGOR

M&S

Canadian Cataloguing in Publication Data

Standfield, Donald, 1955-
 Algonquin: the park and its people

Includes bibliographical references and index.
ISBN 0-7710-8232-0 (bound) ISBN 0-7710-8233-9 (pbk.)

1. Algonquin Provincial Park (Ont.). 2. Algonquin Provincial Park (Ont.) – Pictorial works. I. Lundell, Liz, 1959- . II. Title.

FC3065.A65S72 2000 971.3'147 C92-094390-X
F1059.A44S72 2000

Unless stated otherwise, all archival photos are from the collection of the Ministry of Natural Resources, held at the Algonquin Park Museum.

Excerpts on page 19 from Edith Fowke's and Alan Mill's *Singing Our History* reprinted with the permission of Doubleday Canada Ltd.

Excerpts on pages 125 and 127 reprinted with permission from *Path of the Paddle: An Illustrated Guide to the Art of Canoeing* by Bill Mason. Published by Key Porter Books Limited, Toronto, Ontario. Copyright © 1984 Key Porter Books Limited. First published 1980 by Van Nostrand Reinhold Ltd., Toronto.

We acknowledge the financial support of the Government of Canada through the Book Publishing Industry Development Program for our publishing activities. We further acknowledge the support of the Canada Council for the Arts and the Ontario Arts Council for our publishing program.

Designed by Randolph Rozema
Typesetting by: Colborne, Cox & Burns Inc.

Printed and bound in Hong Kong
by Book Art Inc., Toronto

McClelland & Stewart Inc.
The Canadian Publishers
481 University Avenue
Toronto, Ontario
M5G 2E9

1 2 3 4 5 04 03 02 01 00

For my mother,
whose love of The Park
and lifelong passion for my father
and his wildlife adventures,
created in her children an appreciation
of the outdoors
and gave us the freedom
to follow it.

In memory of my father,
who encouraged us to explore the forest and ponds,
and taught us to walk slowly,
watch quietly,
and to respect the environment
and all its creatures,
large and small.

Algonquin Park is a place that has influenced generations of people during its lifetime. It has made an impression on all of us that have travelled along its lakes and portages. It has created legends and given a home to many spirits. This book is for all those people who have lived in the park or have returned to it through the years.

Don Standfield

Contents

Contents Continued

Foreword by Roy MacGregor

I have always believed that Algonquin Park, like those thousand-year old eggs from China, is one of those rare earthly delights that doesn't travel particularly well. It is, after all, almost impossible to describe Algonquin Park to those who haven't the luxury of standing barefoot on soft pine needles as they listen. Pictures of moose along the side of Highway 60 almost always come back from the photo-finishers with the moose missing. Thawed trout on a city barbecue is a poor cousin to fresh trout fried in far too much butter on a shore where the breeze is just strong enough to keep the mosquitoes down.

The park, fortunately, is well used to being misrepresented. The Algonquin Indians avoided parts of the original area because they found it too difficult to move about. In 1835, the famous Western explorer David Thompson – then sixty-five, poverty-stricken and suffering from diminished eyesight – paddled through the corridor lakes and confirmed an earlier report that it would make good farmland. More than a century later the Ontario government took a hard look at the park and saw a pristine wilderness area where one day in the future – say about now – there would be no more cottagers, and old park geezers like my father would be happily trolling for their beloved lake trout from sailboats, which they would eagerly take to once the government outlawed those little three-horse Evinrudes that have all but destroyed the planet.

The cottagers are still there. The best-known farmer that written history recorded – a Captain Dennison, who worked several acres around Lake Opeongo – was forced to give up improving his land in 1881 when a bear came along and killed him. Natives still hunt and fish. And somewhere a little three-horse Evinrude is coughing in the drizzle, a steel line to dinner trailing behind it and eventually vanishing in the dark water.

There is something magnificently persistent about this huge sprawl of grey granite and hardwood bluff and tamarack swamp and dark, dark water. Those passing through change dramatically – at the start of the century trains brought in tuberculosis patients for the air; as the century ends, rented cars are bringing in Japanese tourists for the emptiness – but the park changes very little, if at all. The wolves still howl when the moon is full; the Petawawa still churns in your stomach the first time you see it tumble down through the rocks , the loons still ridicule those of us who think we are at one with nature.

The secret, I think, lies in the people who give themselves over to this park – people who have probably never even taken a photograph of a moose at the side of the road. But who have put out salt licks for the deer. Blazed the portages. Cleaned up after the thoughtless. Pulled the snapping turtles off the road during egg-laying. And bragged – yes, *bragged* – about their connection to Algonquin Park, as if its specialness somehow has rubbed off on them. Which of course is exactly the way it is. And the photographs by Don Standfield prove it. Just look in the eyes of Sam English or at the smile of my aunt Mary Pigeon and say this is not so. In so very many ways, this is the first accurate picture of Algonquin Park I have seen.

I say this because my one great privilege in life was to be born into the family of Algonquin Park. My grandfather was chief ranger. My mother was born at Brûlé Lake in the heart of the park. My father worked his whole life in the park at the lumber mill my uncle owned. Uncles were rangers and lumbermen. Cousins are rangers and lumbermen and cottagers. My own four children are hauled each summer – their eyes surely rolling behind my back – to a rocky point with a southern exposure on Lake of Two Rivers, where we ritually dive from the same rocks where the old ranger once raised his flag each morning and carefully lowered it each evening, a grandchild brought along to ensure the sacred cloth never suffered the outrage of touching the ground.

There is nothing on this point today, but everything is also there, always. In the sky overhead was where George Phillips would spin the Lands and Forests floatplane upside down before picking up the white-knuckled chief ranger for patrol. The two-storey log home on the hill is gone now, but you can still see where the visitors would sit in the sun; Winnie Trainor, who was engaged to Tom Thomson; Uncle Bill, who'd eventually show his World War I neck wound if the kids asked enough; other old rangers like Jerry Kennedy, who'd once chased poachers through the park and who'd lost a leg to frostbite, and Jack

Gervais, who claimed he knew a spring-fed fishing hole where the water was so cold the speckled trout froze solid when they passed through and all he had to do was wait downstream to stack them like cordwood; Aunt Mary and Uncle Lorne down from Cache Lake with their sons, our cousins Tom and Jake, who knew more about the bush and fishing and canoes than anyone alive. When I hear my own children shouting and laughing as they dive, I hear all the children we once were: my brother and sister, cousin Don, who spent all summer there with us, cousins Andy, Elizabeth, Mary, Susan, Tim, Patti, Robert. . . . Such a strange world, where there were no strangers.

I had no sense of the rest of the world then. I had no understanding, ever, for that world that dropped down into the park each summer, the campers heading out on their organized walks, the summer-camp kids with their rich looks and canoe songs and parents who came visiting in huge cars that rippled in the sun by the government docks. We who were the barefoot children of the rangers and the loggers looked down upon these people as invaders who didn't really belong, and it wasn't until I married, and Ellen, herself a camper, had to show me how to set up a tent, that I realized perhaps it was me, not them, who had led the sheltered life.

Had I known back then I might one day write about this magnificent and lost world I would have kept notes. But we barely kept photographs: our past was far away and as melded into the blur as the moose the tourists search for when they pick up their summer pictures. Even so, I know exactly what Mordecai Richler means when he says that Montreal's St. Urbain Street was "my time, my place." And I think I know what Margaret Laurence was getting at when she wrote: "whatever I am was shaped and formed in that sort of place, and my way of seeing, however much it may have changed over the years, remains in some enduring way that of a small-town prairie person."

I am forever the kid on the point, the flag lowering, the old ranger fretting over his lifelong assignment: Algonquin Provincial Park. I am forever walking the half mile over difficult rock with my mother to the spring. I am the scrape of a match under the seat of the old wooden boat, my father at the end of a fifty-hour week just beginning to let out the line, the William's Wob-bler dancing in the wake of the three-horse Evinrude. I am part of Aunt Mary Pigeon, whose paddle stroke is still a work of art. I am part of the story-telling magic of Wam and Jimmy Stringer. I like to think I will conduct my life as Ralph Bice has managed his, a wise man in his nineties who insists that each grandchild, now each *great*-grandchild, be baptised in water he himself draws from a secret lake in Algonquin Park.

When I take my own children to the point on Lake of Two Rivers, I show them where the log house stood and where the old ranger built his fireplace and where my mother and I, one August afternoon, found his shaving mug in a pile, not a chip in it, and the end of a small board of trim that said, in pencil, "Thomas I. McCormick, Sept. 10, 1940." The day the artist signed his masterpiece.

I take them to the water's edge and show them where the ice house once stood and tell them how in winter the men would head out onto the bay with long saws and cut the blocks that would be stored in sawdust to last through the summer. And I go where the ice house is forever in my mind, and we turn over rocks and find that there are still pockets of sawdust left, though it no longer clogs between your toes and tickles your leg and freezes your soles. Its effect now is on another soul, one that hopes the next time there is a century of Algonquin Park to celebrate there is still a park and still a park family – some of them related, some of them not – to remember and care.

Comment

As Superintendent of Algonquin, I don't need to be told what a marvellous place the park is. Indeed, ever since I began my career many years ago as a summer campground attendant in southern Ontario, and well before I actually set foot in Algonquin, I was constantly hearing stories about the granddaddy of the Ontario provincial park system, way up north. Needless to say I had to see for myself, and before long I had many Algonquin stories and memories of my own.

By the time I actually got the chance to work here in 1987, not only did I know a dream come true when I saw it, but I was also confident that I knew and loved the place as well or better than almost anyone.

Well, in the years since then, I have had ample confirmation of the rewards of working here, but I have to admit I was rather naive about being able to claim any particularly outstanding knowledge or appreciation of Algonquin. Quite frankly I have been astounded by the number of people who have been deeply affected by the park and who know it and love it with every fibre of their being. I am fond of saying that over forty books, more than five hundred scientific papers, countless magazine and newspaper articles, half a dozen films, and even a symphony have been inspired by Algonquin Park.

I am even more impressed that the list keeps on growing! It's partly because of the park's upcoming one-hundredth birthday, of course, but that only partly explains the fact that every year sees more and more expressions of the deep affection and reverence people have for Algonquin.

You are now holding such an expression in your hands, and I would be hard pressed to think of a finer reflection of the fact that so many talented people have lived and loved Algonquin for so long. The introduction is by Roy MacGregor, now a nationally acclaimed author and Ottawa political columnist but also the grandson of an Algonquin Chief Ranger, who spent his childhood years here and is a true son of the park. The main text is by Liz Lundell, one of who-knows-how-many thousands of those who, as children, went to camp here and were shaped by the wail of loons and the lapping of water on Algonquin summer shores. Then, of course, there is Don Standfield, who not only took all the marvellous photos you are about to enjoy but also conceived the idea of blending landscape photos with portraits and interviews in this loving celebration of the park and its people on the occasion of its centennial. Don's association with Algonquin also goes back to his childhood. For many years his father, Rod, headed up Ontario's pioneering wildlife research program and, as a boy, Don spent his summer at the park's Wildlife Research Station. It was only natural, therefore, that Don, very early on, gained insights into, and respect for, the park and its wildlife that have continued to characterize his work and personality ever since.

Together Don and Liz have combined to produce the fine book you are about to embark on. I know you will enjoy it as much as I have. You will enjoy it, of course, for what it conveys of the park's beauty and interest, but also for showing the lifelong love affairs that the authors and many other park personalities have had with Algonquin. But don't just take my word for it – read on and see for yourself!

G.E. (Ernie) Martelle July 1, 1992
Park Superintendent, 1988-1997

Preface to the 2000 Edition

In 1993, Ontario celebrated the centennial of its oldest and most famous park – Algonquin Provincial Park. This book was prepared as a tribute to Algonquin's wild spirit and to the people whose stories appeared here. Just as there have been ongoing – yet gradual – alterations in the natural environment, the human face of the Park has changed since this book was first published.

The Visitor Centre, under construction during preparation of the first edition, opened as a world-class museum in 1993. Through programs offered there, thousands of new visitors have been welcomed to Algonquin Park. Ernie Martelle, who so kindly contributed the Superintendent's Comment for the edition, continues to maintain close ties to the Park in his retirement. John Winters is his successor as Park Superintendent.

Regrettably, a number of the people who had a significant impact on this book are no longer with us. This edition is respectfully dedicated to their memory:

Ottelyn Addison, Ralph Bice, J. Harry Ebbs, Sam English, Leonard "Gibby" Gibson, Lu (Farley) Gibson, Edmund Kase, Jr., Mildred Kase, Ernie Montgomery, Lorne Pigeon, Mary (McCormick) Pigeon, Adam Pitts, Page Statten, Wam Stringer, and Bill "Swifty" Swift.

Those who were fortunate enough to meet them were impressed by their attachment to Algonquin. They have left an enduring imprint on the Park.

December 1999

Acknowledgements

I would like to thank the following people and organizations for their support throughout the course of this project:

The Taylor Statten Camps for continued encouragement over many years and for their part in sponsoring the research for this book;

Dr. Taylor Statten II for his support and for his unbroken belief and interest in all of Algonquin Park and its people;

Janie and Page Statten, Win and Jim Burry, Guy Burry, Sara and Chris Turner, for their donations to the project;

The Boland Foundation and the Ontario Heritage Foundation for their financial assistance towards the research of the book;

Don Spring, of Cavalcade Color in Huntsville, for his contribution of film to the project;

Ron Tozer, Interpretive Services Supervisor, and Dan Strickland, Chief Park Naturalist, for giving their assistance throughout and offering comments on the manuscript; and Nancy Checko for her organization and assistance at the museum;

Pat Tozer and The Friends of Algonquin for their much-needed and much-appreciated support in the beginning;

Dale Garner, moose research biologist, who introduced me to another aspect of the park and shared many of his "hidden" locations in Algonquin;

Jerry Schmanda, for his assistance and generosity on Lake Opeongo, as well as for taking me to spots where the bass jump into the boat;

Dave Standfield and Bill Statten on Canoe Lake, who have always had enough dinner to share, and have provided an ear for listening every spring, summer, fall, and winter for as long as I can remember;

Linda Leckie, who has encouraged my daily attempts at dream catching, given years of advice, and shown more patience than one would think possible;

Our editor, Pat Kennedy, and designer, Randolph Rozema, who steered the book through to completion;

and finally, to the many people of the park who told me their stories and helped me uncover the stories of others that have remained hidden for many years – some for good reason.

D.S.

ALGONQUIN

THE PARK AND ITS PEOPLE

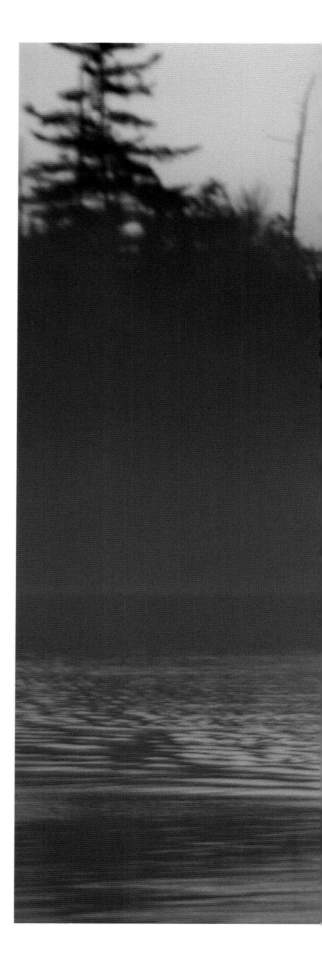

''With all the ghosts that
haunt the park, I wonder
how many of them travel
the canoe routes looking for
the old ranger cabins.''
– Jimmy Coghlan,
former Algonquin
ranger

Introduction

The edges of the lake creep forward, then recede, as black waters lap against the sloping granite. Slowly shifting to expose some other part of its slumbering body, the lake breathes. Moonlight flashes on the silvered backs of feeding fish. A breeze stirs furrows on the filmy surface; they run before the gust towards the opposite shore.

Stars puncture the sky as the moon slips behind distant hills. It pauses just long enough to illuminate the cattails at the water's edge, the reeds quivering as an animal pushes aside their protective curtain and drops into the water. Lines radiate to form a V-shaped trough, the furry head at the apex. Perhaps a muskrat or beaver, it strikes out for the far shore, where rounded crowns of maple and birch are topped by spires of white pine.

Muted whispers of the wind through grass, a bullfrog's throaty grunts, a muffled splash: all sounds of quiet nocturnal activity. Abruptly, a loon's wail pierces the hush. It bounces off the hills and runs around the edges of the lake, encompassing in one magical strain all that is part of a northern summer night.

Staring into a dwindling fire on any Algonquin evening, one appreciates the sense of undisturbed nature that the park offers. A fragrant pile of dry cedar lies ready to toss on the fire, and smooth rocks stretch down to the cool waters – the perfect spot for a breathless pre-breakfast plunge. The feel of wilderness is still here and it's easy to imagine that this is a sample of the primeval forest, the land as it was before European settlement.

The timeless quality of its campsites masks the fact that the area has witnessed myriad changes. It lulls us into believing

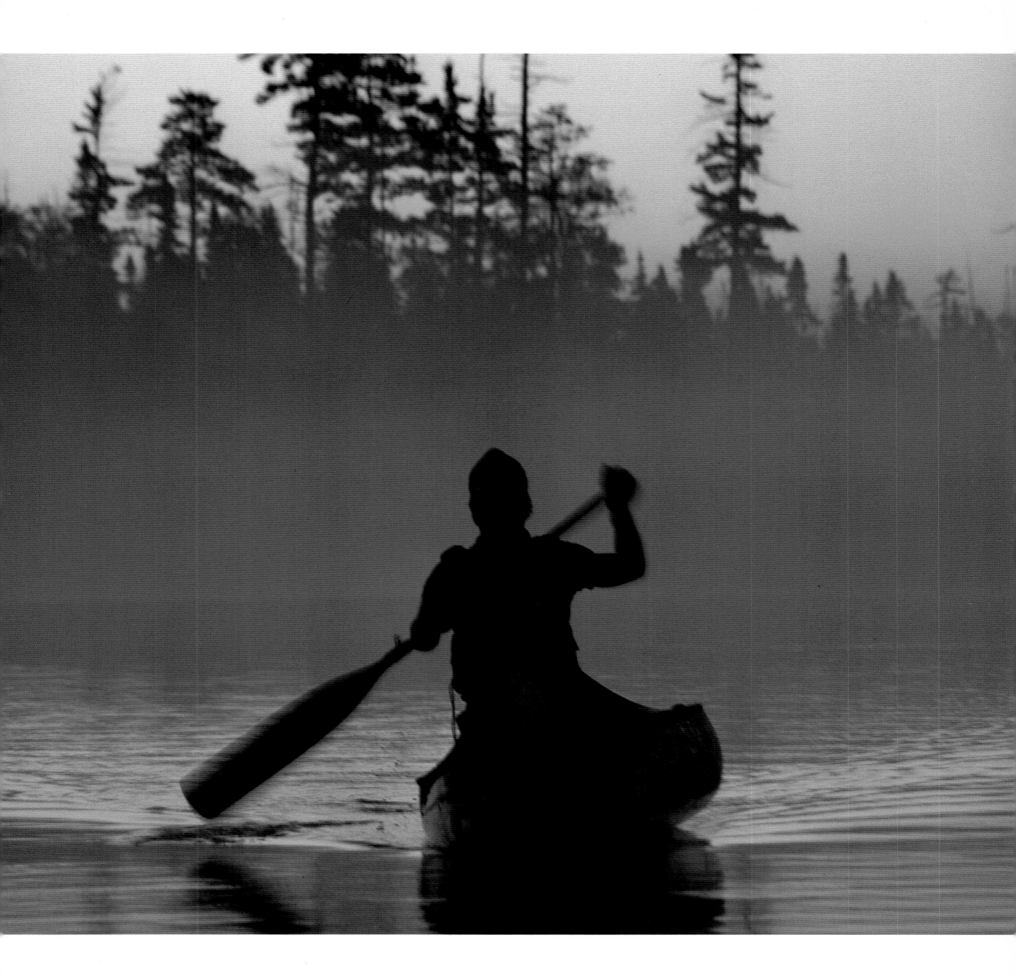

that these forests are much the same as they were when the first native inhabitants occupied them thousands of years ago. What sign is visible that one site served as a fishing camp for generations of nomadic Algonkian tribes, or that crews of hardy men surveyed the hills for farms in the last century? Who could know that toughened shantyboys swarmed the woods, and that thousands of pines, centuries old, were felled here in our great-grandparents' lifetimes? There is no clue that trains whistled by this lake every twenty minutes in 1915, carrying supplies vital to the war effort, or that elegant dinners were served on fine china to discerning American tourists at what is now just a grassy clearing. The evidence of the early settlers' back-breaking work, and the farmsteads they left behind, have long since been reclaimed by the forest.

The fire's orange glow casts a narrowing circle. Fanning the embers coaxes the flames back to their crackling dance, giving a few more minutes to reflect. The park is a priceless asset in its present state, but a colourful history is also part of its legacy. Many others have hunched by a similar campfire, imagining scenes from Algonquin's past. Spiced with the tales of individuals who came to harvest, enjoy, and protect it over the years, the story of Algonquin reveals its own riches. Some of these accounts are recorded in books, many in letters. But some of the best come by word of mouth.

Pollen waterline, Rock Lake. "When I'm up here in the park, I spend most of my time imagining what it must have been like for the first people who paddled through this area."
– Greg Elliott

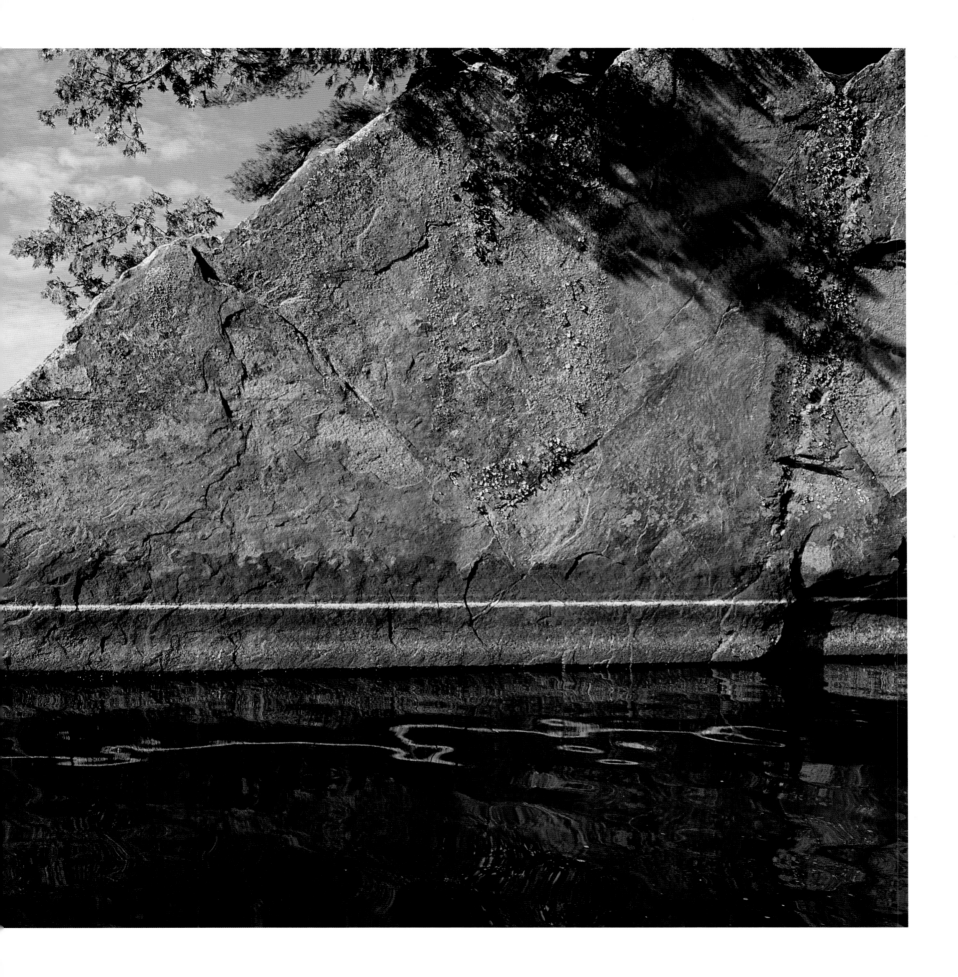

Part One

BEFORE THE PARK

The Geological Record

Lying close to the southern edge of the Canadian Precambrian Shield, the west side of the park sits roughly four to five hundred metres above sea level, making it the highest region in southern Ontario. Just over a billion years ago, a large section of the earth's crust was thrust northwest over the area, squeezing and forcing underlying gneiss and granite into tilted, overlapping layers. We come across the distinctive pinks and greys of this Precambrian bedrock in many places today.

Within the last million years, the rock was sculpted by four successive glaciers that advanced over most of Canada, scraping the landscape and depositing glacial till. The last receded approximately eleven thousand years ago. Nearly two kilometres thick in some places, the melting ice sheet produced a huge volume of water which flooded areas surrounding present-day Lakes Huron and Michigan. It was known as Lake Algonquin; remains of its sandy shores can be seen near Huntsville.

For a time, most of the waters from this vast body of water charged through what geologists call the Fossmill Outlet – the valleys of what are now the Petawawa, Barron, and Indian rivers. From there, the waters flowed into the Champlain Sea, an inland arm of the Atlantic Ocean that covered today's Ottawa and St. Lawrence valleys. Huge sand and gravel deposits found on the east side of the park were left by these meltwaters, and rare cold-water crustaceans survive to this day in deep lakes that once formed part of the Fossmill drainage system. The crustaceans and a few sub-arctic plants are living clues, proving that the rivers of the northeastern part of the park were connected at one time to Lake Algonquin.

Movement of the earth's crust, glaciation, and erosion have all left their mark on the area's topography, shaping hills, valleys, and lake beds within the 7,600 square kilometres of what is now Algonquin Park.

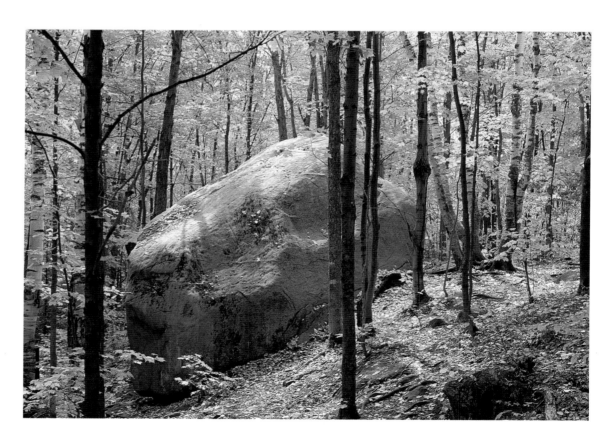

A boulder, left behind by the glaciers, sits peacefully among the hardwoods on the Lookout Trail.

The Natural Environment

Most people who come to Algonquin are attracted by its scenery and wildlife. In spring, visitors are delighted to see moose alongside the highway. The animals drink from salty puddles that are created as sand and salt are washed from the road at winter's end. Spring beauties, trout lilies, and other flowers poke up through leaf litter as the days grow warmer, and loons return as soon as the lakes are free of ice.

By summer, the forests provide deep shade, and the cool lakes attract campers and canoeists. Lichen crunch underfoot on the portages as the drier days of summer arrive. Blueberries ripen, a flavourful reward for patient pickers.

In autumn, the western uplands blaze as maples and birch trees turn colour. Indian summer, with its sunny days and early frosts, is an enjoyable time to explore the hiking trails. The beaver starts to accumulate its winter food-pile of felled branches, and ducks congregate for migration. Fewer people visit Algonquin in winter, but with a snowfall of 200 to 250 centimetres of snow annually, it is ideal for cross-country skiing, snowshoeing, and winter camping. Apart from the black bear, which hibernates, the larger mammals are still active; deer, wolf, and moose tracks are visible in the snow.

Today's visitor learns from park naturalists that Algonquin is a meeting place of northern and southern ecosystems. Forested with both coniferous and deciduous trees, the park can be divided roughly into two zones of vegetation. The east side of the park is dominated by red, white, and jack pine, while the west has large hardwood stands of maple, beech, and birch, in which sugar maple predominates. Since 1968, natural zones have been established to preserve entire ecosystems from logging and development. A reserve on Dickson Lake protects red pines over three hundred years old. Other zones preserve bogs and hemlock forests to represent the diversity of ecosystems found in the park.

Five major natural habitats are represented in the park: hardwood forests, coniferous forests, spruce bogs, beaver ponds, and lakes. Each supports a particular mix of plants, birds, mammals, and other creatures. Over two hundred and fifty bird species have been sighted in Algonquin, and they represent both northern and southern breeds. A strutting northern spruce grouse displays on one portage, while on the next, the more southerly scarlet tanager flashes its bright plumage.

The waters play host to a variety of fish and other aquatic species, and they have attracted avid anglers, many from beyond Canada's borders. Seven major rivers that flow toward Lake Huron and the Ottawa River have headwaters within the park; the Amable du Fond, Petawawa, Bonnechère, and Madawaska rivers empty into the Ottawa, while the Muskoka (of which the Oxtongue and East rivers are tributaries), Magnetawan, and South rivers drain eventually into Georgian Bay. The deepest lake in Algonquin, Eustache, is ringed with rock walls that reach down ninety metres to the lake bottom. Lake trout have been caught in 150 of the cool, deeper lakes, while the pink-fleshed brook trout inhabits 230 lakes and some rivers. Smallmouth bass were not native to most of the park, and were found in only a few areas on the east side until their deliberate introduction by park staff, beginning in 1899. Seventy-nine lakes, half of which are near Highway 60 in the southern part of Algonquin, now support large populations of this fish. Walleye are found in the Petawawa River as far up as Cedar Lake, while pike and muskellunge are restricted mostly to the lower stretches of the Petawawa drainage system.

A variety of mammals inhabits Algonquin. Most canoeists today look forward to sighting a moose. Normally a resident of northern boreal forests, Algonquin's moose are often seen up to their hips in swamp, feeding on aquatic lily plants. Although ungulate populations have fluctuated over the years, visitors may also encounter white-tailed deer, a southern species, browsing on new deciduous growth. Beaver, otter, marten, fisher, muskrat, and mink attracted trappers before the park's creation and scientists after. Because visitors are unlikely to see one, Algonquin's wolves have their own mystique. After dark on some August evenings, Highway 60 is lined with hundreds of people, all waiting soundlessly, as the park naturalist tries to evoke an answering howl from a local wolf pack.

The diverse elements of topography, vegetation, and wildlife in Algonquin have continued to evolve over the last nine thousand years, the period of human occupation of the area. Predictably, these environmental factors had a profound influence on the lifestyle and culture of the first inhabitants.

The First Peoples

Since 1939, archaeologists and anthropologists have been coming to Algonquin to try to piece together the daily lives of the first people who lived in the area in the centuries before European trappers and explorers set foot on the Algonquin highlands. Many sites have been excavated, including those at Rock, Opeongo, Travers, and Grand lakes, and on the Petawawa River. From the extensive collections of pottery fragments, stone tools, quartz projectile points, and European trade goods that have been unearthed, investigators are able to reconstruct the non-recorded past of these earlier cultures. Most of what we now know of the original peoples comes from archaeological excavation in the park area and from accounts written by Europeans at the time of first contact. The rest of their story is extrapolated from the more complete traditional oral history provided by neighbouring native groups.

Nomadic native groups have occupied the Algonquin highlands for nearly nine thousand years. The first people, identified as Paleo-Indians, arrived in the area around 7,000 B.C. By 3,000 B.C., hunting and gathering people, identified as members of the Shield Archaic and Laurentian Archaic cultures, were established in the region. The earliest documented sites in the park were occupied by these people, including those at Grand, Opeongo, Travers, and Rosebary lakes; stone hammers, quartz scrapers, projectile points, and drills were excavated at these sites, but pottery was absent.

Pottery manufacture was introduced to the area by members of the Woodland culture, around 2,500 years ago. When archaeologists uncover pottery sherds at an excavation, they know that they are dealing with a site that was occupied by this later people. The Algonquin Indians, one of the last Woodland groups, were established in the area by approximately 1,000 A.D.

The numerous sites on the Petawawa River lead archaeologists to believe that it must have been a significant route for the first people. Archaeological surveys during the sixties and seventies, led by Dr. W. M. Hurley, identified many locations that had been used as campsites by the native people.

Jack Borrowman, a ranger at the time but now the park's Interior Supervisor, participated. Borrowman says,

It was remarkable how many native sites were still being used. We found them by canoeing the routes and then deciding where to camp. Dr. Hurley would pick a point or a section of shoreline that would be the best place to camp [with good access to water, adequate shelter, and a cross breeze to keep away insects], and invariably he found remnants of Indian campsites there – artifacts or fire-pit indications. We continue to use these sites today, so some of them have been used for hundreds of years.

There has been a great deal of confusion concerning the name of the Algonquin and their hunting territory. Just as German is only one of the Germanic group of languages (which includes English and Danish), Algonquin is one of twenty-three dialects belonging to the larger family of Algonkian languages. The people we identify as Ojibwa, Cree, and Montagnais all belong to this larger Algonkian language group. The Algonquin (spelled Algonkin in some sources), traditionally occupied the lands along the Ottawa River and into the highlands of southern Ontario, and the tribe actually consisted of many small bands, each with a different name.

The name, "Algonquin," is of uncertain origin. One source cites a Malecite label, *a' llegon kin*, meaning "those who are dancing," but the most widely accepted explanation is that Algonquin comes from a Micmac word, translated loosely as "spearing fish and eels from the bow of a canoe."

The extended family was the basic social unit in Algonquin culture. Due to the sparse population, it was often necessary for Algonquin men to search outside their territory for a wife; this extensive intermarriage led to a cultural and linguistic homogeneity among the groups in the region.

The Algonquin were nomadic, moving according to the availability of seasonal food sources. In summer, families congregated in large groups on the Ottawa River, or near other bodies of water where fishing was consistently good. A few Algonquin bands also grew corn in the warm months, adopting the practice from their Iroquois neighbours to the south. In October, when the lake trout spawned, the groups broke up and migrated upland to widely dispersed fishing camps.

Smoke Lake hills. "The Indians were very much driven by the spiritual, and must have been surrounded by it when they paddled the lakes and camped on the shores of Algonquin." – K.M. (Kate) Graham, artist and Smoke Lake cottager

By winter, the people scattered into distinct hunting groups of between ten and twenty people, usually made up of extended families. Since a hunting band required somewhere in the neighbourhood of five hundred square kilometres to support it, there were probably no more than sixty to two hundred people hunting in the park area in any given winter.

The male members of the group hunted moose, rabbit, deer, squirrel, and other mammals to supplement stores of berries and fish harvested in summer. February and March were hard months, as supplies dwindled, but by late March, the maple sap began to run, and the people rendered sugar from it in birch-bark pots, a sign that heralded the arrival of more plentiful times.

The forest and its warm-blooded animals provided most of the materials the Algonquin required for transportation, shelter, and clothing. The white birch was a valuable resource that many neighbouring tribes lacked. The light birch-bark canoe was well suited to the terrain and to a nomadic lifestyle, and the Algonquin were able to trade birch canoes for corn and fishing nets with the Huron, their neighbours to the west. Birch trees also provided covering for the portable, conical shelters of the Algonquin. Gum for patching and roots for binding came from spruce trees. Clothing was made of hide and fur.

Lichen was used to supplement Algonquin food supplies. It contained very few vitamins and minerals, but, soaked and then boiled, it was used to provide bulk in the diet and fend off starvation.

As in other native cultures of North America, there was an indivisible relationship between their environment and their way of life. Reverence for the land and the wildlife guided the daily lives of the Algonquin, and the people manifested their respect and gratitude through rituals and festivals.

According to Algonquin belief, each natural object, both animate and inanimate, had a spirit, or manitou. The most power-

Native pictograph on Rock Lake. Pictographs were paintings made from red ochre and usually done on rock faces. They may represent spirit quests, voyages, or daily events in the lives of the Natives.

ful of all was Gitchi Manitou, the Great Spirit, who could cause violent weather or the disappearance of game. At puberty, both boys and girls participated in a spirit quest, fasting until a guardian manitou presented itself. The Algonquin observed taboos to ensure that the manitous were not offended, and they showed respect for the animals they killed by following certain customs, such as conducting elaborate rituals when a bear was killed to pay homage to its spirit, or placing deer antlers high in the branches of a tree. The people appeased angered spirits with offerings of tobacco or precious objects, or by appealing to the shaman.

The shaman would burn deer, beaver, or hare bones over a fire to reveal messages. Great emphasis was placed on his interpretation of dreams. Wendigos, or windigos, were evil supernatural giants that fed on human flesh. To consult discontented wendigos, the shaman conducted shaking-tent rituals. Since the wind was associated with these troublesome spirits, the shaking of the tent communicated their grievances. The shaman was able to interpret all of these messages and suggest appropriate action.

Most spirits were neither innately good nor bad. Wiske'djak, the trickster or transformer spirit, is central to many legends. Many elements of the Algonquins' daily lives are also reflected in these legends. Interestingly, today one of the colloquial names for the bold gray jay, a common bird in the park, is "Whiskeyjack," after the trickster of Algonquin lore.

The Algonquin lived as hunters and gatherers in the park area until the Iroquois Wars in the middle of the seventeenth century. In 1649, they were driven from their traditional grounds in the park area by the Iroquois, their long-time adversaries. Our picture of the upland hunters becomes blurred from this point. They were widely scattered to the north and east, and were to trickle slowly back into the area only during the 1800s.

Throughout the period of Algonquin occupation, the Ojibwa people hunted in the park area west of the park's central height of land, and they, in turn, drove out the Iroquois in the late 1600s. Pictographs – rock paintings of animals and abstract figures – that were likely made by the Ojibwa are visible at Rock Lake and Lake Louisa.

The French and English came to outnumber the native residents of the area in the eighteenth century, but we still see evidence of the Algonkian influence in many place names within the park. Opeongo, the name of the largest lake, translates as "sandy at the narrows." Legend has it that a famous Chief Opeongo is buried on the large island that bears his name on that lake. Roaring rapids on the Petawawa River probably suggested the river's name, for Petawawa translates as "a noise is heard far away." However, a contradictory source claims that the river was named after an Indian woman who lived on its banks for one hundred and fifteen years. There are many other names of Algonkian origin: Chibiabos, "ghost rabbit"; Kwonishi, "the dragonfly"; Nipissing, "little water"; Amikeus, "the beaver"; and Animoosh, "the dog". Even the Great Spirit, or Manitou, of the Algonquin belief system is remembered in the name of Manitou Lake.

Although we do not have all of the pieces of the puzzle, studies into the archaeological sites in the park continue to provide a clearer picture of its early inhabitants. As we rely on the canoe to cross the lakes and make use of some portages which were there before the arrival of white trappers, we recall the native people's respect for the land. The very name of the park reminds us of the Algonquin people who lived in harmony with the majestic natural environment that surrounded them.

Surveyors and Mapmakers

The Algonquin area was still rich in fur-bearing animals at a time when the lands to the south had become over-trapped. The Iroquois and their British allies had been drawn originally to the district by its furs and its strategic location close to major water routes. After the British conquest of New France in 1760, and the resolution of the European conflicts of which the Iroquois – Algonquin hostilities were only a small part, the Algonquin slowly rejoined European and Iroquois trappers in the region. Marten, fisher, wolf, and mink were native to the area, but, as in most parts of Canada, it was the large population of beaver that was most attractive to trappers. As a result, by the early 1800s, trading posts had sprung up at Ottawa, Penetanguishene, Golden Lake, Lake Lavieille, and the mouth of the Petawawa River, each vying for furs from the Algonquin highlands.

The first recorded trips into the Algonquin Park area were conducted by the British Army in the early part of the last century. After the War of 1812, the British were anxious to find a route from the upper Great Lakes to Montreal that would bypass the precarious lower Great Lakes that were so close to the United States. Three separate expeditions, between 1818 and 1827, led by Lieutenants James Patrick Catty, Henry Briscoe, and John Walpole, examined water routes linking Lake Huron and the Ottawa River through the Algonquin region.

The first creditable map of the district was produced by early settler Alexander Shirreff, from his travels in the area in 1829. Shirreff's journal chronicles visits to Cedar, Travers, Peonga (Opeongo), Lavieille, and Clair (now Dickson) lakes. These lakes had been named already by the original peoples and trappers. He noted enthusiastically that "white pine abounds across the whole country in the greatest perfection," and that "the scenery is of the most pleasant and inviting nature. . . . Here, amidst the most enlivening scenery, there is every appearance of fertility; and both from the nature of the soil and waters, an assurance of the country being of the most healthy nature." We can understand his enthusiasm for the beautiful setting, but he overstated the agricultural potential of the region.

Later surveyors included William Hawkins, David Thomp-

son, the famous explorer of Western Canada, and Alexander Murray, of the Geological Survey. In 1837, Hawkins and Thompson were sent to assess the feasibility of a civil canal system that would link Georgian Bay with the Ottawa River. Hawkins surveyed the Magnetawan–Petawawa route. Thompson's party travelled up the Oxtongue River, through Smoke, Big Porcupine, and Harness lakes, and then down the Madawaska to the Ottawa River. Neither was able to endorse the plan for a canal because of the rugged terrain; the change in elevation was too great, there were too many rapids and other obstacles to overcome, and many of the rivers were barely wide enough to allow canoes to pass.

Murray's 1853 expedition travelled via Canoe, Otterslide, Burntroot, and Cedar lakes, then down the Petawawa River to the Ottawa. In addition to naming Lake of Bays, Canoe, Burnt Island, and Otterslide lakes, and making improvements on existing maps, Murray produced a record of the soils and rocks for the Geological Survey. He did not believe, as Shirreff had, that large trees indicated fertile soil. Murray advised that the

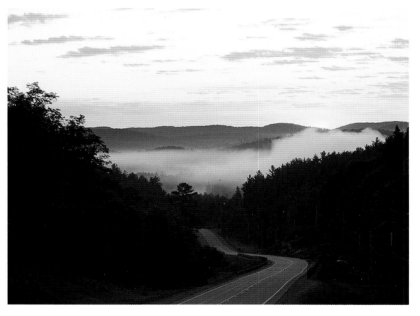

Highway 60. Built as a works project during the Depression, Highway 60 was opened in 1936. The majority of today's visitors enter Algonquin via the Frank MacDougall Parkway, as Highway 60 was named in 1976.

soil was poor and that the few pockets of arable land in the area would not support large-scale agricultural settlement. He also had discouraging news for the mining companies. He found no evidence of mineral deposits of any appreciable size or value. Murray's report indicated that the only feasible avenue for development was logging, and he recorded that there were already extensive timber operations in the northeast reaches, even at this early date. Both Murray and Thompson contributed greatly to the accurate mapping of the district. However, although their reports also contradicted Shirreff's views about the feasibility of agriculture, the authorities were not yet convinced of the impracticality of settlement.

Beginning in the late 1830s, the Algonquin area had entered a new phase in its development. Logging and settlement pushed farther up the Ottawa Valley, putting new pressures on its pine forests.

The Square-Timber Era

The forty-foot white pine square timbers from the upper Petawawa began their trek to the Atlantic each spring as soon as the ice had left the rivers. The logs had been left on the ice by the winter logging crews, and after break-up, they crashed into the frigid waters and floated down the turbulent course of the swollen spring river. Stoplogs were removed from dams, and the ensuing rush of water swept the logs through the sluice with a thunderous roar. Where there were no log chutes built to bypass rapids, clusters of timbers running too closely together were often heaved against the rocks and wedged tight. The jams had to be broken, and they were plucky volunteers who clambered down to remove the key logs that were holding the rest fast. Amidst the tumult of the rushing water, the river driver would cut through the offending timber, keeping an eye to the slightest movement which might give him a moment's warning. Then, as the tons of loosened logs lunged forward, the calculation of seconds or of a few inches made all the difference as he scrambled for the safety of the shore. The nameless graves alongside the river attest to the fact that many were caught off-guard.

It was war in Europe that had started the timber boom in the forests of the upper Ottawa Valley. During the Napoleonic Wars, French blockades of timber shipments from the Baltic prompted the British to seek other sources in North America. Philemon Wright, the first settler in present-day Hull, was also the first to drive pine logs down the Ottawa River to Quebec, in 1806. This event marked the beginning of the square-timber era in the Ottawa Valley.

Within twenty years, the original stands on the Ottawa were depleted and the lumbermen were moving farther up its tributaries. Loggers had begun to take red and white pine from the eastern side of the Algonquin area by the late 1830s. Although there were plenty of hardwood trees in the region, only pine floated, allowing it to be moved profitably to market. When the first crews reached the park area, they found mature stands of huge pines, one metre in diameter and weighing two or three tons, and, as Ralph Bice says in *Along the Trail with Ralph Bice*, "the expression then was that you could drive a wagon in amongst the trees."

'Twas up on the Black River at a place called Hogan's Lake
Those able-bodied fellows went square timber for to make.
The echo of their axes rung from shore to shore –
The lofty pine they fell so fast, like cannons they did roar.

– verse of "Hogan's Lake," from Edith Fowke's
Lumbering Songs from the Northern Woods, NC Press, 1985.

Some of them were willing and some of them were not
For to work on jams on Sunday, they did not think we ought.
They had not rolled off many logs when they heard his clear
voice say
''I'd have your men be on your guard for the jam will soon
give way''
These words were scarcely spoken, when the mass did break
and go
And carried off our six brave boys and their foreman Jack
Munro.

– a widely known folk rhyme, quoted in Charlotte Whitton's
A Hundred Years A-Fellin', a Gillies Company publication, 1943.

I'll eat when I'm hungry and drink when I'm dry;
If the water don't drown me I'll live till I die –
If the water don't drown me while over it I roam,
For I am a river driver and far away from home.

– verse of "A River Driver," from Fowke

In those early years Alexander Barnet, the Gillies family, Alex Macdonell, Dan McLachlin, John Egan, James Wadsworth, and the Perley and Pattee Company all held timber limits – areas where they paid for the right to cut timber – within what are now the park boundaries. Once a lumber company had leased rights from the Province, a company depot was built to serve the shanties in the vicinity. Staples – potatoes for the men and oats for the horses that hauled the log sleighs in winter – were grown at the depot farms during the summer. The farm also served as the administrative centre for the company's bush operations, and non-perishable supplies could be brought in and stored there until they were needed by the winter crews.

Each winter, the companies sent men into the Algonquin bush to cut timber and pile the logs in preparation for the spring river drives. There were no passable roads for transporting large timbers in Ontario, so the rivers were the only practical route; river drives were used as late as 1959 to bring timber down to the Ottawa River. Tote roads, for hauling supplies to the camps, criss-crossed the forest, and soon these provided a network of bone-jarring tracks into the interior.

The winter camps in those early years were called "camboose camps" after the shanties in which the crew lived. The camboose shanties took their name from the French word *cambuse*, "canteen," the cook's fire and sole heat source for the cabin, a raised open hearth in the centre of the building, which vented through a one-metre hole in the roof. Forty to fifty men lived in each windowless, log building. The walls were roughly fifteen metres long, and the low roof was made of hollowed half-logs, or "scoops." The men slept, two to each bed, on two-level bunks mounted on the outside walls. Each logger supplied his own bedding and mess kit, while the camp cook provided large quantities of hearty food. Beans, salt pork, strong tea, dried apples, and fresh bread were the staples.

Rising before dawn, the men worked long hours, lunched in the bush, and returned to the crowded shanty only after dark. For most, seasonal logging was the only way to supplement a meagre income from farming, and many a young man left his home to spend the winter working deep in the bush for one of the lumber companies.

The men in the camps had specialized jobs, there being an unwritten hierarchy amongst the members of each shanty. The

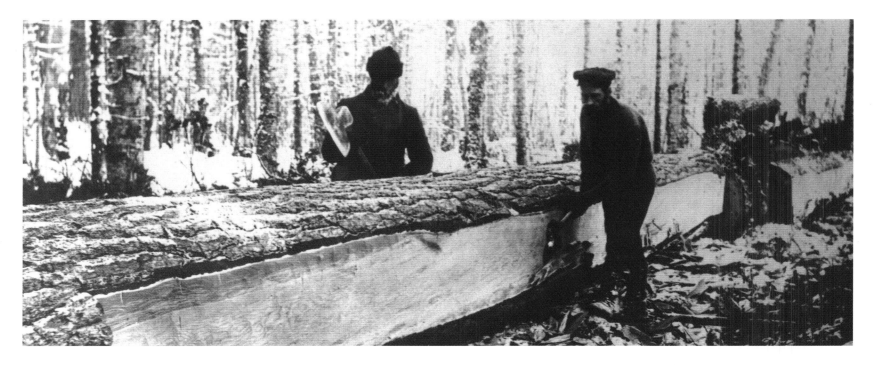

The pine was squared right in the bush, with the older, experienced loggers hewing each side "as smooth as a table top."

feller began the timber-making process by bringing down the trees. Once the branches were removed, the *scorer* stripped the logs of bark, marked the line for the *hewer* to follow, and notched or "scored" each side at regular intervals. The hewer then used a finely sharpened broad axe to shave off large portions of the tree, working on each side until it resembled a smoothly planed board. Squaring did waste up to half the log, but squared timbers could be packed tightly into the holds of the ships bound for Britain, making more efficient and cost-effective use of cargo space. What did waste matter when there was a seemingly inexhaustible supply of the giant pines?

The hewers were the most highly skilled of the woodsmen, since they had to wield the heavy broad axes and keep right to the scorer's line. There is one tall tale of an impromptu competition, held to identify the best hewer in the area. It came down to a difficult decision for the judges, who were unable to select a winner from so many fine examples of axemanship. In order to break the stalemate, one old-timer pasted an open sheet of newspaper on a smoothly hewn log. He carried away the honours by shaving the print off only the exposed side of the page; the words on the reverse side were still stuck to the log.

The farmers' sons they leave their homes,
their friends they love so dear,
And into the lonesome pine woods
their pathway they do steer.
There's tinkers and there's tailors,
likewise mechanics too —
Takes all sorts of tradesmen to form
a lumbering crew.

– verse of "The Shantyboys in the Pine," from Fowke

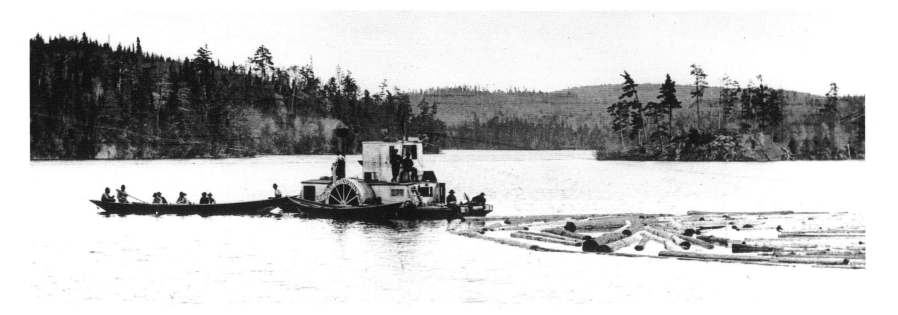

Steam tugs, called "alligators" because of their ability to winch themselves across land, were used to tow log booms. This alligator and the pointer boats are on Burntroot Lake, 1908.
– University of Toronto Archives

In 1846, five-million cubic feet of red and white pine floated down the Madawaska, Bonnechère, and Petawawa rivers during the spring drive. Once the logs, or "sticks" as they were called, reached the more placid waters on the Ottawa, they were tied together into cribs of twenty-five. These cribs were eventually lashed into enormous rafts, which were frequently pushed by sail to the shipping yards. Long, straight timbers were used for the huge "traverses," or cross-beams, for the rafts. Lake Travers may have been so named because it was an excellent source of these specialty timbers.

Log drives often lasted the whole summer; sometimes it took two years to get the timber out because of low water on the rivers. Many of the lake levels in Algonquin today are artificial, raised by dams built in the early days to control the water depths for log drives.

The demand for the square timber in Britain remained strong well into the 1850s, and the intensive logging put new pressures on the Algonquin forest. The first great fire in the region was recorded in 1851 on the Bonnechère River, and it was likely started by the careless handling of a lumberman's firearm. Another swept the northeast side of the park in 1863. James

On the Opeongo Line I drove a span of bays
 One summer once upon a time
 for Hoolihan and Hayes.
Now that the bays are dead and gone and grim old age is mine
 A phantom team and teamster
 start from Renfrew, rain or shine.
Aye dreaming, dreaming, I go teaming
 On the Opeongo Line.

– Tom Devine, quoted in Clyde C. Kennedy's *The Upper Ottawa Valley*, published by the Renfrew County Council, 1970.

Dickson, the surveyor, reported on the destruction during his survey of White Township (including Radiant Lake and Lake Travers) in 1884. The following excerpts from his report were quoted in the August 24, 1989, issue of the park newsletter, *The Raven*.

Dickson noted that only a very "small proportion of the township escaped the destructive fire which swept over the district some twenty years ago, as the blackened and charred pines that still remain towering above the dense tracts of poplar and willow brush attest." Adding to the disfigurement of the recklessly cut areas, was the *slash*, or waste, left from the trimming of square timber. The stands in Bishop Township, south of Tim River, were also "cut in a very careless manner," he wrote, "the best trees only having been taken out, while there are hundreds of saw-logs and many pieces of large square timber now lying rotting at the stumps or on the skidways." The pressures of over-logging, the clearings made for depots, and fires led to a shortage of trees big enough to square in some areas by the 1860s. "Waney" timbers – octagonally-trimmed logs – made their first appearance in 1861, because they could be made from smaller trees. An emerging American market for sawn lumber and the depletion of the huge virgin pine stands sparked a shift in the Algonquin timber trade by the second half of the century and gradually brought the square-timber era to a close.

Early Settlers

Near the south end of Basin Lake, in the Bonnechère River watershed, there is a grassy clearing dotted with yarrow and shaggy alders. Scattered about the area are single poplar and jack pine trees, but denser forest is encroaching on the clearing each year. Looking very closely at the level of the ground underfoot, one can just make out a rectangular depression, outlined by slight banks of earth covered with tall grass. At similar spots in Algonquin's interior, one finds the zig-zag pattern of a rail fence, choked by shrubs, or crumbled stone foundations, or collapsed log structures. These are the few remaining signs of homesteads that were cleared here during the 1800s.

Settlement reached the Algonquin forest by the middle of the nineteenth century. Alexander Shirreff's report had overestimated the suitability of the area for agriculture, but colonization roads were being constructed to encourage immigration and farming in regions all over Ontario – the Algonquin highlands included. The Hastings Settlement Road, started in 1854, stretched north from Madoc, almost to the southern boundary of the present park. In the same year, clearing for the Opeongo Line, a settlement road to run from the Ottawa River past the town of Madawaska, was begun. The Peterson Road linked Renfrew and Haliburton by 1860. Along with these colonization roads went a network of lumbering and tote roads. Tracks from the town of Bissett to Lake Travers, from Deux Rivières to Cedar and Radiant lakes, from Mattawa to Kiosk, and from Round Lake to Basin Depot on the Bonnechère were only some of the primitive trails into the area.

In spite of the poor soil, some settlers cleared farms out of the woods, but they would not have been able to subsist in that environment, so unsuited to agriculture, had there not been an assured market for produce and supplemental employment at the lumber camps. Paddy Garvey, James Foy, Dennis McGuey, Alexander McDougall, William MacIntyre, the Widow McDonald: all are names of early settlers who sold what produce they could to the lumber companies.

With their fathers frequently away at the logging camps, the children were needed at home to help with the chores; they never spent long in school. Peter McGuey, son of one of these first settlers, described his early life at Basin Depot at dedication

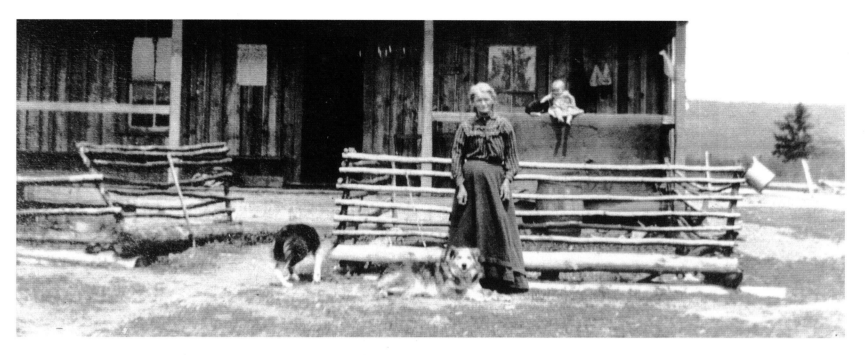

Homesteading in the early days. Mary Ellen Foy minds young Fanny McGuey. Mary Ellen lived with the McGueys, close to the Bonnechère River.

ceremonies there after the restoration of Algonquin's oldest building in 1984. The depot was an important logging centre on the Bonnechere River. In the 1880s, the McGuey family moved to the Basin, just before Peter and his twin brother were born. Tragically, the brother was stillborn and was buried just a few steps from the milkhouse. The family feared for little Peter, so he was kept warm in a prune box on the oven door for the first six weeks of his life.

The two-room house at Basin Depot that has been restored served for a time as the school for Peter and the twenty-six other children in the area. They crowded around the only table, and shared two scribblers that constituted most of the classroom supplies. Some of the pupils walked over a mile through the bush to attend lessons.

None of the land in the region was ever actually sold to these farmsteading families by the Crown. Only timber rights to the land could be leased, so most of the farms were cleared by families who worked in conjunction with the lumber company that held the limits in that area. The one exception is the Dufond Farm on Manitou Lake; the Dufonds were the only settlers to ever have a deed to the title of their farmland.

It is unclear exactly when the Dufond family came to the region. Early explorers described the northern section of the park as the hunting territory of the Indian chief "Map di Fong"; his name was given to a northern route to the Ottawa, the Amable du Fond River. Ignace and Francis Dufond, presumably this chief's descendants, first settled on Lake Kioshkokwi. Later, during the 1880s, they cleared a farm at the north end of Manitou Lake that was linked to Mattawa by bush road, and the family kept a little livestock and grew crops in the sandy soil. The Department of Mines granted a patent for the land to Ignace Dufond in 1888, and the family made a profitable living selling mostly hay and potatoes to the lumber companies.

It was black fly, black fly everywhere,
A crawlin' in your whiskers, a-crawlin' in your hair;
A-swimmin' in the soup and a-swimmin' in the tea;
Oh the devil take the black fly and let me be.

– verse of "The Black Fly Song," from Edith Fowke and Alan Mills's *Singing Our History*, 1984

19

Always hospitable, the Dufond family figures in many of the early rangers' stories.

The other pioneering clan of note was the Dennison family. Following a distinguished career in the military, Captain John Dennison established himself at Dennison's Bridge, now Combermere, on the Madawaska River. After his wife's death in the 1870s, he and his two sons pushed farther up the river to Lake Opeongo, the proposed terminus of the Opeongo Colonization Road, where they set up farmsteads at the narrows to the East Arm.

Captain Dennison met a tragic end at the age of eighty-two. One June day in 1881, he set off to check his traps, accompanied by his eight-year-old grandson. When his grandfather failed to return to the boat where he was waiting, the boy sounded the alarm. A search was launched, but it was not until the following day that Dennison was found. A wounded bear, captured in one of the captain's traps, had mauled and killed the adventurous man. He was buried in a fenced plot back at the farm that he had wrested from the wilderness.

Smoke Lake.
"When I first arrive
in the park each
summer, I get this strong
sense of having to create.
This is a very reassuring
feeling, a feeling that tells
me that Algonquin has
something to offer
visually. . . . It also tells
me that I still belong here."
– K.M. (Kate) Graham

overleaf

Campsite on Tom Thomson
Lake in the early spring.

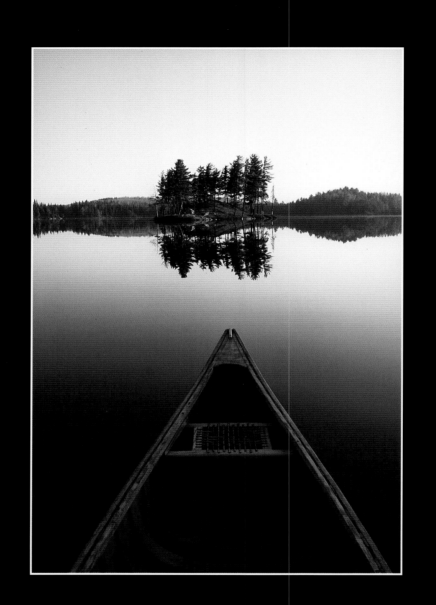

Part Two

THE PARK

What's in a name? If we're talking about Algonquin lake names, plenty. The origins of some names are obvious – Kirkwood Lake, Tom Thomson Lake, Sheriff Pond – but others are intriguing. To add to the mystery, many names have been changed over the years. Why is the body of water where a tragic drowning occurred named Happy Isle? Who was Hogan?

A park map provides yet another record of Algonquin's past. When the first aerial map of Algonquin was produced during the 1930s, it became apparent that there was much duplication in the names of lakes. It also became obvious that there were still many unnamed bodies of water. Many of the older local names were replaced to avoid duplication – frequently with township names. Manitou Lake was renamed Wilkes Lake for a time, while Eagle Lake became Butt Lake permanently. To reduce confusion with other bodies of water with the same names elsewhere in Ontario, White Trout was changed to Big Trout and Pine River to Tim River. Clear Lake became Dickson, and Big Shoal became known as McIntosh. Other suggestions were solicited from the children's camps, which led to the naming of lakes Tanamakoon, Alsever (after an outstanding camper at Camp Kephart), and Namakootchie (provided by Northway campers from one of their canoe-trip songs).

In 1974, when the first complete Canoe Route Map was prepared by the Ministry of Natural Resources, more unnamed features were given titles. Many of the names that date from the seventies were given in recognition of pioneering families and park founders of the early years.

Lakes Named after Surveyors and Public Men

Aubrey Lake and White Lake – for Aubrey White, Assistant Commissioner of Crown Lands in 1893

Dickson – after James Dickson, who surveyed many Algonquin townships. He named Cache, Brûlé, and Misty lakes.

David Thompson – mapmaker and explorer

Mowat – after Sir Oliver Mowat, Premier, 1872 to 1896

Phipps – after Robert W. Phipps, Clerk of Forestry in the 1890s and a keen supporter of the park

Kirkwood – after Alexander Kirkwood, Chief Clerk in the Department of Crown Lands

Lakes Named for Settlers, Loggers, and Trappers

Foys, Garveys, and McIntyre lakes – all named for early settlers in the Bonnechère area

Sawyer – for Jim Sawyer, trapper, who had a camp on Butt Lake and became a ranger after the park was created

Hogan – for Bill Hogan, an Ottawa Valley broad-axeman during the square-timber days

Lakes Named for Rangers

Borutski, O'Gorman, Robinson, Stringer (for ranger George Stringer, who drowned on Rock Lake), Turcotte, and Godda (from Godin) lakes are all named for park rangers.

Billings Lake was named for Jack Billings, a game warden from Barry's Bay. Patrolling for poachers on Billings Lake, he and Joseph Stringer both met a tragic end. Their bodies were found in a burned-out cabin, and rumours circulated that the fire had been set to cover up a double murder.

Found Lake was first dubbed "Lost Lake" by Ranger Mark Robinson, who was surprised that a lake so close to park headquarters was unnamed on early maps. After the highway was opened in 1936, the lake became "Found."

Kootchie Lake was named after a dog that belonged to Ranger William Bell's sister. Bell produced one of the earliest canoe-trip maps, and when the little dog fell out of a canoe, the lake was named to commemorate its rescue.

Miscellaneous

Bonnechère meant to sup well and enjoy "good cheer" to the voyageurs who named this river during the 1600s.

Galeairy was a name formed by combining the names of two townships: Nightingale, named after Florence, and Airy, after Sir George Airy, distinguished British scientist and astronomer.

Happy Isle's title was changed from Green Lake at the request of a woman who lost her husband and son in a drowning accident there in 1931. A plaque still commemorates the pleasant times the pair had on their canoe trips there.

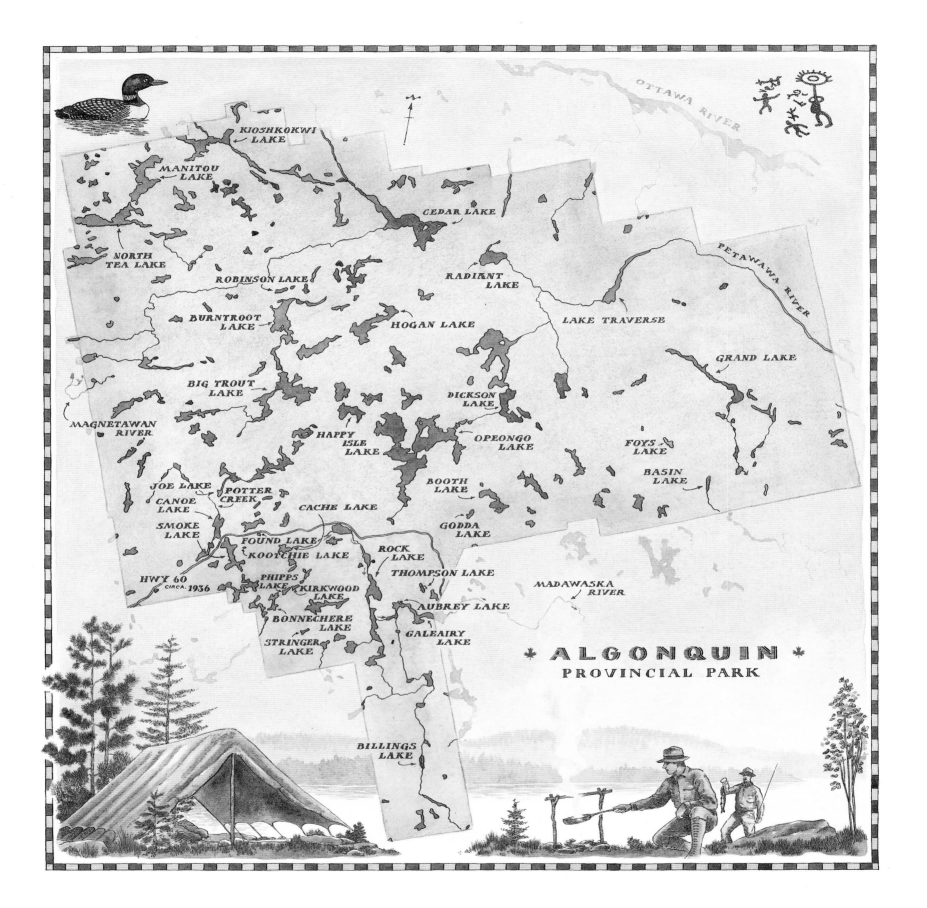

KIOSHKOKWI
LAKE

MANITOU
LAKE

CEDAR LAKE

OTTAWA RIVER

NORTH
TEA LAKE

ROBINSON LAKE

RADIANT
LAKE

PETAWAWA RIVER

BURNTROOT
LAKE

HOGAN LAKE

LAKE TRAVERSE

BIG TROUT
LAKE

GRAND LAKE

MAGNETAWAN
RIVER

DICKSON
LAKE

HAPPY
ISLE
LAKE

OPEONGO
LAKE

FOYS
LAKE

JOE LAKE

POTTER
CREEK

BOOTH
LAKE

BASIN
LAKE

CANOE
LAKE

CACHE LAKE

SMOKE
LAKE

FOUND LAKE

KOOTCHIE LAKE

GODDA
LAKE

ROCK
LAKE

HWY 60
CIRCA. 1936

PHIPPS
LAKE

KIRKWOOD
LAKE

THOMPSON LAKE

MADAWASKA
RIVER

BONNECHERE
LAKE

AUBREY LAKE

STRINGER
LAKE

GALEAIRY
LAKE

✷ ALGONQUIN ✷
PROVINCIAL PARK

BILLINGS
LAKE

25

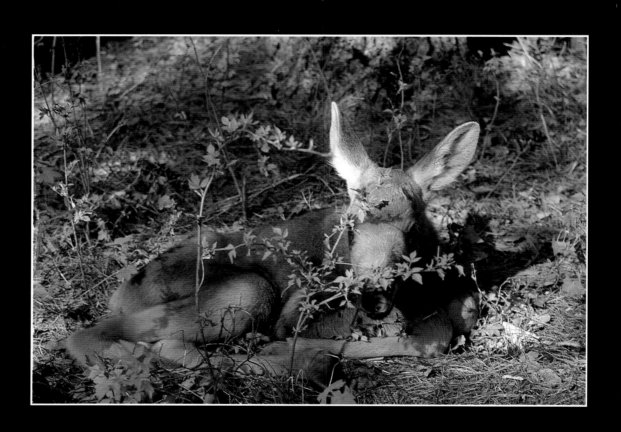

Algonkin, Forest and Park

The Government of Ontario was still encouraging further colonization of the two million hectares of fertile land in the less-populated areas of the province in the 1870s. Since the erroneous notion that Algonquin was arable persisted, most of the townships of the present park area were surveyed and plotted as forty-hectare farm lots in preparation for settlement. Several surveyors described large burned tracts at the time, and it was noted that some sections had been burned over more than once. Although there were proponents for increased settlement in the area, the logging companies had become aware of the rapid depletion of virgin stands, and they blamed the fires on settlers, accusing them of being careless when they cleared their land for farming.

Potential disaster had to be anticipated and prevented. The soil was unfit for agriculture. Clearing would only lead to the wasteful destruction of forests, and contribute to erosion and

the fouling of the rivers that had their headwaters in the park. A few government officials saw the value in preserving this area from encroaching settlement.

In 1885, Canada's first national park was established at Banff, Alberta, because a few Canadians were far-sighted enough to realize that some natural environments were being threatened by the rapid growth of mining, logging, and settlement. Some, including Robert Phipps, Ontario's Clerk of Forestry, and Alexander Kirkwood, Chief Clerk in the Department of Crown Lands, were beginning to recognize the importance of preserving large areas for the protection of wildlife, waters, and forest. The following year, Kirkwood wrote to the Commissioner of Crown Lands, T. B. Pardee, describing the benefits of an immense reserve in the highlands of southern Ontario that would preserve and maintain the forest and waterways.

> There is a gloomy grandeur in the natural forest. The noble pines and stately oaks bespeak the growth of centuries. The winds sound solemnly among their branches, and the rooks caw from their hereditary nests in the tree tops.
>
> – A. Kirkwood, published letter, "*Algonkin, Forest and Park, Ontario*," 1886

Kirkwood's description is more poetic than real – there have never been any rooks or "stately" oaks in the park – but the idea of creating a park gained support.

In 1892, Ontario's Premier, Sir Oliver Mowat, established a Royal Commission to examine Kirkwood's proposal. The Commission members were Robert Phipps; Archibald Blue, Director of Mines; Aubrey White, Assistant Commissioner of Crown Lands; James Dickson, Inspector of Surveys; and Alexander Kirkwood himself.

Kirkwood had an important ally in James Dickson, who had already investigated the suitability of the Algonquin highlands for the project. Dickson was very familiar with the region, from his surveys of the area between 1878 and 1886, and he had counselled against settlement because of the poor soil. As recorded in Audrey Saunders's *Algonquin Story*, he did describe the beauty of the area in its natural state in his reports for Finlayson and Peck townships. He wrote, "As we float along the streams or skim over the calm water of the lakelets almost every

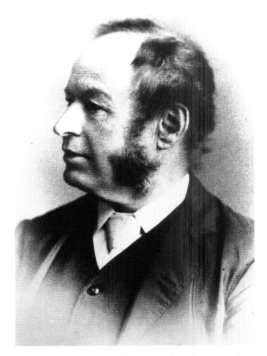

Alexander Kirkwood, who, in 1885, came up with the idea of a "national forest and park" in the Algonquin highlands.

stroke of the paddle unfolds some new scene of rural beauty, seldom equalled in any part of our fair province, and to paint them in all their pristine beauty would take the most gifted pen or pencil of either author or artist."

The 1893 Report of the Royal Commission on Forest Reservation and National Park described the large-scale destruction of watersheds, soil depletion, and the accompanying imbalance in micro-climate which had resulted from deforestation in parts of Europe. The report cited that "the experience of older countries has everywhere shown that the wholesale and indiscriminate slaughter of forests brings a host of evils in its train. Wide tracts are converted from fertile plains into arid deserts, springs and streams are dried up, and the rainfall, instead of percolating gently through the forest floor . . . now descends the valleys in hurrying torrents, carrying all before its tempestuous flood." Ontario could prevent the problems that plagued Russia and France by protecting the rivers' headwaters and the forest.

The commissioners recommended the allocation of approximately 3,800 square kilometres within eighteen townships for the preserve – an area which has since been doubled with the addition of part or all of more than twenty other townships over the years. They suggested that a park would protect the headwaters of the seven rivers originating in the region. Hunting would be outlawed in the park, giving diminishing animal populations within its boundaries and in adjacent townships a chance to rebound. Tourists would find a healthy retreat in this natural area, while the park would also provide a field laboratory for the application of sound forestry practices. The commissioners also articulated the need for planned lumbering to ensure long-term productivity. They noted that valuable timber was being wasted by fire, irresponsible logging practices, and misguided settlement, and that "if extensive clearings were allowed to be made, ostensibly for farming purposes, the consequences would be that the district for forest purposes would be rendered useless, and possessing little or no value from an agricultural point of view, it would soon be converted into a dreary and abandoned waste."

In 1893, Arthur Hardy, Commissioner of Crown Lands, drafted the legislation to create Algonquin National Park – the name changed to Algonquin Provincial Park in 1913. The legislation stipulated that operating costs would be covered, for the most part, by the revenues from timber leases. Since the act guaranteed continued logging, the lumber companies welcomed the legislation as a deterrent to colonization and the fires associated with it. The bill passed easily through the Ontario legislature, and formal assent was given on May 27, 1893, establishing that "the said tract of land is hereby reserved and set apart as a public park and forest reservation, fish and game preserve, health resort and pleasure ground for the benefit, advantage and enjoyment of the people of the Province." The justification for the varied activities occurring in the park today are found in this first act that designated logging, recreation, and preservation as undertakings of equal importance in Algonquin.

"Can you think of anything that has the majestic quietude, the reposeful calm, the slumbering restfulness of a forest of great trees."
– Grey Owl

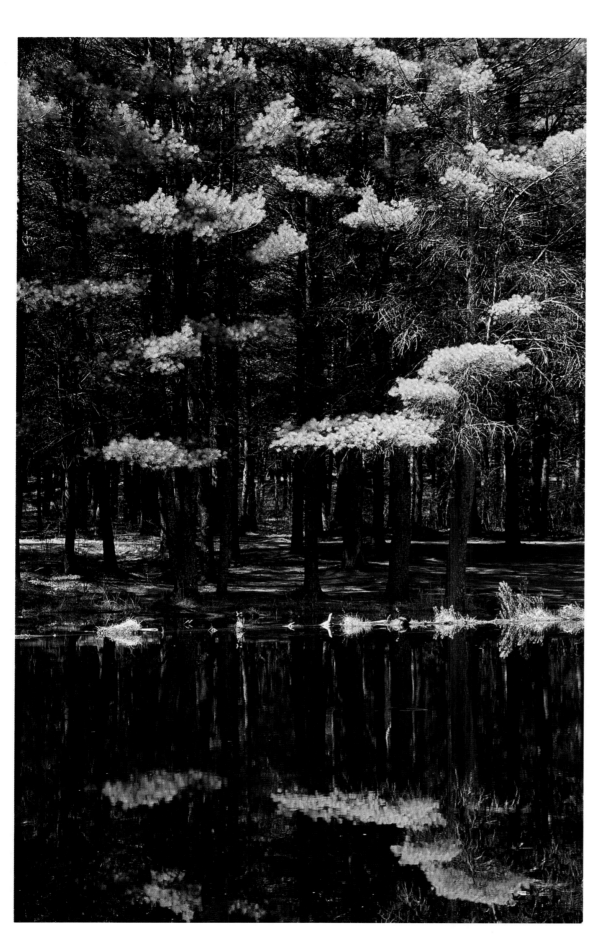

Cow moose, feeding in shallow water. ``Algonquin Park is for all creatures, great and small. It can accommodate the mouse and the moose.''

– David Anderson, park visitor

left

``Its waters day by day reflect its countless moods, and the everchanging colours of the sky; today a perfect shadowgraph of the surrounding woods, unruffled, lucent and jade green.''

– Grey Owl

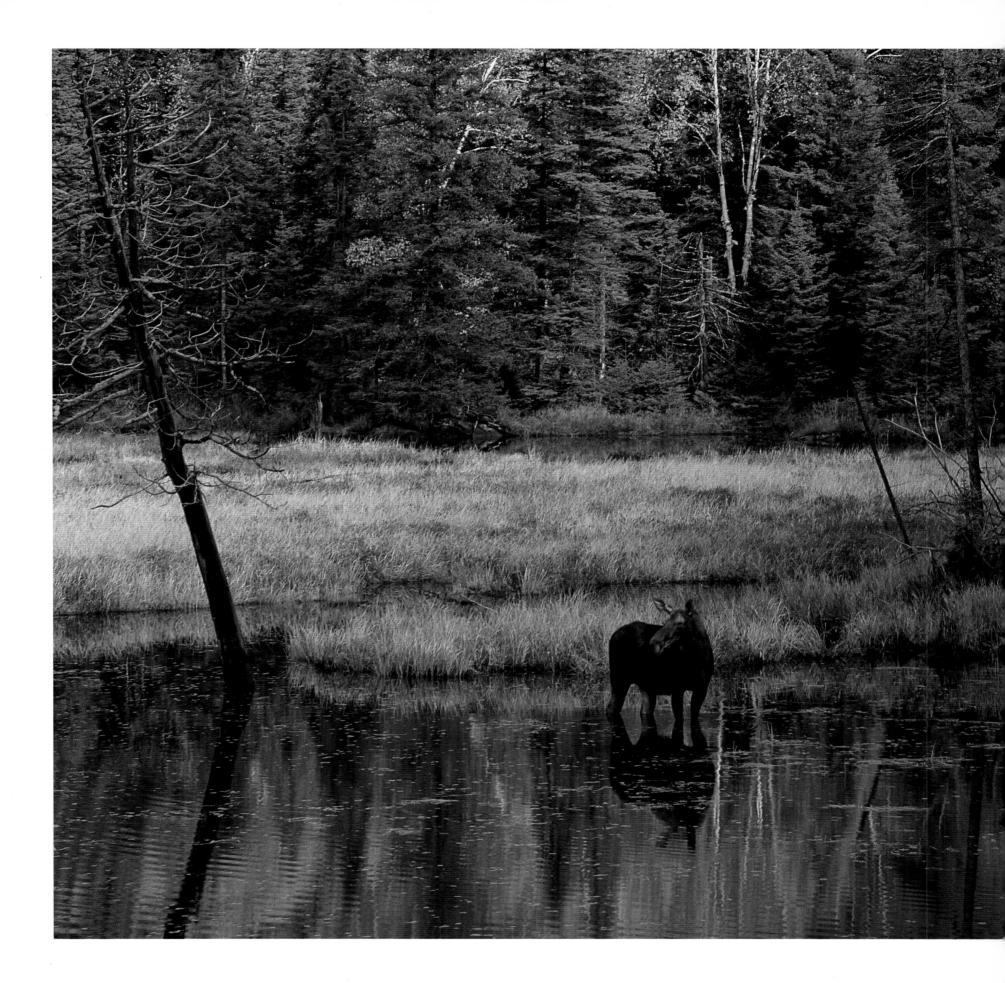

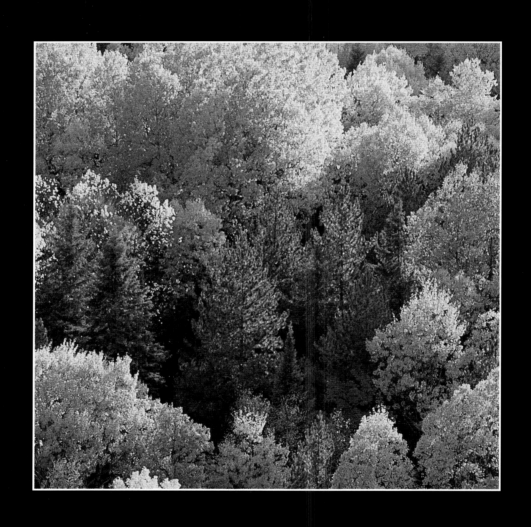

A Century of Logging

After Algonquin was established, logging continued. The timber licences, which granted the right to harvest within a certain area, or limit, provided much-needed revenue for the park's improvement. Beginning in the 1860s, growing demand for lumber in the United States and the depletion of giant pines led to a shift away from square timber to sawn lumber, while the arrival of the railway in the 1890s brought further changes to Algonquin's timber trade by making it easier to transport logs to the expanding American market.

Newcomers joined the older lumber companies. Perley and Pattee, E. B. Eddy, the Gilmour Brothers, Alex Barnet, the Gillies Brothers, and the McLachlin Brothers all now logged within the Park – but the best known is John Rudolphus Booth.

Born in eastern Quebec in 1827, Booth left his family's farm as a young man to work as a carpenter for the Central Vermont

Railway. He moved to Ottawa in 1853, taking a job at a machine shop, and within a short time he was promoted to manager of the mill. He soon struck out on his own.

Several times his mills burned down, but he persisted. One of his first large orders, in 1859, was for lumber for the construction of Canada's Parliament Buildings; with the profits from that job he was able to expand operations.

In 1867, Booth purchased the timber rights to 650 square kilometres in the park from the bankrupt estate of John Egan, and from there he went on to become one of the wealthiest men in Canada. During the 1870s, he employed six thousand men in his Ottawa mills and bush camps. He eventually owned rights to seven thousand square miles of Canadian pine forest, and his mills were among the world's top producers.

In 1879, the entrepreneur and his partners formed the Canada Atlantic Railway Company to transport timber to New England markets. His next endeavour was the Ottawa, Arnprior and Parry Sound Railway, pushed through the park between 1894 and 1896. Construction of the rail line over Algonquin's height of land was difficult, but once it was complete, it provided the shortest route from the upper Great Lakes to eastern Canada and the United States. Even in the north part of the park, the timber baron's influence was felt. His descendants built a fishing camp on Lake Travers in 1933, and the lodge was built in the shape of a turtle – a registered mark that was stamped into the logs felled by Booth's men. Although the buildings were dismantled in 1978, the clearing and chimneys of "Turtle Camp" are still visible.

Booth died in 1925 in his ninety-ninth year, but his influence is still observable today in the name of Booth Lake, and in the abandoned railway bed and its trestles.

The Gilmour Company has a less successful, but equally colourful, place in Algonquin's history. In 1892, the Trenton-based company bought cutting rights to an area surrounding Canoe Lake, but to reach the company's Lake Ontario mills, the logs had to be driven through three different watersheds. The plan was to build a steam-powered jackladder to raise the logs thirteen metres and carry them a kilometre over the height of land at Dorset. From Raven Lake they would enter the Gull River system and be carried on through the Kawarthas.

The first year, the drive was halted in October; the logs had

"Every part of nature teaches that the passing away of one life is the making room for another."
– Thoreau

been driven only as far as Campbellford on the Trent River. By the time the timbers reached the Trenton mills during the following spring, rot had already set in. For three years the Gilmours tried driving to Trenton, but they were never able to get the logs all the way to the mill in one season. The company went bankrupt in 1900, leaving behind a handful of buildings on Canoe Lake. Two homes built by the Gilmour brothers in

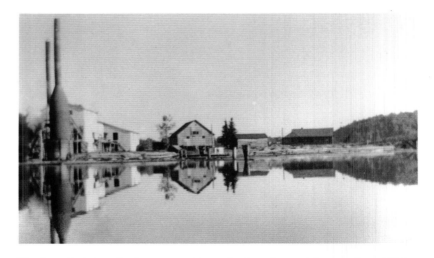

The Canoe Lake Lumber Company on Potter Creek at the top of Canoe Lake, c. 1925. It later became the Omanique Lumber Company.

1893 on Pirie's Island and an office building on Potter Creek were sold.

Other companies began constructing sawmills within the park in the early part of this century. Canoe Lake Lumber Company built a mill on Potter Creek that was used by the Omanique Lumber Company as late as 1943. Muskoka Wood Company milled at Brûlé until the buildings burned down in 1957. The St. Anthony Lumber Company operated a mill at Whitney, and they built a spur line from Booth's railway to their stands on Opeongo. The McRae Company operated mills at Galeairy, then moved to facilities on Lake of Two Rivers in the 1930s. The Huntsville Lumber Company, with headquarters on Rain Lake, Canadian Wood Products, Brennan Lumber Company, and Munn Lumber Company also milled within park boundaries. The last mill in Algonquin, operated by the McRae Lumber Company at Rock Lake, was eventually closed in 1980.

By 1910, square timber had largely disappeared, and huge volumes of sawlogs were being transported by rail. The completion of the Canadian Northern Railway through the northern section of the park facilitated transport there. In fact, Canada Veneers continued to ship lumber by rail from Oden-back station long after trucks had replaced trains in the south.

During the First World War, some municipalities contracted for fuel wood to alleviate coal shortages. Wood-cutting camps in Algonquin included those at Source, Rain, and Brûlé lakes. There was a shortage of labour, so some convicts were given the choice of a jail sentence or working at one of the camps.

The next shift in Algonquin lumbering occurred in the 1930s. There were new markets for birch veneer and maple, and pine gave way to hardwood extraction. By 1928, over 60 per cent of the Canoe Lake Lumber Company's harvest was hardwood.

The 1940s and 1950s brought many changes to logging in Algonquin. Interior logging roads were expanded during the Second World War, and by the 1940s, most timber was being removed by truck. A demand for Algonquin's yellow birch emerged, when light and pliable birch veneer was used to cover the wings of Mosquito aircraft. During the 1950s, mechanized skidders replaced horses for hauling felled trees out of the forest to the trucks. Chainsaws replaced old saws and axes. Camps became more portable, and, as roads improved, most loggers started to commute from homes outside the park.

The Algonquin Forestry Authority

In the early seventies, some groups began questioning the wisdom of logging in Algonquin Park. As Joanne Kates put it in *Exploring Algonquin Park*, published in 1983, "the crucial question is whether a provincial park should be a tree farm, even a well-managed one."

In response to these concerns, in 1974 the provincial government established a committee to study Algonquin forestry. At the time, there were fourteen different companies cutting timber in the park. Murray Brothers, Consolidated Bathurst, Weldwood of Canada, Canada Veneers, Canada Wood Mosaic, G. W. Martin, and several other companies had camps in Algonquin, while United Oil Products had a company town at Kiosk, complete with veneer plant and sawmill.

That same year, the Economic Council of Ontario released a study about the economic impact of the Algonquin forest industry; approximately forty million dollars in revenue came from forestry, while tourism generated only three million dollars annually.

The committee recommended that the Crown set up an agency to oversee all logging in the park, and the Algonquin Forestry Authority was founded in 1974 as the single licensed operator. The agency's mandate, as stated in its 1980 Forest Management Plan, is "to produce a continuous supply of forest products to the forestry industry in the region in harmony with other uses and in a way that preserves other values."

In 1983, the A.F.A. took over additional forest-management duties that the Ministry of Natural Resources had been responsible for since it replaced the Department of Lands and Forests in 1972. These duties included such things as tree marking, scaling, road maintenance on the public-access roads, and reforestation. The M.N.R. continues to set cutting prescriptions, but harvest, renewal, and silvicultural management fall under A.F.A. jurisdiction.

Roughly one-third of the timber coming out of Algonquin is in the form of hardwood sawlogs, one-third is softwood sawlogs, and another third is pulp. The park also provides more than half of Ontario's red-pine utility poles and 40 per cent of the province's maple output.

One of the A.F.A.'s missions is to sustain yields by selective

37

cutting and replanting. In 1989, 250,000 seedlings were planted. Research continues into the most effective methods of harvesting different types of trees to maximize natural regeneration and to produce the highest-quality timber. But the agency is also concerned with minimizing the impact on recreational users. No cutting is allowed in buffer zones bordering canoe routes, portages, and roads, or along shorelines. Bridges and culverts are removed when roads are abandoned, and machinery operation is restricted to seasons when recreational use is low.

Logging has been part of the Algonquin scene since the park was created. Although its critics agree that timber harvest as conducted in Algonquin is probably the best in Ontario, they look at accelerating development outside the park and ask that Algonquin be preserved from timber extraction.

The concern for the forest and the necessity to manage, and manage well, is now crystal clear. If you take a close look, you'll see that thinning competing trees actually allows the remainder to thrive. The A.F.A. is actually improving natural stands. We can show you stands where we cut five years ago, and if I didn't tell you we had been there, you wouldn't know. They're beautiful, and we have increased the yield and the quality too.

As rich as we may think we are, we're not rich enough to not use this renewable resource. Algonquin produces high-quality timber and has the capability of doing so for years to come, to the benefit of all of the people of Ontario.
– E. R. Townsend, retired Operations Co-ordinator, Algonquin Forestry Authority

Cutting Timber for J. R. Booth:

Felix Voldock

Felix sits in his usual chair at the kitchen table. From this vantage point, he can see the comings and goings in town, and the Madawaska River as it runs through Whitney, while he reminisces about the rugged life in the shanty camps when he cut and skidded timber for J. R. Booth's company. At seventy-seven, he is a picture of stocky strength, and his roughened fists clench and unclench when he speaks of the cross-cut saws and heavy broad axes they used in the old days.

Felix went into the bush at sixteen and he logged at a Booth camp at McDougall Lake (now Booth Lake) that winter of 1931. Later he worked for the McRae Lumber Company north of Opeongo, on Proulx Lake. His last year in the camps was 1968, but during the thirty-eight years he logged, most of the timber was still taken out the way it had been for over a century.

"You used to go into the bush in August and come out in April. A lot of the time, the men would stay in even for Christmas, because it was too far to walk out."

The food was always good and hot, and the shanty where the fifty or more men slept was warm. "You had to be quiet when the lights were turned out, and if someone was noisy or was snoring too loud, you would just pick up a boot or something, and, by God, you gave him a good hit with it."

Felix had a lot of respect for the experienced older lumbermen. "Some of them would have great big moustaches and beards, or big, bushy eyebrows. When they were in the bush, with all the clothing on and a hat, all you could see was a big hairy face, two little eyes, and a mouth that was telling you to do something.

"All the men would know the jobs they were doing. . . . You had to be at work at seven o'clock in the morning, but on the sleigh haul, you might leave camp before six, sometimes in forty-below weather." At times, the teamsters were at work until eight o'clock at night, feeding and bedding down their horses before they could rest themselves.

In the camps where Felix worked, there were often fifty teams, and the roads through the bush could be dangerous. The sleighs were just under four metres wide and five metres long, and they hauled roughly twenty large logs per load. If the logs were smaller, there might be up to fifty of them on a sleigh. The roads were iced for easy gliding, and the hills were sanded or covered with straw to slow the descent. The horses were shod with cork to keep them from slipping; a runaway load could kill both team and driver. Felix remembers, "You would always be shouting to warn the other teamsters before you took a full load down one of these hills. It was a cold job for the men who worked the water sleds, but the men who iced and sanded had quite a responsibility, and the teamsters appreciated a safe road."

On one of Felix's trips the slope had frosted. "I was coming down a straw-covered hill with my team and a full load. The hill had three curves on it. I made the first two okay, but I was picking up speed, and it felt as if the horses' feet were only touching the ground every other step. All the men were yelling at me to 'Jump, jump, jump off, Felix. You're not going to make it,' but I stayed right up there on top of the load of logs, trying to make sure the horses got down safely. We did, and I got off and had a good little talk with those horses, telling them what a good job they had done."

When spring came, some of the men walked home; others joined the river drives. "There were usually forty men. One gang of twenty worked one side of the river, and the second gang was on the opposite shore. We had the big rowboats – the pointers – about six of those to go into the river to help keep the logs moving. You could never dry your clothes until the end of the day when you would have a fire, but even then you wouldn't get completely dry, because you were living in tents and always moving camp down the river.

"If you worked and worked at a jam and couldn't move it, then you would use dynamite. There were lots of accidents, and quite often you would lose a man trying to get a jam to move. The river gang would put a cross on the river where they lost the man, and then they would have to bring the bad news back to his family." Felix pauses, and fixes his attention on his hands. It was honest, hard work, and a rugged camaraderie ran deep.

"The days in the bush weren't always good, and you were there usually because you needed the money, but the men you worked with were men that would always be friends. All the cold days and nights were worth the celebration you had together in the spring when you came out."

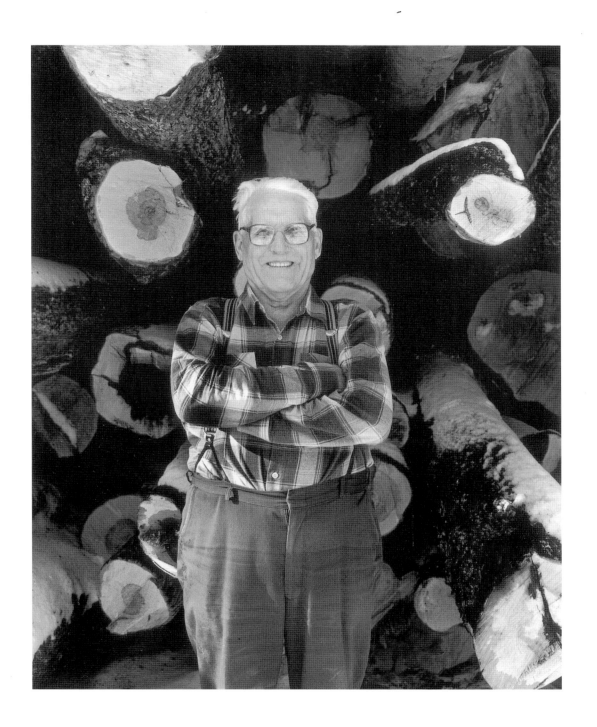

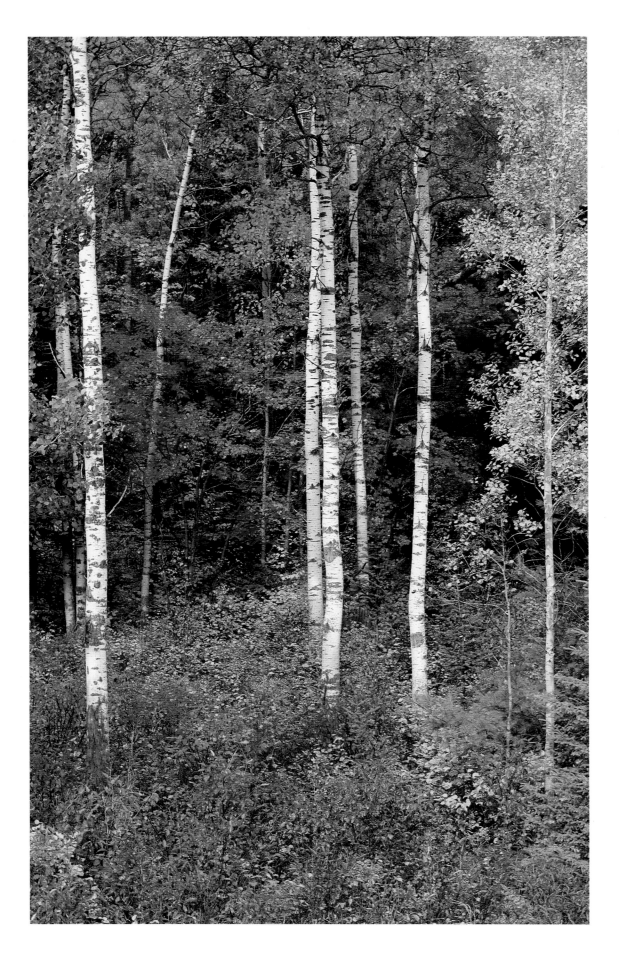

"Algonquin has a real softness to it. The pine needles and leaves under your feet soften the Precambrian Shield, the bones of the land. It is a wonderfully safe place; it is not at all threatening here. You feel very much at ease when you're in Algonquin Park."
– K.M. (Kate) Graham

"Algonquin Park
offers much-needed privacy
without the feeling of
isolation. Being in a canoe
by yourself
in a quiet marsh
is magic."
– Helen Davids, canoe
tripper

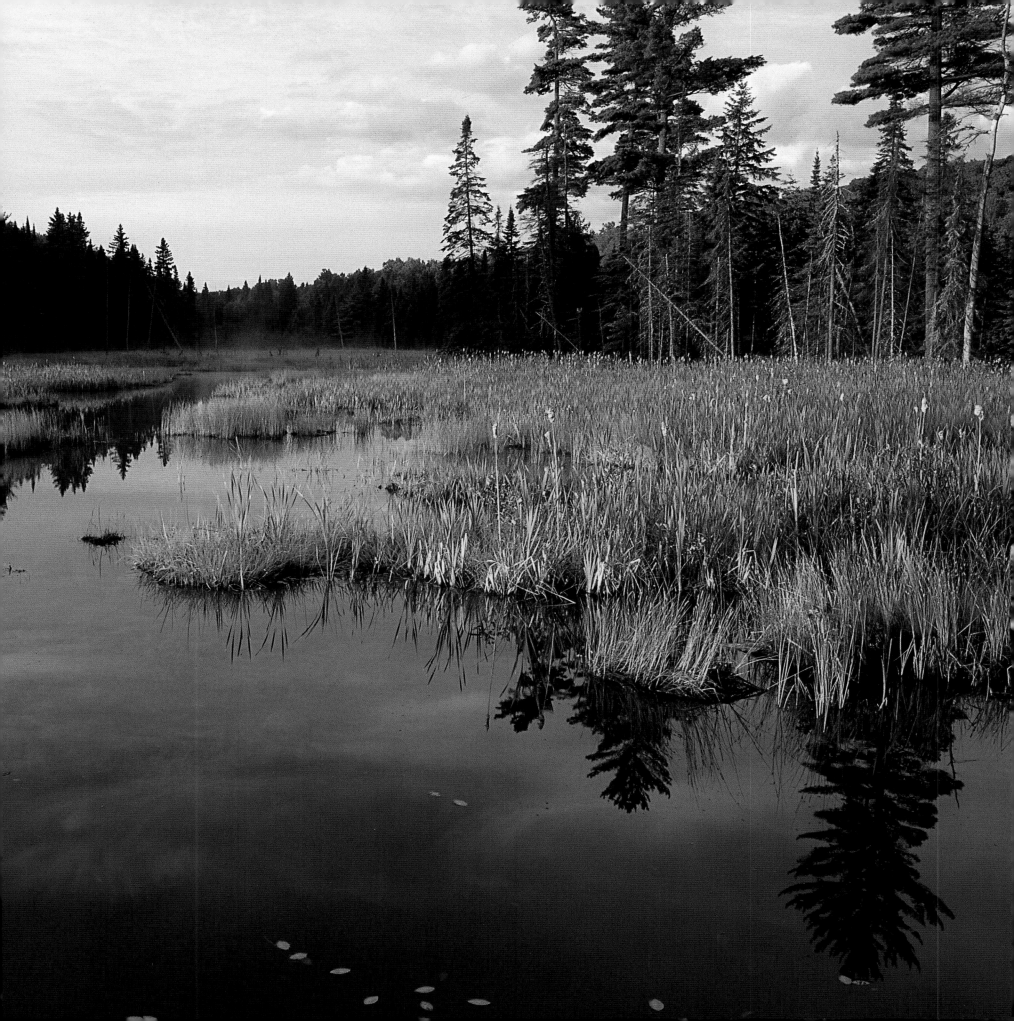

Early spring sunset with full moon, Potter Creek

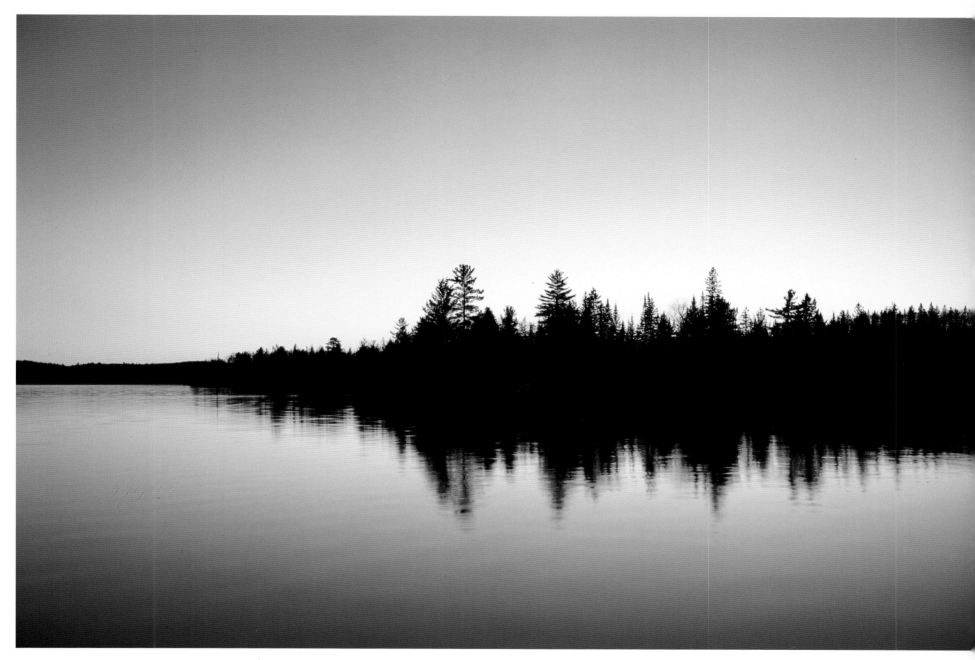

Late fall sunset on Canoe Lake

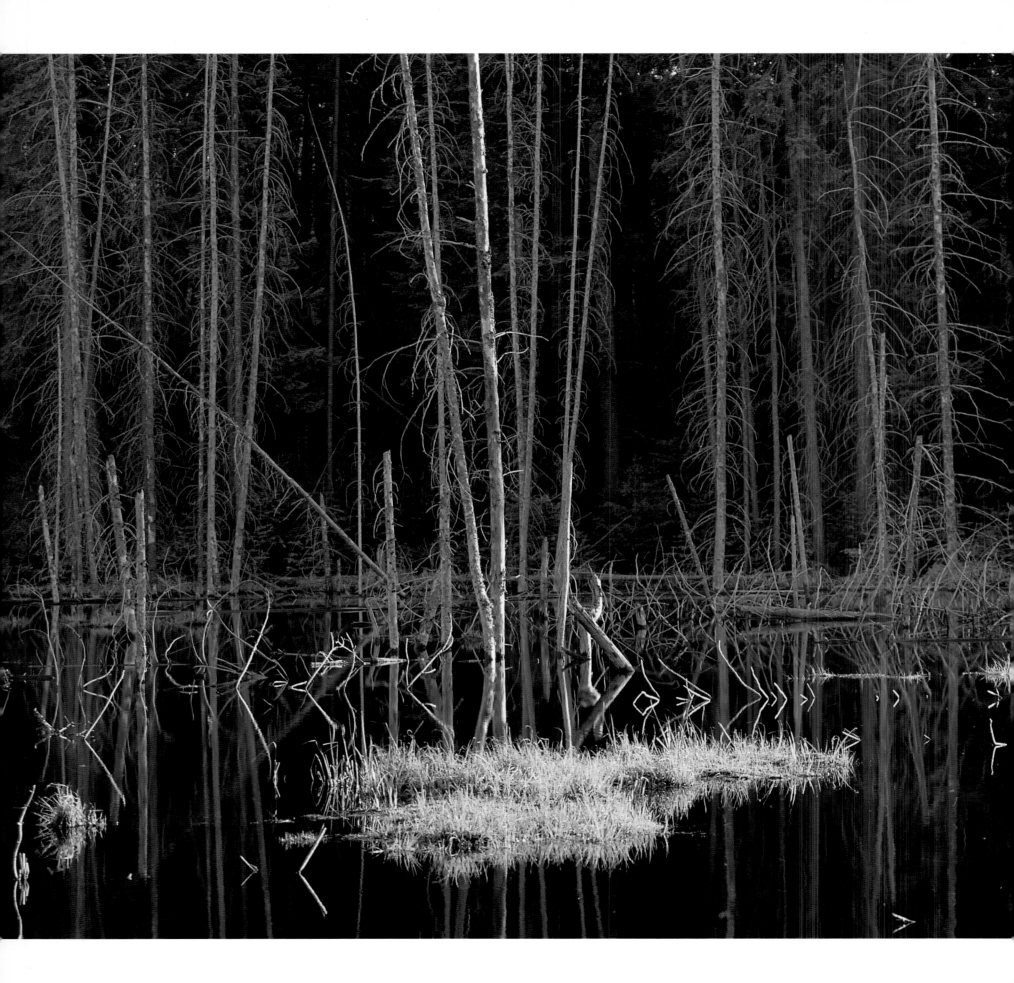

An example of the environment in which the great blue heron chooses to nest. Active colonies, or ''heronries,'' tend to be used for a few years, and then are abandoned, possibly when the accumulated excrement starts to kill the trees.

overleaf

This Wenda Lake ranger cabin was used by park rangers in the early 1900s.

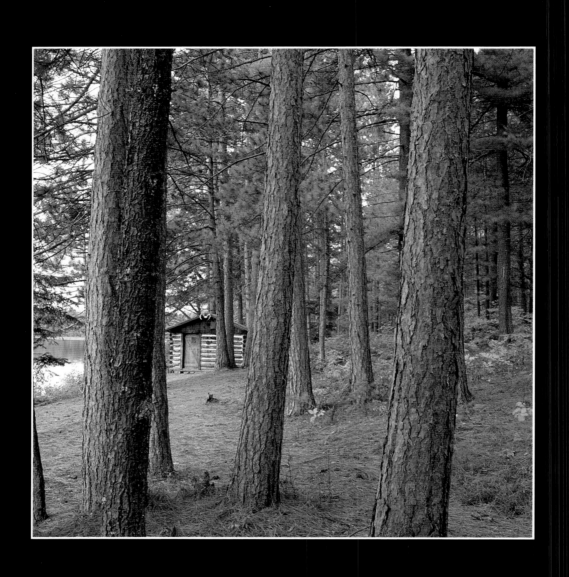

The 1892 Royal Commission on Forest Reservation and National Park recommended that rangers be hired to patrol the park – to prevent poaching, preserve timber, and protect wildlife. These rangers had to be able to withstand the physical demands of travelling through the park in all seasons and weather conditions, and be used to long periods in the bush and committed to preserving forests and wildlife. Rangers were to be granted the power of a magistrate, and were to be the only lawful carriers of firearms in Algonquin.

It was not long before the commission's recommendations were put into practice. Peter Thomson, a former road- and bridge-builder from Brussels (fifteen kilometres northeast of Stratford), was appointed chief ranger, and on August 2, 1893, he arrived at Canoe Lake, having paddled up the Oxtongue River from Huntsville with James Dickson, three rangers, and

three other men. While the remainder of his party started constructing park headquarters at a site near the Gilmour Company camp on the west shore of the lake, Thomson and two men set out on their first patrol.

> The house at headquarters was finished about the latter part of August. It is a substantial, hewd-log building, twenty-one by twenty-eight feet, with hewd lumber floor and scoop roof. We selected this site for headquarters because of its accessibility to Canoe Lake and the chain of waters of which this lake forms a part, its nearness to the proposed line of railway from Arnprior to Parry Sound, and also because of the fine grove of balsam, spruce, and a few pine trees which stood upon it. During the absence of myself and staff in October, the employees of Messers. Gilmour and Company, who own the pine timber in this part of Peck, built a lumber camp (doubtless through some misunderstanding) immediately alongside and within ten or twelve feet of our headquarters. They also entered the grove and took out the pine, at the same time cutting down a great many of the other trees and marring the beauty of the place which I had hoped to preserve.
>
> – Peter Thomson, *Reports on the Algonquin National Park of Ontario for the year 1893*, Algonquin Park Museum archives.

Headquarters were eventually to be moved to Cache Lake in 1897, after the opening of the railway. Canoe Lake, although on a much busier water route, then became a sub-headquarters.

A difficult initial task for the park staff was to ask trappers who had been working in the area to move their lines outside the new park. Some trappers joined the ranging staff; others resented having to relocate without compensation. As a result, chasing poachers made up a large part of the rangers' duties.

From the beginning, the park was to be used for logging, and it fell to the park staff to keep an eye on lumber operations. Although a separate fire-ranging corps was directly responsible for combatting fires until the 1930s, park rangers were always on the lookout for telltale smoke.

The rangers also built huts, so they would never be more than a day's travel by snowshoe from shelter in the event of a storm. Clearing and marking portages, building docks, and making regular patrols kept them busy throughout the summers.

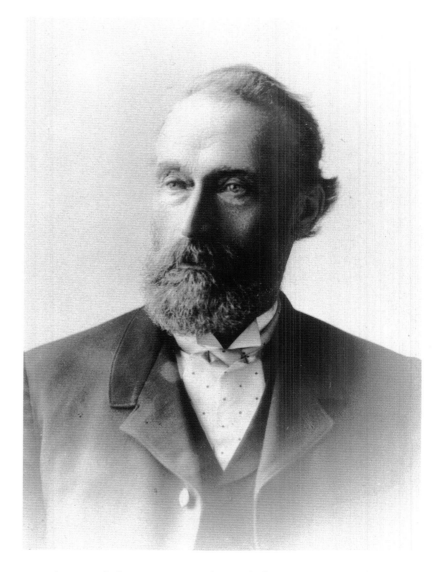

Peter Thomson. Chief ranger in 1893 and 1894, he became the first superintendent. His duties: "To protect the Park, game, and fish, and see that law is observed."

During the winter, the men tracked poachers, fixed equipment, and cut ice and wood. For years, they snared or poisoned wolves to thin the ranks of the "destructive beasts," as everyone thought of them at that time. For a short period, the rangers were also responsible for maple-syrup production on the Minnesing Road, but the job was too labour-intensive and it coincided with the busiest poaching season, early spring, when the rangers were required elsewhere.

Thomson was promoted to superintendent in May of 1894, but he did not hold the position long; he died at Canoe Lake in September 1895. Former chief ranger John Simpson was promoted to superintendent for a time, but, according to Audrey Saunders's *Algonquin Story*, some of the rangers "became involved in dishonest practices, and the Park had consequently fallen into disrepute." It became clear that a strong leader was needed if Ontario's first provincial park was to succeed, and George W. Bartlett was asked to take over the park's administration in 1898. Bartlett was the right person for the job, having acquired a reputation as a hard worker and a strict supervisor in his time as a foreman with the J. R. Booth Lumber Company. Appointed superintendent on August 5, 1898, he held that position for a record-setting twenty-two years. Under Bartlett, the ranging staff was increased, and regular patrols became more frequent. Bartlett himself went on lengthy tours of inspection by canoe and dogsled and on snowshoe.

He recorded one trip with the aptly named ranger Albert Ranger in 1909 through the territory west of Canoe Lake.

> Oh the glory of it all, to listen to the music of the snowshoe on the crisp snow, to glide in and out among those grand trees, to come out on top of a great bluff and find before you a stretch of the finest hardwood.
>
> Then again you may never have tasted the joys of a snowshoe tramp in our northern woods, and you may fear it on account of the supposed hardships. Once try it, however, once experience the appetite a day's travel gives you, the night's rest o' a bed of balsam, to say nothing of the pipe after supper, and the stories of your French-Canadian companion, who for forty years has followed the life of the lumberman and bush ranger, and you'll want more.

– G. W. Bartlett "A Winter's Trip through Algonquin National Park," *Rod and Gun in Canada*, Vol. 11, 1911.

More than fifty full- and part-time rangers were employed while Bartlett was superintendent. Some of those who figure in the early stories are: Tim O'Leary; Steve Waters; William Gale; John Simpson; Dan Ross, who spent nearly twenty years on staff; Jim Sawyer, a former trapper; Jim Bartlett, the superintendent's son; and Bob Balfour, an experienced log-cabin builder. Albert Ranger and his two sons, Peter and Telesphore,

Chief ranger Mark Robinson at Brent in 1928. When his doctor advised him to seek outdoor work for his health, he was forty, and he signed on in the park, arriving in November 1907.

ranged the northern section with dog teams. The list continues with Dr. William Bell, who made one of the first canoe-route maps; Zeph Nadon; George Stringer, who fell through the ice and drowned in Rock Lake; Jack and Dan Stringer; Art Briggs; Edwin Colson, later manager of Hotel Algonquin; Mark Robinson; Bud Callighen; and Jack Christie, David Valentine, and Bill Christie, who patrolled around North Tea Lake.

In his report for 1902, Bartlett described the duties that kept

the rangers busy year round. They were much the same as they were when the park was established:

The month of January, 1901, was mostly taken up getting wood at headquarters, making sleighs, snowshoes, etc. Then the rangers went out in pairs to their several sections, each man drawing a sled loaded with provisions. February, March, and April were spent patrolling the park. During the month of May, the rangers returned to headquarters by canoe, leaving sleds and snowshoes in the shelter houses for next winter. In the months of June and July, the rangers were employed, except when prevented by fires, in improving grounds and buildings at headquarters, cutting out portages, etc. August was principally devoted to building new shelter houses, repairing those already built, and cutting out portages. In September, most of the rangers again took out canoes and those who have sections farthest out removed from headquarters carried with them supplies sufficient to last them til they came out at Christmas on snowshoes, bringing their sleds with them to take back supplies for the Spring.

Bartlett initiated several experiments in introducing non-native wildlife to the park in 1899; the introductions of elk, ring-necked pheasant, and black grouse were unsuccessful, but smallmouth bass thrived.

By 1908, the beaver population had rebounded from earlier overtrapping, so it was decided that the rangers should do some controlled trapping to supplement park revenues. This practice angered former trappers, spurring them on to further poaching, and a few rangers were caught selling furs for their own profit.

In March of 1909, rangers were warned to be on the lookout for a trapper named Archie Belaney, who had made a bet that he could cross Algonquin, carrying a gun, without being detected. Bud Callighen, one of the rangers watching for the law-breaker, actually came to his rescue. Belaney had broken through the ice, and his feet were badly frozen. Ranger Mark Robinson nursed the trapper until his feet were healed. Many years later Belaney, by then known as "Grey Owl," the famous

writer, conservationist, and lecturer, sent a message of thanks for his Algonquin rescue.

Over the years, the rangers continued to trap or poison wolves, and they were entitled to the bounty paid for each. In addition, to supplement the Canadian meat supply during the First World War, they hunted and shipped deer from the park.

Trapping by the rangers was halted in 1920, but it was not until winter air patrols were initiated in the 1930s that poaching could really be controlled. Art Eady, who has a cottage in Algonquin, recalls his father, park ranger Stewart Eady, talking about tracking poachers during the early thirties.

Dad was once out in the bush with another ranger, Jack Gervais, and they were chasing this fellow that was poaching in the winter on snowshoes. He was wearing the shoes backwards, so anyone tracking would go the wrong way. Dad and this other ranger finally caught up with him. He turned around and held a gun up and fired. Jack [though unharmed] fell on his snowshoes. Dad raised his rifle to fire, but the poacher yelled out, "I didn't shoot him. I didn't shoot him, Stewart. I shot over his head." He knew that my dad was a good shot and wouldn't miss if he took aim. They never did actually catch that guy, but they knew who he was, and he knew that they knew. He kept his nose clean for a good long while after that."

Lorne Pigeon, a Cache Lake cottager and former park and fire ranger, also remembers the tense times trying to apprehend poachers:

I used to enjoy being hooked up with Aubrey Dunne when there was a job to be done. He was a very intelligent man and a hard worker. I park-ranged with him in the fall, when we were after poachers. We would stay out for nights and watch the trails that we thought they were using. They would be on the alert twenty-four hours a day. You couldn't build a fire or smoke for fear of giving yourself away.

We used to wait hidden along the portage at night, and when everything was quiet you could sometimes hear the

Early park rangers included Albert Ranger (left), who had a dog team, Mark Robinson (centre), and Bud Callighen, who joined the Algonquin Park staff in 1907 at the age of thirty.

Stephen Waters (seated) and Tim O'Leary, camping at a shelter hut, 1897. The stretched loonskins were used as moccasin liners in the winter.

paddle hitting the gunwale somewhere on the lake. Then, if you were lucky, you would hear the canoe touch the shore at the beginning of the portage, so you knew he had landed and that the games were about to begin. I know the feeling I had waiting for this man in the dark, so you can imagine what this poor soul was experiencing. They must have had nerves of steel. We would let him walk by, so that he would be in between the two of us. It wasn't exciting; it was more nerve-racking. Most of these guys were pretty tough and knew their way around the bush. Some of them could get pretty snarly. Oh, we had some battles. Guns were frequently fired; paddles were broken over heads; lots of bruises from fists and rocks.

The first park telephone lines were strung in 1911 on railway telegraph poles, allowing rangers at stations along the tracks to call in reports of poachers, emergencies, and fires. In 1922, additional lines were strung from tree to tree through the bush, finally linking the shelter huts with headquarters. "No thrill in

auditory communication equalled that of lifting the receiver from an ancient telephone set in a distant cabin, cranking the phone for dear life, and finally hearing a faint, though usually audible, answering voice from the other end of the line," wrote Edmund Kase in his biography of ranger Jack Gervais. However, maintaining the lines turned out to be a very labour-intensive job; animals and fallen trees caused frequent breaks.

The new crop of rangers have made a good beginning. . . . But rangers like Jack and his contemporaries will probably not be seen again. The times and the conditions of life and service as ranger have changed. Jack grew up in the bush. In his teens he participated in log drives. Winter and summer he spent most of his time patrolling his beat alone. No chain saws then, travel in winter by dogsled, no landing of supplies by plane except when fighting fires, the snaring of wolves to supplement the meagre ranger's salary. How different the life of the ranger today!

– Edmund Kase, *Jack Gervais: Ranger and Friend*, private printing, 1972.

Fire Ranging

Although they have never rivalled the size of Northern Ontario's blazes, Algonquin fires have kept rangers busy in the drier seasons. In the early years, the men reached them by train, canoe, or on foot, carrying in all supplies with them. In 1917, the Ontario legislature passed an act to bring all matters of fire prevention under a separate agency known as the Ontario Forestry Branch. Fire lookout towers were constructed to aid detection, some reaching thirty metres high. In 1922 the first steel tower was built; by 1956 all of the older wooden towers had been replaced.

Manning a fire tower was lonely work. In the driest season, the rangers climbed up to their perches and watched from dawn till dusk for the slightest wisp of smoke. At the first sign of fire, they would line up the site in the cross-hairs of a range finder; a second tower's bearing would pinpoint the exact location of the blaze. Frank MacDougall, then superintendent (and, after 1941, Deputy Minister of the Department of Lands and Forests), wrote in a 1941 article in *Timber of Canada* that "the district including the park is organized into a self-contained fire unit with its towers, and planes for detection, telephone lines for communication and modern fire fighting equipment for putting out the blaze. Gas cars on the railway, trucks and cars on the roads, canoes and motor boats on the water form the methods of transportation." In the early days, news of a fire had to be carried by word of mouth, and often it was the lumbermen who put out the alert; later, the bush telephones sped the dispatch of fire crews. Eventually, the job was made easier with the replacement of the bush telephone lines by radio.

Aubrey Dunne, a former park ranger and later a District Forester, found an unusual way to get a view of the Smoke Lake area in 1924. He was quoted in the July 12, 1990, issue of *The Raven*:

Well we felt a sort of a lack [of a tower] at Smoke Lake, you see, so we decided we'd climb up to the top of this hill where we could see these pine trees towering above the hardwood in the spring. . . . [they felled a tall maple to climb up into the lower limbs of a large pine]. This was quite a bushy topped pine and we were able to climb right

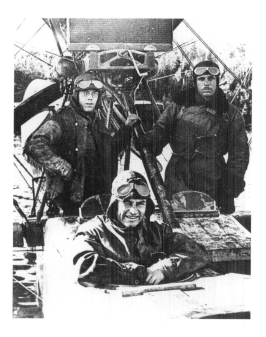

*District Forester,
W. A. Delahey (front),
ready for takeoff from the
Whitney airbase, 1922.*

to the top-most boughs. In fact, you could get on the top limbs and put your head above any obstructing branches. Following that we decided that it was possible to build a structure on top that would give us a few more feet. . . . it had a railing too. In a wind it swayed, but nothing more than a tree would normally.

Lorne Pigeon described in an interview the conditions under which the fire fighters worked.

In those days it was all manual work; we didn't have any water bombers or helicopters. The tower would give you a bearing, then you would take your canoes, all your equipment and food, and start cutting through the bush until you got to the fire. Sometimes we wouldn't take a tent, just a blanket. You wanted good men with you because everyone's life depended on the next guy. The crown of the trees would just be popping away and there would be a lot of noise from trees falling and the fire rushing from one tree to the next – it was unbelievable how fast it could travel on a real hot summer day.

The first air patrols of the park began in 1922, based out of

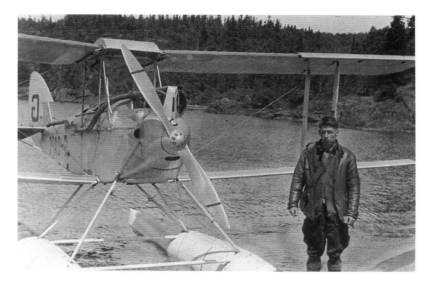

Frank MacDougall, park superintendent, standing next to the first plane used to patrol Algonquin, 1930s.

Whitney, with HS$_2$L craft being used for fire detection. In 1924, an airplane was stationed at Cache Lake, and in May of 1931, Frank MacDougall, the first superintendent who was also a pilot, arrived with his plane. A hangar was built behind the Cache Lake headquarters. Where it had taken Peter Thomson twenty-two days to inspect all of the park, MacDougall was able to do it in an afternoon. In 1939, a new hangar was built at Smoke Lake, and towers were last used for fire detection in 1975. Today, fires are spotted quickly by plane, and they rarely cause significant damage.

The Past Twenty Years

During the early 1970s there was a restructuring of responsibilities in parks across Ontario. Algonquin's canoe rangers continued to patrol the interior, but a new classification of park wardens was created to enforce laws in more heavily used areas. Wardens became law-enforcement officers, and they were given authority to impose fines for infractions under several forms of legislation, including the Game and Fish Act and the Provincial Parks Act. In addition to park wardens, provincial Conservation Officers also have jurisdiction in Algonquin.

They enforce fish and wildlife laws and assist wardens along the highways or at corridor campgrounds. Serious poaching and wildlife-related matters are often referred to the "C.O.'s" by park staff.

The canoe rangers have become more concerned with the maintenance of campsites and portages, and a major part of the job during the seventies was cleaning up garbage left by campers. Introduction of a can-and-bottle ban in 1978 reduced this time-consuming part of the task. Jack Borrowman, Interior Supervisor, explains improvements that have occurred in spite of financial cutbacks:

> In the late sixties, we had fewer than 20,000 interior users, and right now we have 60,000 to 70,000 per year. In the early seventies, we had nine hundred miles of canoe routes, and we now have sixteen hundred to maintain. In 1979, we had seventy-nine people and were never really able to keep up with the clean-up. This summer, we will have twenty-one people in the bush committed to doing the canoe routes, maintaining campsites and portages, as well as cleaning up. The bottle ban and education made a huge difference in the cleanliness of the park. It's one of the reasons we are able to maintain the park. We have fewer people out there working, the park is bigger, there are more people using it, and yet the park is cleaner. It has to be because the user is caring more and taking better care of the park.

There is a growing concern about rehabilitating over-used campsites on some of the busier routes near the highway. Rangers restore these sites by closing them temporarily, or by planting trees, replacing soil around exposed tree roots, building safe rock fireplaces, and making easily distinguishable tent sites, so campers don't disturb more vegetation than is absolutely necessary. New staff members are paired with more experienced rangers, just as they were in the first days of the park, and each team is still assigned a particular area for which they are responsible. Says Borrowman, "The rangers today do as much canoeing and foot patrol as the old guys did. The patrolling is more efficient because of the aircraft, but the park is being paddled and walked as much as, maybe more than, in the old days."

My first year, I was asked to do a physical inventory of all the canoe routes in the park. Well, it was a dream come true; I couldn't believe what I was hearing. Another fella and I were supposed to canoe through the park and take note of what had to be done. I finally got up the nerve to ask my superior if we could fish when we were out there. He said, "Of course. That's part of the job. I want to know what lakes have fish and what kind they are." Well, I had to shake my head a little bit, because I couldn't believe that they were going to pay me to do this. I left that meeting thinking I was going to wake up in a minute and realize it was all a dream. It was like being in heaven for those three or four months.

– Jack Borrowman

"The challenge is to try and be as comfortable as possible, to live and to adapt to your environment."
– Winter camper on Canoe Lake

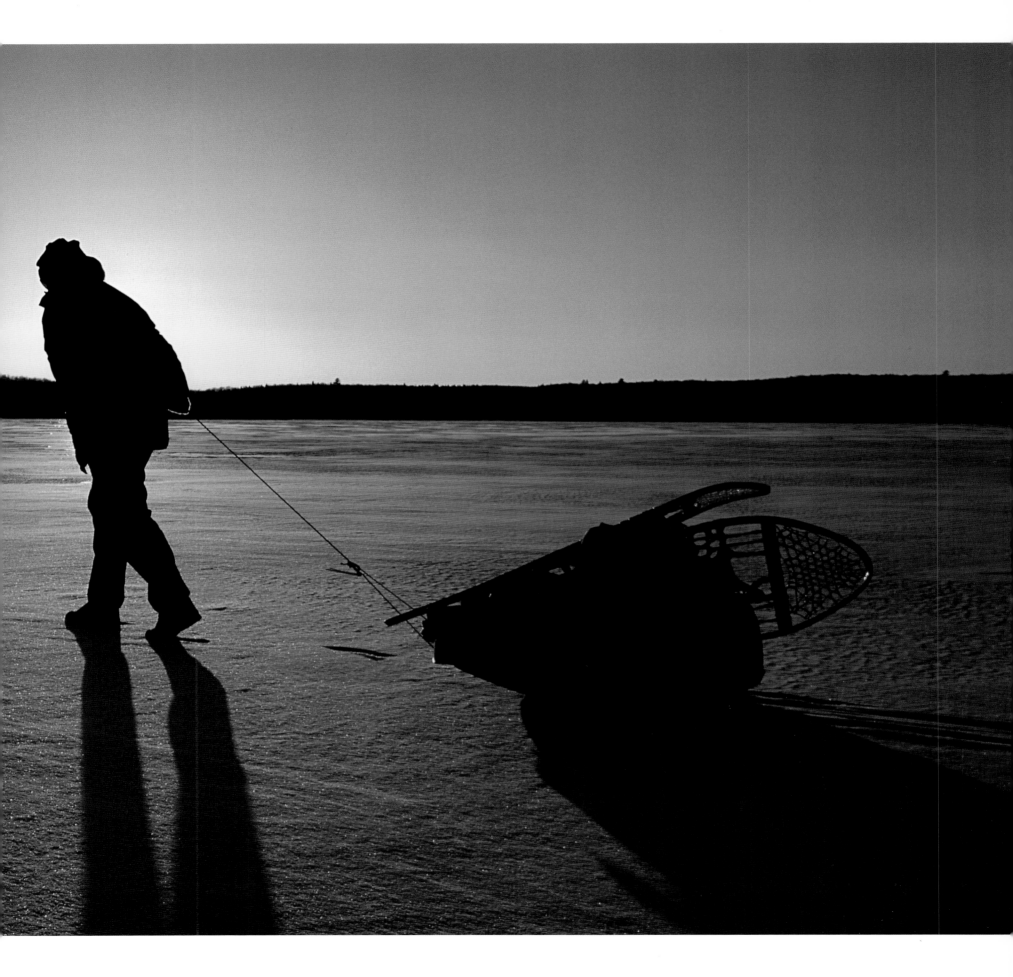

A Citation for Bravery:

Sam English

The Muskoka River, which passes Sam English's house, is already free of ice in March. Water drips off icicles that hang from his many bird feeders; chickadees, jays, and grosbeaks flock to his call when he steps outside his home just south of Huntsville. When friends call, Sam is quick to offer a "cup of tea," some form of distilled refreshment – a trademark for which many Park rangers and pilots remember him.

Born in England, he came to the Algonquin area in the late twenties, at the age of twenty. After trapping west of the park for a time, he took up guiding. "I first went into the park when I was guiding out of Limberlost Lodge." Later, he worked from Highland Inn, Whitefish Lodge, and finally, Camp Tanamakoon. His park work was interrupted by the war, but he was back in 1951.

"I was sent up to open the west gate in 1952, and Jack Gervais was keeping the gate awhile there with me, too. One day, a bunch of scouts came by," Sam chuckles. The boys were chattering about a bear that had torn their tent and taken all their grub. "Well, Jack was listening to all of this from behind a pillar. He came walking out and they showed him the tent and all. He walked away muttering so they could hear, 'I knew me I should have cut dat devil's toenails last fall. I knew me.' Well, those scouts probably still believe that it's the ranger's job to clip bear toenails."

"I was at Lavieille, too [as a ranger]. One day, this bunch of fishermen came in. They had a stone barbecue out in front of the cabin and they had these steaks, beautiful T-bones, real dandies. There was a jeweller from Ottawa, and he had his apron on and was doing the cooking. 'Come on,' he says. I was just coming, and I saw this big, goddamn bear coming down." Without looking over his shoulder, the cook held out a T-bone on a long barbecue fork to what he thought was his buddy. The bear ambled up and helped himself. "I can see him yet," Sam laughs. "Oh, the *roars* of him. The bloody thing was hot, but he wouldn't drop that steak."

Later, Sam helped look after the fragile bush telephones, that linked ranger cabins in the days before battery radios. Once, he and a partner had to extricate a moose whose antlers had become tangled in the wires. The animal was exhausted, so while the other ranger sat on its head, Sam quickly took off the antlers with a hacksaw.

English liked his job looking after the planes and the Smoke Lake hangar best. Although he was not a pilot, he got up in the planes quite a bit, parachuting supplies to fire-fighting crews for pilots like Yorky Fiskar and George Campbell. "We'd drop the hose, the pumps, and the food out of the plane. George was flying when we went in to one fire up north. There was a nice beaver meadow, and there was one last pine that hadn't been cut." Sam attached a parachute to the first barrel and let it go on the pilot's signal. "It lit right in the middle of that big pine tree, and wouldn't you know, that was the radio." All was not lost; once the saws were dropped, the crew was able to rescue their radio.

From a pile of old snapshots, Sam pulls a certificate. It reads "The Order of the Spirit of Algonquin – Samuel W. English did under abnormal conditions of high wind and rough water, and at considerable risk, assist in the saving from drowning of three men." "I got that Award for one of our rescues," he says. "It was June 16, 1964, and it was windy. The waves were just coming right over the Smoke Lake docks. Yorky Fiskar called down.

"'Get the plane ready! We've got an emergency.'

"I said, 'Holy Jeez, you're not going to take off in that, are you, York?'

"'Yup, it's an emergency!' So away we went to Big Crow Lake. Yorky put the plane down, but every time it went over a blasted wave, it was just like being in a shower.

"I had my foot hooked in the ladder, and I reached the first man, who was hanging onto the sinking boat. I had to hit him on the side of the face. How I heaved him up into the plane, don't ask me.

"It took a few minutes to get close enough to the next guy – the only one wearing a life preserver, and the whole plane was shaking when I got him in. The last fellow had a life preserver underneath his arm, and he wouldn't let go of it to grab the line. I finally got a rope right round his neck, and somehow I got him in.

"I had a lot of faith in Yorky. We flew an awful lot together and, as far as a pilot, you couldn't beat him." Sam pauses, gazes out the window, and slowly lets out a deep breath. "The pilots and the other boys up there – they were all my friends. It became a very special place to me."

left

*Smoke Lake.
Firefighters and pilot load
equipment and food into a
twin-engine Otter before
taking off to the interior.*

above

*A quiet moment at
the campsite.*

63

Algonquin from the Air:

George Campbell

George Campbell, wearing his old Department of Lands and Forests jacket, crosses the Pembroke airstrip, grasps a wing strut, and steps up onto the float of the Turbo-Beaver he used to fly. Settled into the cockpit, he starts to reminisce about the seventeen years he spent flying over Algonquin Park, beginning in 1964; his face sheds some of its seventy years as he talks about the "old days" and the pilots with whom he shared them.

George logged over fifteen thousand hours in the Beaver and the Otters. "Air transportation in the bush is a link that a lot of people depend on. If someone was hurt, it was very important to get them out. Taking men in and out to fires, or just showing up on time at the right place with supplies was a good feeling. I also did the moose and wolf surveys during the sixties. We were on call from daylight to dark.

"Fighting fires was an exhausting job. We started off parachuting a lot of stuff in before we got the water bombers. Then we started to water bomb with the rollover tanks on the Otter, one on each float, and then we changed to one big tank slung under the belly. They eventually put the in-float water-bombing systems on the planes. That was quite a technique to get used to. You wanted to touch the water at stalling speed – 55 m.p.h. – and you had to keep that up so you had enough speed to get off again when you were full. It wasn't really that dangerous, just a little tricky. With the Otter, you did a lot of low flying, because it didn't climb very well, and you wanted to be right at tree level when you dumped."

The weather posed other challenges. "You could get yourself into some touch-and-go situations, but I knew all the lakes and hills, so I could just sneak over the portage trail into the next lake until I got home. You got to know your plane, the lake sizes, the weather, and what you and your plane were capable of doing."

He speaks almost reverently of Algonquin's first pilots. Frank MacDougall, Algonquin's first "flying superintendent," who continued to come to the park after becoming a deputy minister in the provincial government, was a reliable pilot and a loyal friend. George Phillips replaced MacDougall as superintendent in the early forties, and he "was a bold, happy-go-lucky fella." Phillips was famous for stunts, especially for his daring landing on Found Lake, which was just over half a kilometre long. Campbell has managed the tricky landing twice himself, and he did it with an Otter, which needs even more space for landing and take-off.

When George came to the park during the early sixties, then-superintendent Yorky Fiskar had a Beaver at Smoke Lake during the summer. "So I just supplied from the permanent base at Pembroke with the Otter," he recalls.

"When Dave Croal came in 1966, we took turns with the Turbo-Beaver and an Otter. There were some interesting people at that end of Smoke Lake. We used to have a lot of the old park characters gather down at the Smoke Lake hangar. I'm sure it was because of Sam [English] and his so-called 'pots of tea.'"

Campbell was known for enjoying a nap while he was flying. "Sometimes I used to doze off, coming home from flying a full day with the fires, exhausted from all the heat and time spent in the air, but then again, I used to doze off all the time. I would be wearing the headset and, with the sun in my eyes, I'd fall asleep. All the people who would fly with me over the years wouldn't think twice when they saw my head start to nod, then everything go limp at the controls. They knew that I would always wake up if the plane got tipped over too much on one side or the other. The regular guys used to enjoy watching the expression on a newcomer's face when he caught me dozing. All the people who flew with me over the years swore that I flew the plane smoother when I was asleep," he laughs.

The yellow plane glows in the last of the day's sun as George turns and heads back across the tarmac. "Skimming the top of the trees on an approach to an interior lake in the old Beaver, or coming down from the north end of the park behind one of the summer storms that Algonquin gets is something everyone should experience at least once." George has a wistful smile on his face as he glances back at the airfield. "You know," he says, "I'm beginning to feel a little bit like I used to, flying home at the end of a sunny day from Big Trout, knowing that when I touched down on Smoke Lake and landed at the dock, Sam would be there to greet me. If I put on a headset right now, I don't think it would take me long to nod off."

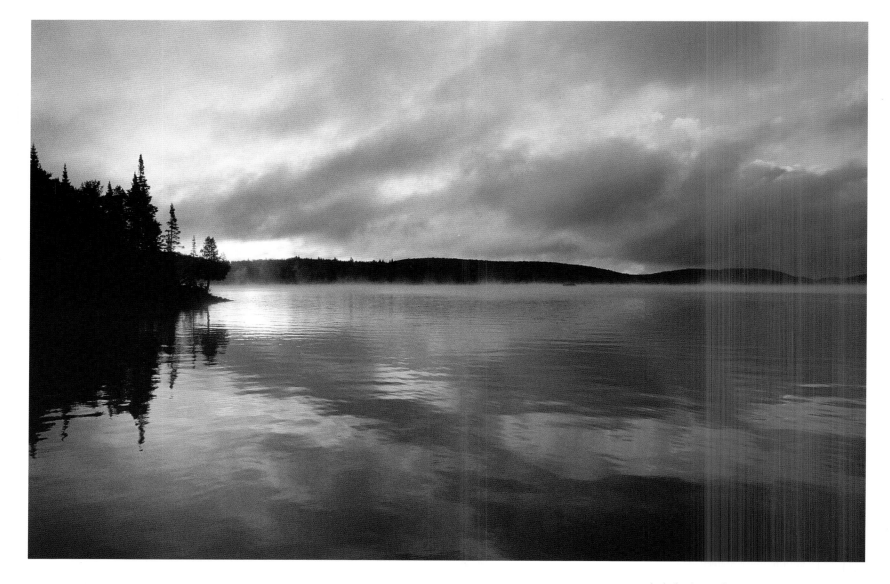

"It's a little hard to explain
to my city friends,
but when I'm
in Algonquin and out in the
'wilderness,' I find the
simple things really
satisfying."
– François Beaubien,
solo canoe tripper

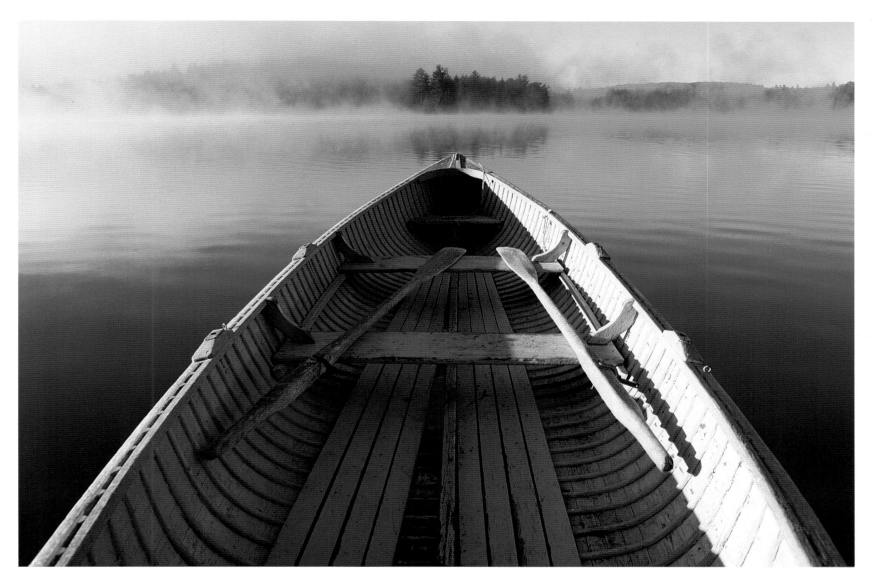

"The boats used to pretty much know the way around the lakes by themselves. Even with just an old oil lamp for light on some of those pitch black nights, that old boat would somehow find the dock."
– "Gibby" Gibson, long-time Potter Creek resident

Portaging between lakes.
*"A canoe trip seems bigger
and better
when you can share it with
someone."*

– Spencer Robertson,
canoe tripper

*"Algonquin gives you
a breather from the daily
noises of the city and
replaces them with more
natural sounds,
like the wind,
the water,
or the birds singing."*

– Dylan Hawks,
canoe tripper

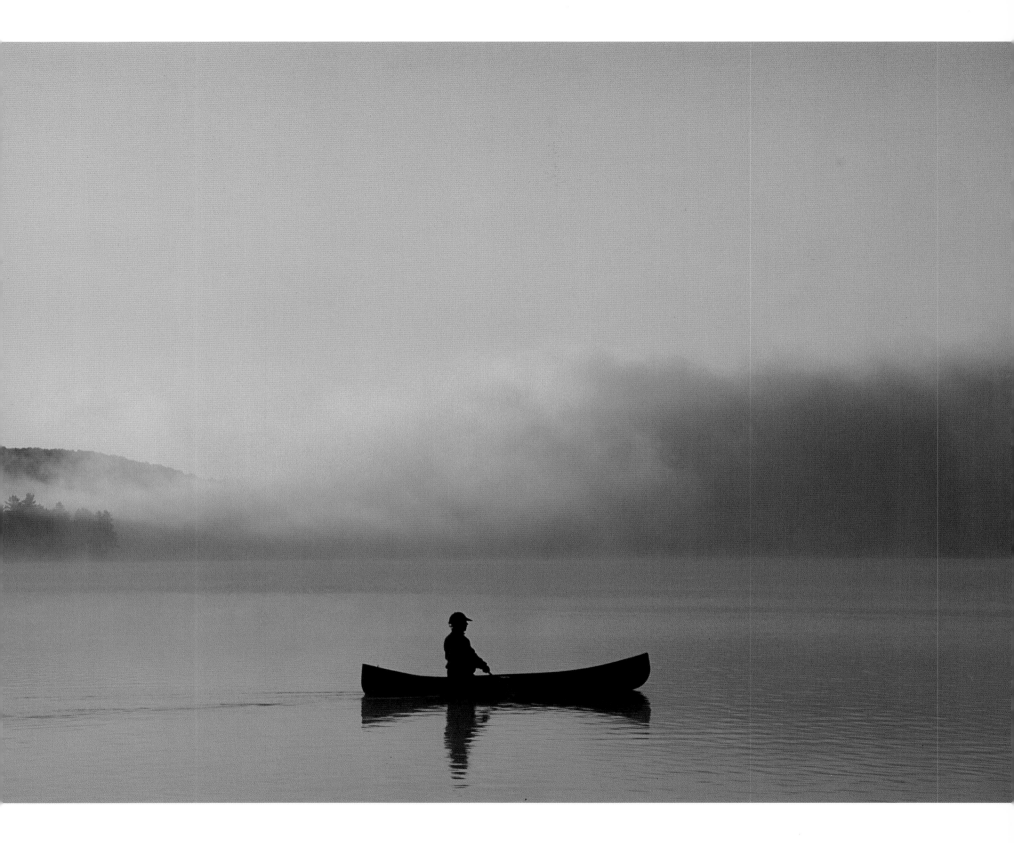

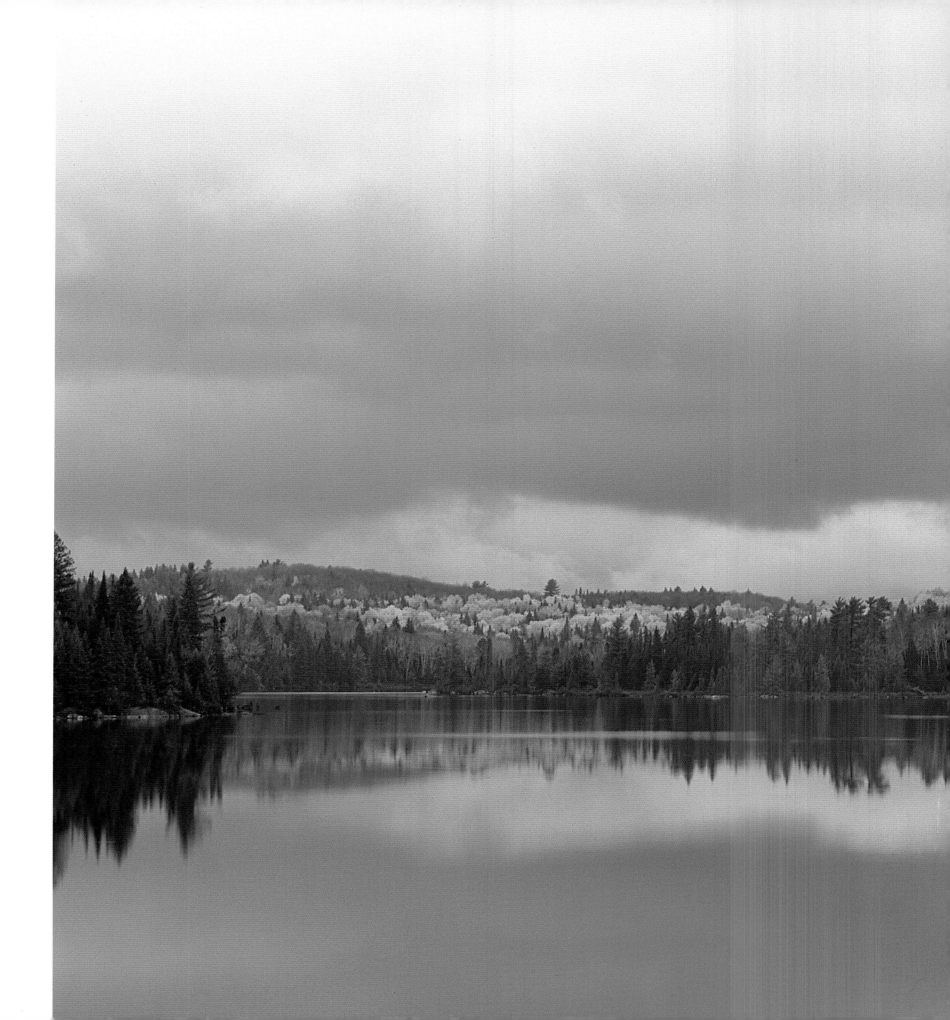

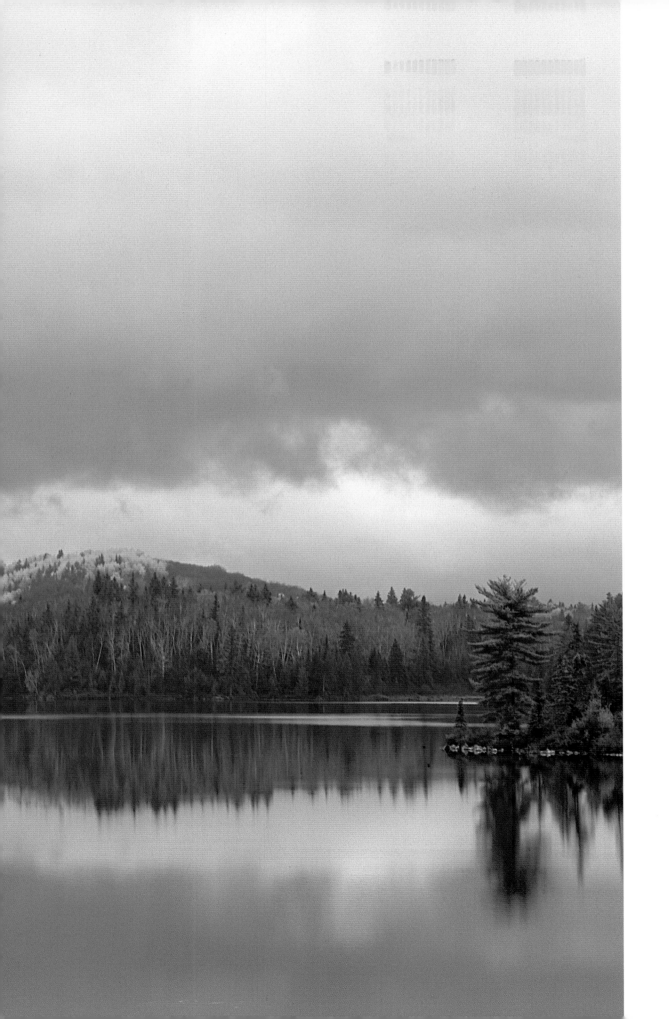

Joe Lake.
"I have to get
across that first portage
before the city and all its
problems start to fade away.
Once I reload the canoe and
paddle up Joe Lake,
it's a completely
different world."
– Gord Carl,
year-round park visitor

The Islet Lake trestle
and an old
wood-burning locomotive

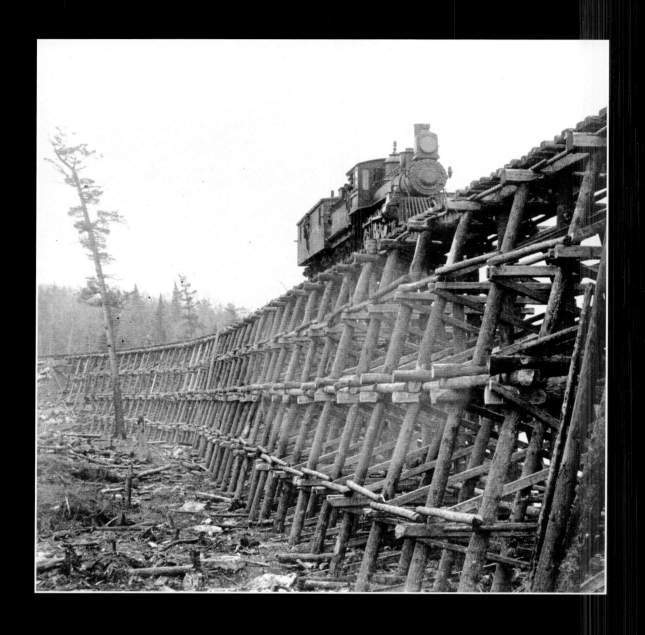

Booth's Railway

The Ottawa, Arnprior and Parry Sound Railway was built through Algonquin by J. R. Booth between 1894 and 1896 to link his extensive lumber empire with growing markets. Driving the rails through the Algonquin highlands was no small achievement. The Precambrian bedrock was blasted with dynamite, while men laboured with horses and block-and-tackle to remove the debris. The crews filled in low-lying areas, and, where this was impossible, they painstakingly raised massive log trestles. But it was worth the effort, for once the line was completed, it provided the shortest route from the upper Great Lakes to eastern Canada and the United States beyond.

The first log hauls were shipped through the park by 1897, and soon spur lines were constructed to reach deep into Algonquin timber limits. At the western terminus of the line – Depot Harbour on Georgian Bay – prairie grain was transferred from ships onto railway cars bound for the eastern seaboard.

In 1905, the Grand Trunk Railway took over the Ottawa, Arnprior and Parry Sound Railway, and traffic continued to increase. By the First World War, the line had become one of Canada's busiest; trains whistled through Algonquin every twenty minutes, carrying grain, lumber, and troops, and guards were posted to prevent sabotage at major bridges.

The railway also made the park truly accessible to tourists. After leaving Whitney, passengers travelled west through Rock Lake Station: a community of a few farms, station buildings, and a small grocery store. Next came Algonquin Park Station on Cache Lake, one of the busiest stops within the park. Park headquarters had been moved there in 1897, and the Grand Trunk Railway opened Highland Inn there in 1908. Next, at Joe Lake Station, guests disembarked and walked up the steps to the grand veranda of the Hotel Algonquin. Canoe Lake Station served Mowat Lodge and Camps Ahmek and Wapomeo – and guests who transferred to boats for the trip down to Nominigan, the Highland Inn's wilderness outpost camp on Smoke Lake. The line then climbed to Brûlé Lake, where a mill community thrived. There was also a fire-ranging station there; the rangers made the most of rail access, using smaller gas cars to reach forest fires. The highest point on the line, at 495 meters above sea level, was just beyond Brûlé, and engines often strained with their heavy loads over the height. The last stop in the park was Rainy (now Rain) Lake. In 1917, an eastbound freight stopped for water there, but a faulty throttle caused the engine to pull out while the crew was in the station. The runaway climbed the summit and raced through Brûlé, but fortunately it ran out of steam before reaching an oncoming train at Canoe Lake.

Canadian National took over the GTR in 1923 at about the time pine log shipments declined; however, most tourists, cottagers, and campers continued to make their way into Algonquin by rail until the late 1930s. In 1933, as construction on Highway 60 was begun, the wooden trestles across Cache Lake were condemned, and through service was discontinued forever.

Tanamakoon, Northway, Ahmek, Pathfinder, Wapomeo – all those camps used to come in by train, and the trains [from the west] always ended up at Cache Lake because that's where they turned around. Every now and then,

Tom and I, when we were kids, would be able to drive the engines when they had to be turned, but also, when we swept the cars out we would get all the comic books and odds and ends that were left behind. Tamakwa was the best – Tamakwa left the best comic books by far.
– Jake Pigeon, former Cache Lake resident

The last train to Cache Lake from the west ran in 1959; after that the tracks were torn up and the highway became the only mode of access for visitors to the southern part of the park.

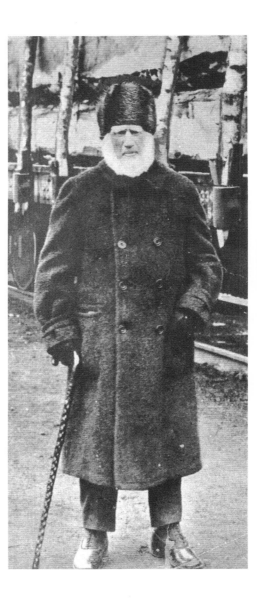

J. R. Booth. Algonquin's best-known timber baron, in his ninety-eighth year, 1924.

Old railway trestle bridge on Cache Lake. ``It was nice back then to see the children going to school in the morning, throwing snowballs at each other and at the passing trains.''
– Adam Pitts, the only year-round resident of Brent

"We All Loved the Railway":

Ernie Montgomery

Ernie Montgomery and Anna, his wife of sixty-eight years, live in a neat, white frame house next to Madawaska's public school. The youngsters clamouring in the school-yard next door provide a sharp contrast to soft-spoken Ernie, who will be one hundred years old this September; he still loves talking about the railway and the days when he ran steam engines through Algonquin Park.

"I was sitting at home one day [in 1912], reading the paper, and I saw that the Grand Trunk wanted firemen." He accepted a post in Madawaska and, "once I was up here, I couldn't leave." Anna was born in this small town, nearly 200 kilometres due west of Ottawa, and the two were introduced by her brother-in-law, another railwayman. She jokes that she would have liked to have moved away, but she believes Ernie was worth a lifetime in Madawaska.

Ernie started off as a fireman, stoking the large steam engines. "I went down to Montreal and fired the train all the way there and back again, and for the round trip we got eighteen dollars. It was hard work, keeping the fires stoked, but I would say that back in those days we all loved the railway and had this common feeling."

Later he was an engineer. Some of his biggest loads were of pine timbers, hauled for J. R. Booth. Once, he saw the lumber baron inspecting his shipment. "He and his two sons were watching my train pull out fully loaded with squared pine, and he looked up and gave me a slight wave. There were people taking pictures of him, and I think I've seen one of the pictures in a book. We just considered him to be a very smart businessman, and we didn't realize that he was making history with his lumbering. If we had known this, I would have given him a ride in the engine.

"Later I ran the trains one winter up around Brent and Kiosk, and a little town called Odenback, too. We used to get our dinners at the lumber camps, and we would sit with all the loggers. They all liked the trains and would ask us questions about the engines or where we had been. I think almost everyone at an early age loved the trains."

Ernie enjoyed driving passenger trains as well. "Everyone back then had to ride the trains if they came into the park. When we used to stop at a station, we would let the people go up into the engines. Well, when they were ready to come down, you would put both arms up in front of you to catch the young ladies. A lot of the time you couldn't hold onto them because of the silky slips that they would be wearing underneath their dresses. It was just like trying to hold onto a slippery fish. One of the many hazards of being a passenger-train engineer, I guess.

"Highland Inn was *really* something when you would pull up in front of the hotel. It stood up on a hill overlooking the tracks, out to Cache Lake. They had flowers all along the path and up the steps all the way to the hotel. When I would drive the train in, all the people would come down to see it and meet the people who were getting off. Even the people who lived on the lake would be out in their boats watching the train come in."

He plays down the risks, but there were accidents too. Ernie was on a train that derailed at Joe Lake in 1916. "Just after the bridge going towards Brûlé, we must have hit something, and some of the cars jumped the track." The engine stayed on the rails, and there were no injuries, but fifteen empty cars folded like an accordion into the lake.

Ernie's love of trains is infectious. When he talks about his work, the scene comes to life; you can almost hear couplings screeching and steam engines wheezing. "I've driven a lot of trains up into Algonquin and enjoyed every trip. Many things have happened over my lifetime, but certain things haven't changed," he says quietly. "You can still see the same look on people's faces when they watch a train go by." A smile of remembrance spreads across his face. "You can still see the same expression in the engineer's eyes when he waves out the window at a little boy or girl who is waving back."

left

*Cascade Rapids on the
Petawawa River.* "You
board the train amid the
noise, the dust, and crowds
of the city, and lo! in the
morning you open your eyes
in a fresh green world, all
silent and peaceful and
beautiful."
– Canadian National
Railway brochure, 1927

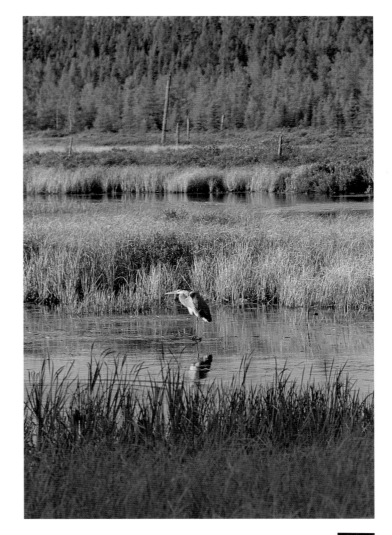

above

Great blue heron.

overleaf

*Ladies on the veranda
of the Highland Inn,
overlooking Cache Lake.*

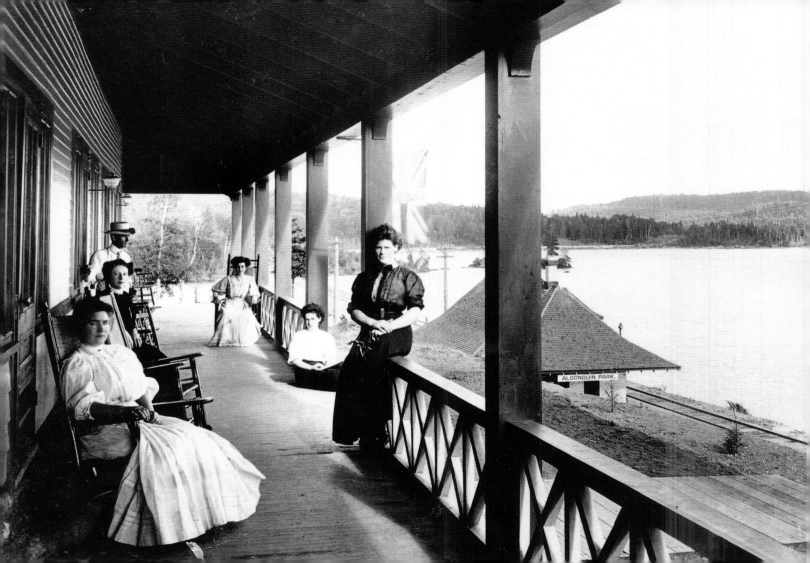

Hotels and Lodges

With the establishment of rail access to the park around the turn of the century, tourists flocked to Algonquin seeking both relaxation and improved health. Between 1900 and 1930, several hotels and lodges were established to meet the needs of this burgeoning tourist trade. The park was noted for its clean air, and a vacation in Algonquin was considered both a fashionable and a healthy holiday. Apart from the Highland Inn and its two outpost camps, Nominigan and Minnesing, which were built by the Grand Trunk railway, the park hotels and lodges were privately owned. Many in the south catered to a well-heeled clientele, who expected outdoor activities, such as angling and canoeing, combined with elegant dining and all comforts. The lodges in the north or in the interior were more rustic, providing log-cabin accommodation for fishing enthusiasts.

One of the first people to take a "rest cure" in Algonquin was Molly Cox, an Ottawa nurse, who came to stay at Dr. and Mrs.

William Bell's home at Cache Lake in 1900. A favourite picnic spot was subsequently named for her: Molly Island on Smoke Lake. Molly stayed on in the park as housekeeper for the ranging staff at Cache Lake and, in 1907, she married ranger Ed Colson. The following year, they were appointed managers of the Grand Trunk Railway's newly opened hotel: the Highland Inn at Cache Lake.

Close to park headquarters, the Highland Inn was a hub of social activity. It became so popular that it was expanded several times, and guests were even accommodated in platform tents during the busiest times in the early years. Among its more celebrated visitors was Sir Arthur Conan Doyle.

Highland Inn guests arrived at the luxury hotel by train. They disembarked at Algonquin Park Station and walked up flights of stairs to the expansive veranda. The hotel could accommodate one hundred and fifty people in comfortable rooms, each outfitted with hot and cold running water; activities included picnics, croquet, tennis, and badminton. For those who were less active, there was a cozy library, or the veranda, where the ladies often enjoyed the impressive view of Cache Lake while engaging in leisurely conversation. Fishing and boating were the major attractions. The hotel was able to outfit guests with boats and all items necessary for fishing excursions and arrange for a fishing guide if visitors wished; the guides were based at the hotel, but were paid by the guests themselves. At the end of the day's activities, the guests dressed for a sumptuous dinner, and, afterwards, they could enjoy an evening of billiards or dancing. The Highland was one of the few hotels that was open year-round, and it was a popular winter vacation spot as well. The CNR ran the hotel for a time after it took over the Grand Trunk in 1923; however, the hotel was sublet to private operators in 1928.

In 1908, Tom Merrill opened his Hotel Algonquin on Joe Lake just steps from Joe Lake Railway Station. "Built of red pine slabs with the bark on," the Hotel Algonquin was described in Grand Trunk Railway brochures as "finished inside in hardwood, occupying an elevated location on a wooded slope overlooking the lake and affording a fine view of the surrounding lakes and mountains. Especial emphasis is laid on table and service, while airy rooms and wide verandahs assure the comfort of the guest."

In 1917, Merrill sold the hotel to Molly and Ed Colson, who moved from the Highland Inn and became an important part of the Canoe Lake community. Molly delivered babies and set broken limbs, and the Colsons were responsible for at least one rescue, which took place on a stormy April night in 1918. Larry Dixon and George Rowe, two Canoe Lake residents, had hit a submerged log while paddling nearly a mile away from the hotel, and they had been tossed into the frigid water. Dixon hit a stump, and his lung was punctured. The Colsons responded to Rowe's cries for help, and they found the two just on the verge of succumbing to hypothermia. Molly recognized the severity of Dixon's injury and accompanied him to hospital in Toronto, where he later died, but Rowe survived and went on to guide from the Hotel Algonquin.

In 1912, the Grand Trunk opened Nominigan, "the camp among the balsams" on Smoke Lake. The following year Camp Minnesing, "Island Camp," was built on Burnt Island Lake. Both were log-cabin outposts, built as more rustic adjuncts to the Highland. Each had a large central lodge surrounded by cedar-log cabins that boasted hot and cold running water. Guests arrived by boat or by a bone-jarring stagecoach ride from the railway.

The Nominigan cabins burned down in 1926, but the main building survived. It was sold to Garfield Northway of Toronto and was used as a cottage for many years. Minnesing was sold to Dr. Henry Sherman in 1923 to be used as a base for religious seminars. Both facilities were dismantled when the leases expired.

A second year-round resort was opened by Mr. and Mrs. Shannon Fraser in 1913 in the old Gilmour Company bunkhouse at Canoe Lake. Named after the townsite, Mowat Lodge had a retail store and outfitting services, and the Frasers could arrange to hire guides for their guests.

In 1923, Alfred Bartlett, G. W. Bartlett's son, expanded the former Bell cottage at Cache Lake to create Bartlett Lodge. Still running today, Bartlett is Algonquin's oldest surviving resort.

Among the other lodges in the park was the Wigwam on Lake Kioshkokwi, where guests enjoyed "real camp life with only the rough edges taken off," according to the Canadian National Railway's brochures. It is still used as a summer cottage today. On Cedar Lake, Kish-Kaduk Lodge welcomed guests for about

fifty years, beginning in 1928. Opeongo Lodge ran for a time out of buildings that had once been part of the St. Anthony Lumber Company on Opeongo Lake. Since 1935, Killarney Lodge has been attracting tourists to its log cabins on Lake of Two Rivers. In 1939, Whitefish Lodge opened on Whitefish Lake, and Arowhon Pines was founded three years later on Baby Joe. Established originally to accommodate parents who were visiting their children at Camp Arowhon, Arowhon Pines is one of only eleven resorts in Canada to belong to the Relais and Châteaux group, an international designation given to some of the world's most charming hostelries.

After the Second World War, a growing number of vacationers preferred to camp or go on a self-guided canoe trip in the park. At the same time, the older hotels were becoming run down and harder to maintain. As part of a policy to return Algonquin to a more natural state, the Ontario government purchased the Highland Inn and Hotel Algonquin in 1956. The following year, they were dismantled and burned. One by one, the other lodges closed or burned down, so that today only Killarney, Arowhon Pines, and Bartlett Lodge remain.

Stages leaving Highland Inn for Minnesing and Nominigan lodges, 1927.

I am having not only one of the most enjoyable holidays, but also one of the most beneficial I have ever spent. There are quite a number of good 'sports' here at the Highland Inn, and we have tramped every trail, skated, tobogganed and used our skis. I have commenced to show the results of my holiday in ruddy cheeks, a sound sleep and increased weight. I could not believe that a week here could possibly work such changes in my health and outlook.

– a Toronto businessman in "Enjoy Winter in Ontario's Highlands," Grand Trunk Railway brochure, 1920

Hotel Algonquin, built by Tom Merrill in 1905, was located back from the railway station overlooking Joe Lake.

Hotel Algonquin Hospitality:

Mary Colson Clare

Mary Clare's large kitchen is welcoming – the cookie plate is replenished regularly and coffee is always at the ready. She and her husband share their home with three dogs and a cat, and outside the window, bird feeders attract hundreds of feathered guests. She laughs easily as she recounts the wonderful times she spent at the Hotel Algonquin on Joe Lake.

Mary was just a baby when she first went to the park. Her uncle, Ed Colson, was manager of the Highland Inn in those days, and her parents used to take the family for visits. Ed and his wife, Molly, purchased the Hotel Algonquin on Joe Lake in 1917. After they left to run another hotel in Renfrew, Mary's father, George Colson, managed the Algonquin for them. Mary grew up spending summers at the hotel.

Mary's Aunt Annie was in charge of the general store at the hotel; the clientele came from Canoe and Joe lakes. "It was a popular place, so Annie was busy. We used to come up for the summer and drive her crazy when we were little. When we got big enough, and were able to look over the counter, we were put to work. That's how I got to know everybody who lived on the lake." When Mary's father died in 1927, her uncle and aunt came back to the hotel to manage it themselves, but Mary's mother continued to bring her five children to the hotel each summer.

Mary points out that the Hotel Algonquin was more rustic than the Highland Inn, but it still had all the amenities. There were "about twenty rooms, and two great big screened-in porches at the end. The furniture was nice; people today would pay a fortune for some of the pieces that we just took for granted. Each bedroom had iron or wooden beds, a toilet set with a washstand, dressers, and coal-oil lamps. The dining room would seat fifty to sixty. There were pressed-back chairs, eight beautiful wooden tables, and they all had fresh linen tablecloths and table napkins." The housekeeping and the running of the store kept a team of young women busy for the season, which ran from May to September. Like so many hotels, the Algonquin was closed in winter, because it was impossible to heat the guest rooms.

Guests arrived by train, and many would stay a month or more. Mary remembers fondly, "they would do all sorts of different things. A lot of the women would sit on the veranda and talk throughout the day. Often the men, women, and children would go on picnics, walks, swims, or fishing out on the lake. Most of the men would spend time out on the other lakes, several portages away, fishing with our guides and other men guests; a few women would join their husbands on these trips. I'm sure that some of the women were up there under duress, but most of the people that were at Hotel Algonquin liked the place and the environment."

Mary also speaks with admiration about the guides who worked out of the hotel. "All the guides were great, like old Charlie McCann, Mosie Lamab, Gus Cochrane, Jimmy Jocko, George Rowe, and the others. Bill Stoqua used to arrive early each spring to help open up. All of the guides would stay in the guide shack at the back of the hotel and come in and eat with the staff. . . . The guests would get to know them, but it would look funny to see the ladies with washed skin and clean dresses talking with the old, bushy guides, who would be standing there scratching their heads."

For two winters, Mary stayed at the hotel with her aunt and uncle and taught school at Potter Creek on Canoe Lake. They lived at the back of the hotel in rooms that they could close off and keep heated: the kitchen, Ed's office, and a few rooms right above. She chuckles now about worrying whether there would be enough to do during the winter. "Mowat shoreline was quite active back then. When one of the mills was based out of Potter Creek, we would have dances at Joe Lake Station, and the mill boys [from Polish communities outside the park, including Wilno and Barry's Bay] would come over and teach us all how to square dance and do their Polish dances. Wam Stringer would play the fiddle and do the calling. We always used to get together to listen to the hockey game on Saturday night on the battery radio at the Stringers' place, and then everyone would come over to the hotel on Sunday nights and we would have a rip-roaring time singing hymns and eating chocolate cake. Never a dull moment with all those characters up there, like Chester Nicholls, who used to wear a deer-skin toupee."

Her voice captures the excitement that was in the air as the train pulled in, full of returning guests, or the joy of simple entertainments at the hotel. She sums up her happy memories: "Algonquin is a beautiful place in all seasons, but it is really the people that the park attracts and holds onto who make it so truly unique and special."

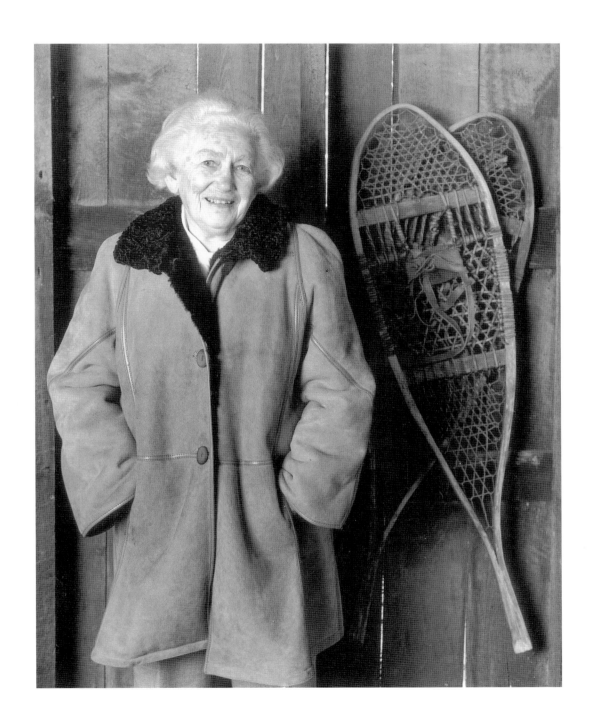

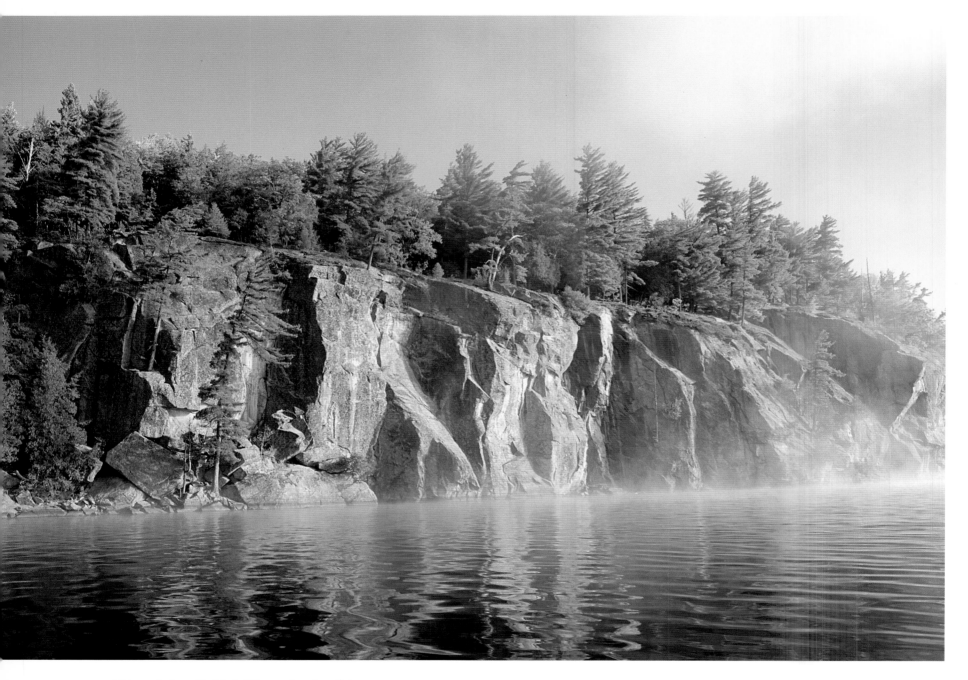

Pictograph site on Rock Lake. "Can you imagine what
Algonquin would have been like with just the
Indians? Their spirits must still be in the forests and
rocks, showing themselves on those cold misty
mornings."
– Mike Taylor, artist and Rock Lake cottager

Red pines on Tea Lake.
"I think the mornings when everything is waking up
and the birds are singing their songs is one of the best
parts of a canoe trip."
– Hilary Graham, canoe tripper

Fine Times at Canoe Lake:

Wam Stringer

"Wam" Stringer is a real "character," and his Algonquin family roots run deep. Jack "Pappy" Stringer, his father, was a ranger, as were Jack's cousins George and Joseph. Wam's brothers were also well-known in park circles: Dan "Mud," the ranger; Jim, who lived with Wam at Canoe Lake; and Omer, who wrote *The Canoeist's Manual* and was involved with several films that set standards for canoeing technique and safety.

Wam's parents raised sixteen children, so it's not surprising that many Algonquin regulars have recollections of the Stringer family, but many of these memories are of Wam in particular. Even the source of his nickname draws varied stories. Wam's passion is fishing and, according to a popular yarn, he once found himself with a large lake trout flipping around the bottom of a tippy canoe. With no club at hand, he grabbed the tail and finished the fish off by "wamming" it against the gunwale.

The Stringer family moved to Algonquin from Killaloe, southeast of the park, when Wam was a young boy. They lived at Brûlé Lake for a short time, and Wam had a reputation as a lighthearted mischief-maker even then. If he wanted an egg, he would walk over to the neighbours' hen house and grab a handful; once, he helped himself to a whole chicken, and then invited the owner for leftovers. But he was so good-natured, people found it hard to get angry with him.

The family moved to Canoe Lake, into one of the old Gilmour Lumber Company buildings, when Wam's father was posted there as a ranger. Wam remembers, "It was a nice little community – all on one shore. There were about fifty people, and a lot stayed on in the winter. We'd get together for visits, and we used to cut wood and help other people. Most everybody had dogs and a toboggan, and we did lots of ice fishing for lake trout. We'd set out our lines at night and, in the morning, if they were wobbling, we knew we had a bite. We'd take 'em home and mother would cook 'em up for breakfast.

Wam was famous for always knowing where to catch the fish. He would take along potatoes, some lard, and home-baked bread – all ingredients for a mouth-watering shore lunch featuring fresh trout. "I'd be away guiding sometimes two weeks at a time, but I'd take plenty of bread, butter, and a few other staples, and we'd live on fish. Fried speckled was one of my standards. We knew where to get them, and, if we liked the people we were guiding, we'd tell them the spots to catch them too." He smiles. "We had to break them in or get rid of them."

Jeff Miller, in *Rambling Through Algonquin Park*, relates a widely known story about one of the ways Wam "broke in" newcomers. Wearing his brother's ranger hat, he would stop visitors near the gate and quiz them good-naturedly about their plans and what they were bringing into the park. He'd inquire whether they were carrying any spirits. If the answer was a sheepish "yes," Wam would cite a fictitious article in the Parks Act, confiscate the bottles, and send the tourists on their way, happy that they had got off with just a "warning." For this frequent trick, Miller dubbed Wam "King of the Visitor-harvesters."

Wam has a zest for life that's still evident in the way his shoulders bounce in silent laughter. The Stringer place was always a hub of Canoe Lake social activity during the many years he lived there, first with the whole family, and later with his brother Jimmy. Their friends could always count on a warm welcome. On Saturday nights, they would gather to listen to hockey games, or wind up an evening with Wam on his fiddle or someone at the piano. The happy sounds of laughter and good-natured joking would drift over the lake.

Wam and his brother lived on Potter Creek for years, and they hauled in their supplies by toboggan or boat from the Portage Store at the foot of Canoe Lake. The life was physically demanding, but Wam is nostalgic. He smiles when someone mentions the story about him talking Jake Pigeon into driving him to Whitney for a case of beer. Apparently, after sampling a few bottles here and a couple there, they found five days had slipped away. "Oh, I got myself into a little trouble in the park, but nothing bad really." He chuckles when he says his friends could all tell some interesting stories about him, "lots of them, but I hope not."

"Oh, I miss the park," he pauses to light his pipe. "We had a lot of good times all together. I didn't tell you about all of them . . . but I don't dare."

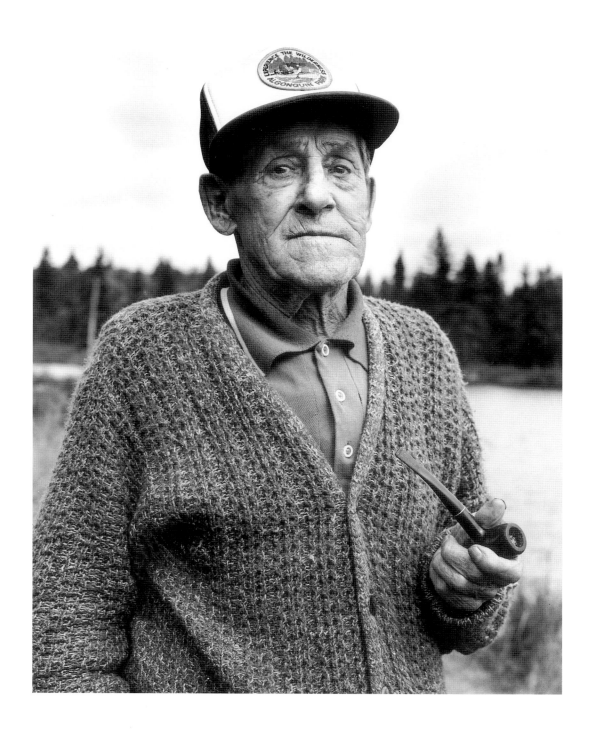

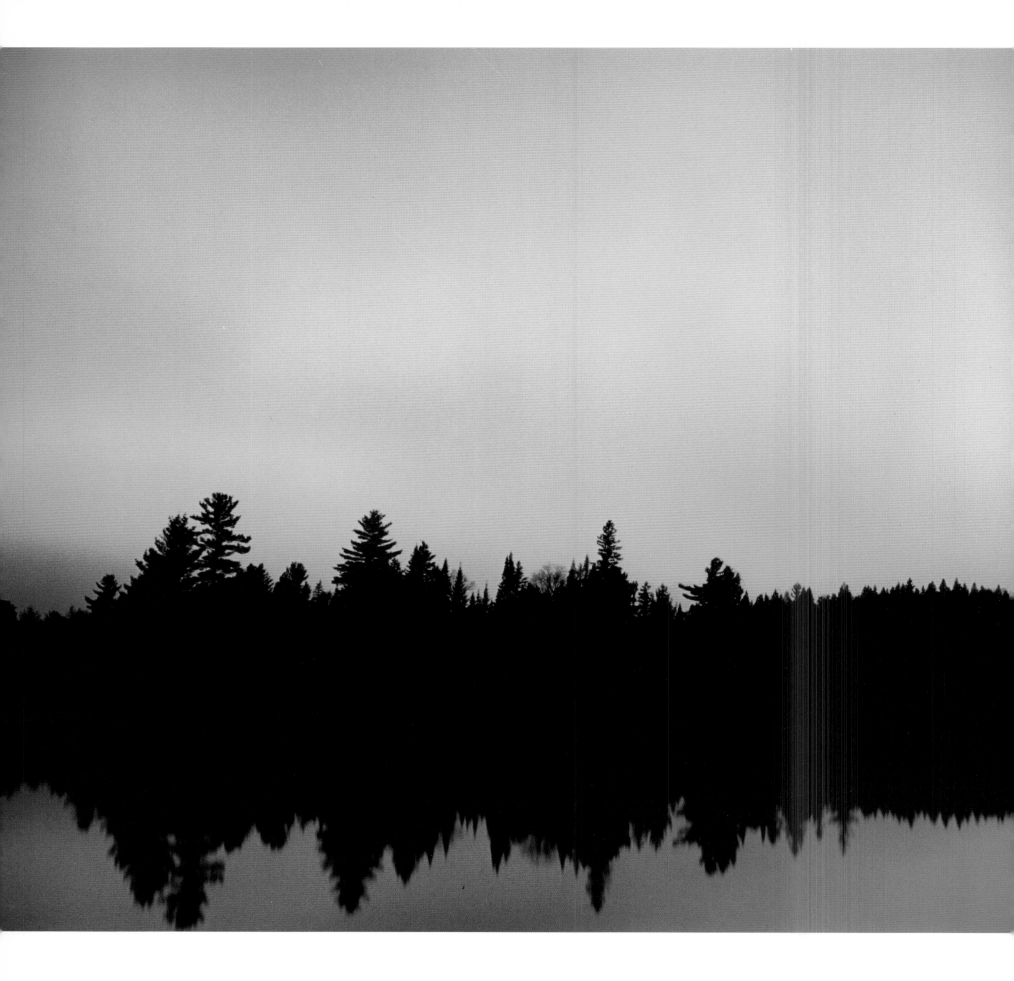

Northern lights, known scientifically as *aurora borealis, cast an ethereal white, green, yellow, red, and violet tapestry across the night sky.* "Algonquin is a piece of art on its own, and nature is the work of a real master."
– K.M. (Kate) Graham

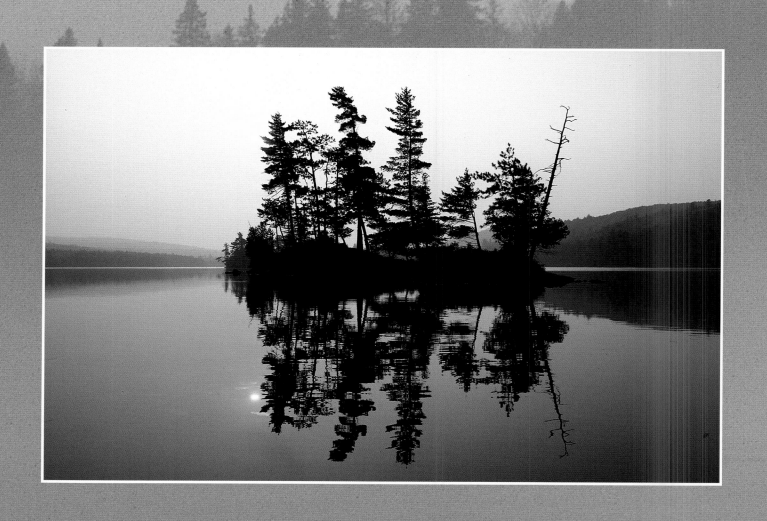

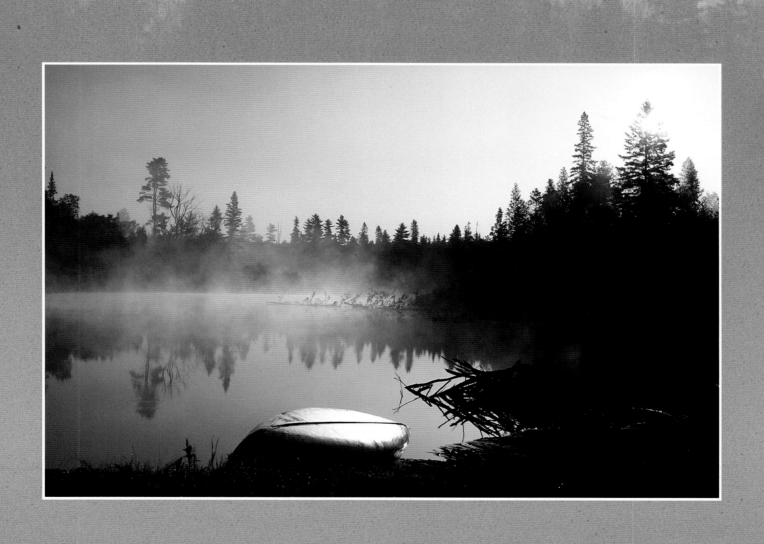

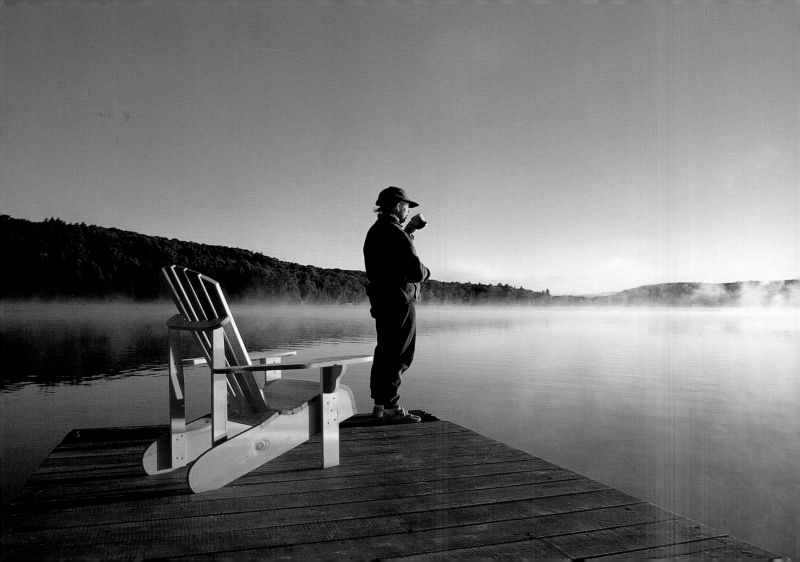

Cottages

The first sounds in the morning are the small thud and the scurry of red squirrels dropping pine cones on the roof. Gold light swirls across the ceiling, cast by the lake's reflection of the sun. A screen door slaps. Down to the dock giggles follow quick steps. There's a pause – then the loud splash.

When terry-rubbed faces appear back in the kitchen, fresh trout is sizzling in a cast-iron pan. The wood stove throws out a warming welcome. These are cozy surroundings: rag rugs, kerosene lamps, a stone chimney. Pencilled scribbles on a pine door frame chronicle the growth of three generations of Algonquin cottagers.

Cottagers in Algonquin are a different breed. Most came first to the park as canoe trippers or campers, then settled down with their families to make the park their permanent summer home. Even second and third generations have maintained many of the original traditions of the cottage: hand-pumped

water, access by canoe or small runabout, and, for most, no electricity. They have become unofficial caretakers of the park, cleaning up litter on busier lakes and coming to the rescue of swamped or stranded canoe trippers.

The first cottage leases in Algonquin were issued in 1905, when two large homes that had been built in the 1890s on Pirie's Island, Canoe Lake, by Allan and David Gilmour of the Gilmour logging company, were purchased by Dr. A. F. Pirie and Dr. Thomas Bertram to be used as summer residences. Known as "Uncle Tom's Cabin" and "Loon's Retreat," they became Algonquin's first summer cottages.

Roughly five hundred leases were issued from 1905 until the practice of leasing for cottages was halted in 1954. Original leases ran for twenty-one years, with a twenty-one-year renewal clause. In 1954, the government announced plans to phase out all leases as they expired, in order to bring the park back to a more natural condition. Then, as some leases ran out

or were sold to the government, the cottages were dismantled or burned.

Throughout the seventies, cottagers petitioned the government to reconsider the decision. Because of uncertainty over lease extensions, some summer homes became run down. However, the ruling also meant that there was no further pressure for development, and cottagers who remained in Algonquin had to be dedicated to a simple and rustic experience.

A reprieve was announced in 1986. Leases for the remaining cottages, numbering about three hundred, have been extended to 2017, but there have been drastic lease-fee increases. Cottagers still have to comply with restrictions that cover things like the manner of pruning trees and the colour of paint and shingles that can be used so that residences blend with the natural scenery as much as possible. Nonetheless, the extension is good news for these long-time Algonquin residents.

The cottage of Dr. Harry and "Couchie" Ebbs.

Mowat shoreline, Canoe Lake. "I remember quite clearly the days we would know that spring had officially arrived, by watching Gibby's Christmas tree float down the lake."
– Bill Statten, Canoe Lake resident

"Every spring it's great to see the lakes break up, but it takes some time to get used to the flotilla of boats that are following the last chunk of ice."
– Rob Gamble, canoe builder and Cache Lake resident

Pringrove's Magic:

Dr. Edmund H. Kase, Jr.

"Pringrove" sits on quiet Brûlé Lake, peering out from between tall pines on the east shore. Afternoon sun burnishes the weathered bark of the log home and Adirondack twig chairs on the veranda. When strangers approach, Ed "Doc" Kase welcomes them warmly and offers a tour of his cottage's historic buildings. It is a classic Pringrove welcome; hundreds of visitors over the years have found Doc and his wife, Mildred, ready to share their fascination with Algonquin.

Paths wander past woodpiles covered with colourful used canoe canvases, donated by different children's camps. Doc proudly displays the plank icehouse, filled with sawdust and frozen blocks, cut the previous New Year's by a group of volunteers. This is a popular, and necessary, Pringrove tradition; there is no electricity here. Instead, there are kerosene lamps, a hand pump, and wood stoves. They preserve a spirit of simple community living appropriate to the wild surroundings.

"Mildred and I first came to the park to fish in 1932," he starts off, "and we bought the cottage in the spring of 1938." Pringrove seemed a fitting name for their cottage: it is a blending of Princeton and Grove City – two American colleges with which Kase was affiliated. Doc has the air of a steward or curator, as though he feels a duty to share as much of his love for the place as possible.

Brûlé Lake was a busy lumbering community when the Kases first started summering here. The cottage was built by Alex Barnet, an Algonquin lumber baron. It was from Barnet's daughter that the Kases acquired the lease. It's a tranquil setting, but it's also isolated, reached by canoe or along the abandoned railway bed. In spite of this, Mildred and Doc still come each summer to Pringrove.

They have offered more than their share of assistance to other park visitors as well. He talks about the special responsibilities of cottagers: "The cottagers provide assistance, and on numerous occasions have detected and extinguished fires left by campers at campsites, as well as fires caused by lightning. They have rescued overturned canoeists and provided shelter for many in stormy weather."

As part of his own informal interpretive program, Doc brought dozens of his students from colleges in the United States to Pringrove through all seasons between 1938 and 1952. He was honoured for this contribution to appreciation of the park when he was given The Friends of Algonquin Park Directors Award in 1987.

Part of Pringrove's magic is the lasting friendships that are formed there. For Doc, his friendship with Jack Gervais, who was ranger at Brûlé for years, was an important part of that experience. Doc's reverence for the ranger is evident in a book he printed privately in 1972, *Jack Gervais: Ranger and Friend*.

"Jack loved to tell a story," Kase wrote. Kase cites Gervais's account of the time Jack and a group of rangers found themselves without fishing tackle near a spring on the Petawawa River. "The water in this spring was so cold, Jack remarked, that ice formed in it throughout the year. . . . Flaying his arms, Jack succeeded in driving a nice batch of fish out of the river and up into the spring, where they were soon frozen solid. The hungry rangers needed only to pull them out of the spring and stack them up like cordwood. By the time they returned to Barnet's Depot, the fish had thawed out and were ready for the frying pan."

For so many, the spell of Pringrove has revolved around the sharing of simple joys in a beautiful environment. Doc summed up this feeling in his book about Jack. "For many of us, Jack's friendship was built on the solid foundation of shared experiences. We had caught trout and immediately tossed them into the frying pan, and at other times we had nothing but stale bread; we had seen a portage mowed and a dock completed at the end of a hard day's work when the flies were at their worst. . . . We had enjoyed the cozy warmth of ranger cabins in winter and their dry shelter and protection from flies in summer – all this and much more, we had experienced together. Each shared experience was, as it were, a spike securely fastening together the foundation logs on which our friendship rested."

Like other Algonquin leaseholders, the Kases have used their cottage as a starting-off point for such memorable experiences in the park's interior. Pringrove has provided them, and their many guests, with a way of leaving the city's complexities behind and attaining a true renewal of spirit.

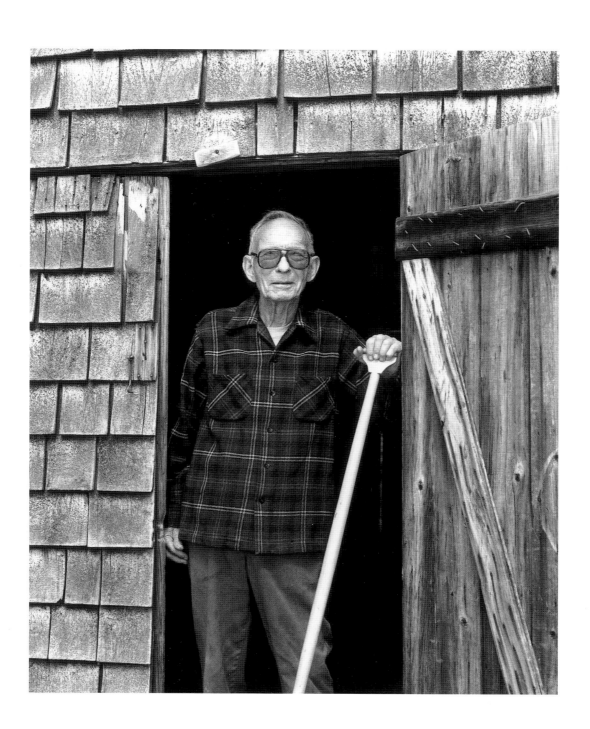

*A Wapomeo camper
looks out through the screen
door on her cabin.
"Here let the Northwoods'
spirit kindle fires of
friendship."*

*Smoke Lake sunrise. "There
is good fortune here in the
park. Your way of life is all
your own creation for the
most part."*
– Lela Shepley-Gamble,
Cache Lake resident

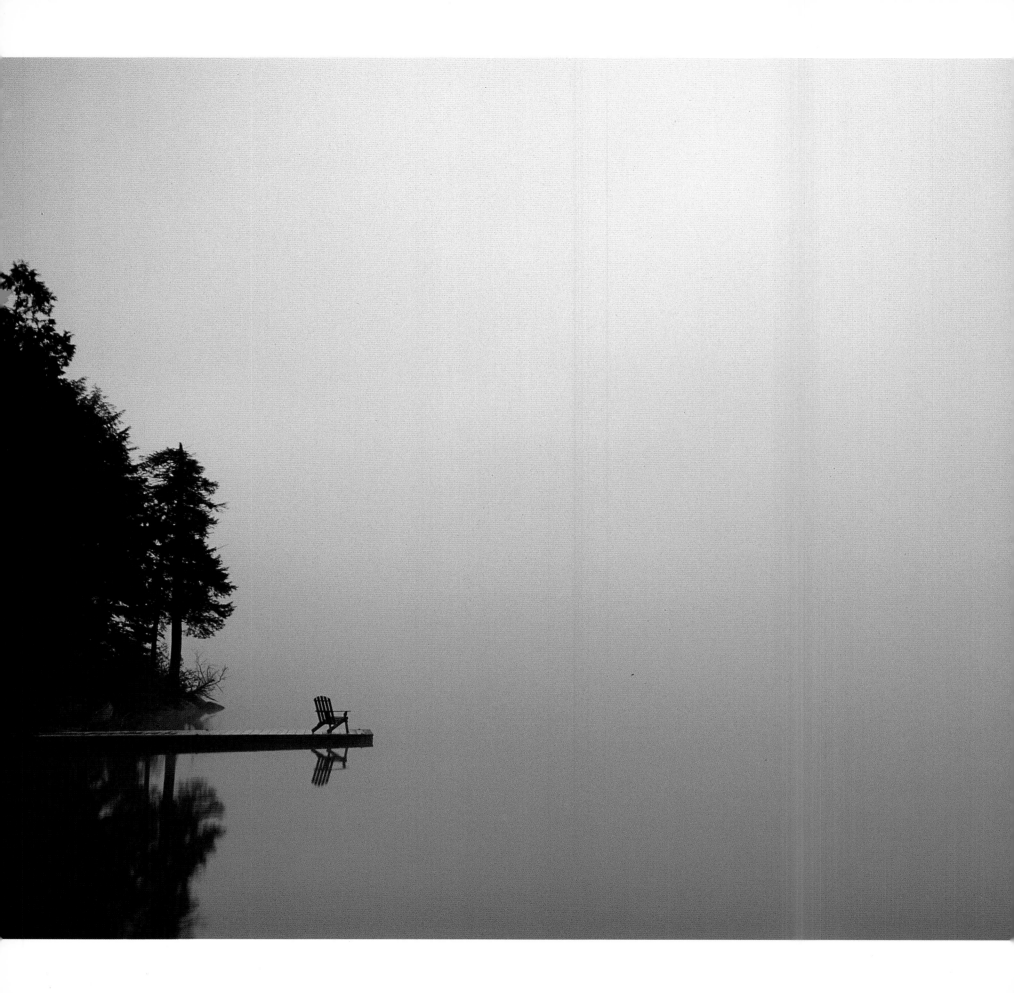

*Heavy mist on an August
morning, soon to be burned
off by the rising sun.*

*Old logging bridge
for trucks
over Potter Creek*

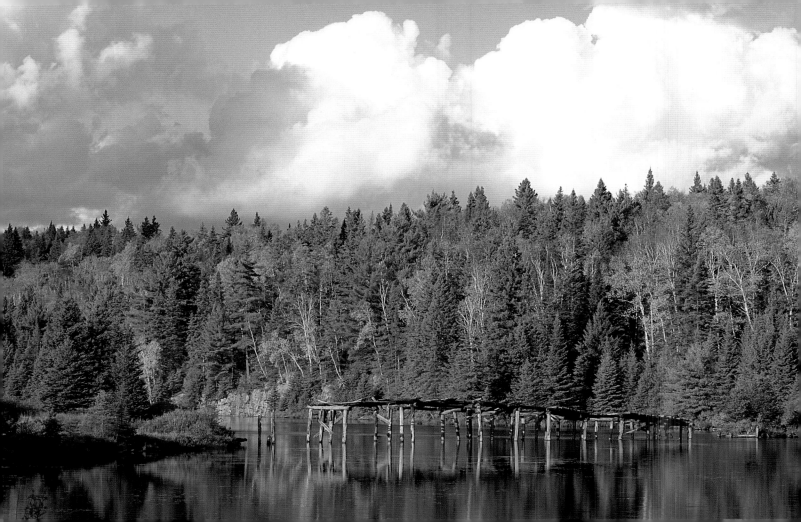

Communities and Ghost Towns

Many Algonquin communities have come and gone, their fortunes tied to the lumber industry, rail access, or the growth of tourism.

One settlement affected by the lumber trade was Mowat – named for Sir Oliver Mowat, who was Ontario's Premier at the time it was created. Mowat was a Gilmour Company mill town, complete with hospital, school, post office, and whitewashed board houses for the millworkers and their families. It became an important divisional point on Booth's railway, with miles of siding, a pumphouse, and a water tank. In its boom days at the turn of the century, the village numbered six hundred people, but the population shrank with the bankruptcy of the company, and the town had all but disappeared by 1910. For a time some of the buildings were refurbished as Mowat Lodge, which was burned, reconstructed, and razed again in 1930. A few build-

ings still remain as private cottages, but the only other signs of Mowat today are crumbling foundations and a small hillside cemetery.

The Cache Lake community centred mostly around the Highland Inn, Park Headquarters (until it was moved to the East Gate in 1959), and cottage life. A headquarters warehouse with a stone foundation is still used on occasion by an active Cache Lake cottagers' association.

Brûlé originated as a railway station that many logging companies (Barnet, J. R. Booth, and McLachlin Brothers) once used to supply their depot camps. Alex Barnet, the lumberman, built a cottage there in 1904, which still stands. Later came a mill, a school, and a lumbering community of eighty people, which lasted until the buildings burned in 1957. Timber was still shipped out to a Huntsville mill for a time, but the lumber camp was finally closed in 1978.

In the east and north, the Canadian Northern Railway (later the Canadian National) gave rise to tiny communities when its lines were completed in 1915. The station names, from north to south, conjure up images of exotic villages – Kiosk, Ascalon, Daventy, Government Park, Acanthus, Odenback, Radiant, Lake Traverse, Brawny, Achray, Kathmore, Dahlia – but most of the settlement around the stations consisted of a cluster of section buildings or logging camps. Kiosk Station was the site

of a lumber town with a veneer plant, a sawmill, a school, and about thirty-five houses. It faded away after the mill burned down during the seventies. Brent became a year-round community as the divisional point (where crews switched) for the Canadian National Railway until passenger service along that line was halted in 1978.

Achray on Grand Lake was a railway, as well as a ranger, station. Tom Thomson painted his famous *Jack Pine* while fire ranging there during the summer of 1916. A few railway buildings remain, as does Thomson's cabin and a large house built by rangers in their spare time in 1928. They quarried the stone across the lake and carried it to the building site by boat and canoe.

All of these communities have ceased to exist as winter villages. Some of the buildings are still used as summer cottages, but for the most part, there are few signs of the small settlements. Dwindling employment opportunities and access difficulties spelled their demise. The railway in the south has disappeared. There is only freight service on the northern railway line. Mills were relocated outside the park, and loggers now commute from surrounding towns. The pleasures and trials of life in Algonquin's small communities survive only in the memories of its one-time residents.

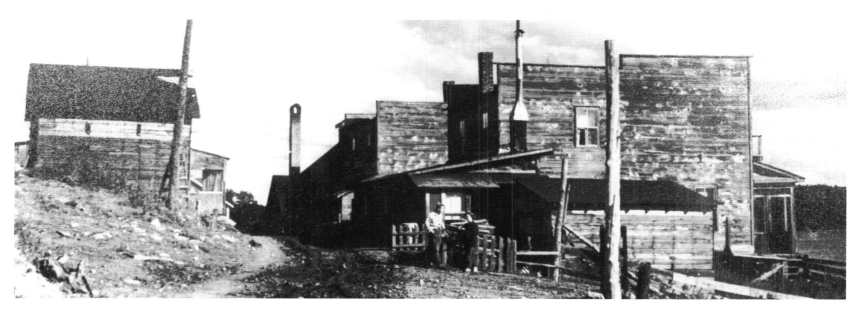

Brûlé, 1953.

"When you would be driving a boat at dusk in the spring or summertime, you had to make sure you kept your mouth closed or you would have hundreds of mosquito beaks stuck between your teeth."
– Gibby Gibson, Potter Creek resident

Family Life at Brûlé and Cache Lake:

Mary and Lorne Pigeon

Mary and Lorne Pigeon laugh as they pick through boxes of old photographs from the days when they lived year-round in the park. She talks about her childhood at Brûlé seventy years ago, while the twinkle in Lorne's eye betrays deep feeling for his life in the bush and the men with whom he shared it. Nearly fifty-seven years of marriage has forged a deep bond between these two, and a strong feeling of mutual respect shines through their easy-going banter.

Mary picks up a photo of Brûlé. "My father looked after the office and the depot for McLachlin Brothers. It was a great place; everyone had lots of fun. The kids had free rein back then and we would be all over – in the boarding houses, the ranger house, and everyone knew everyone else. The men would shovel a skating rink for us, and the adults used to play with us a lot, even when they should have been working. I had an old horse, as well, and I used to hook up a jumper sleigh, pick up all the kids, and go fishing."

After attending high school in Renfrew and teachers' college in North Bay, Mary left Brûlé in 1932. When she and Lorne were married, they lived in a cottage next to the one where they still summer. "We

know Cache Lake pretty well. Back then, three families lived beside us year-round, but there were lots of people on Cache in the summertime, what with the hotel and the railroad."

After their two sons, Tom and Jake, were born, Mary tutored a few neighbours. First she helped the station agent's daughter with her lessons. Then more families arrived. "When it got to be eight pupils, the Department of Education decided there should be a school, so we used a room in our cottage off the back beside the kitchen. You can still see where every kid sat because the floor is worn."

Life wasn't always easy with Lorne away working, ranging in the park. "In the summer you would be back in the bush all the time," he says. "You would take a weekend off or whatever you could get if the summer wasn't too dry. In the wintertime, they would call a gang of us in to cut wood, and then again in the spring to make syrup. I liked being outdoors, so it wasn't too bad." The pay was around $81 a month, he recalls. "It was pretty tight at times; if you didn't have a good woman back home to look after things, you wouldn't be able to tough it out."

Later, Lorne fought fires near Sault Ste. Marie, and he was fire boss for most of his career. He has plenty of stories about battling blazes in northern Ontario. "I almost lost eleven men once, up near the Sault," he says. "I put them into this spot to work and then I had a jump fire that came roaring off over one hill and hit the hill on the far side [trapping them]. They were wise enough and got into a pond and stayed there. They would dunk their heads and only come up for air – hoping there would be fresh air to gulp down. Later, when I met these fellows, safe . . . I can't explain the feeling. They were all good men, working the fires. I was proud of them."

Mary and the boys followed Lorne to the Sault in the early fifties. Lorne says, "We missed it when we left the park. As soon as the kids were finished school for the summer, Mother and the two boys would jump into the car and head for Cache Lake."

Mary agrees, "Tom and Jake grew up here doing odd jobs. They would deliver ice, coal oil, groceries, and mail to all the people on the lake." They also used to light the fire and haul water to the overnight house used by the railwaymen, and they cleaned out the passenger trains before their trip back west.

Tom and Jake also guided for Camp Northway, and they were a team to reckon with in the Cache Lake Guides' Race. Started over forty years ago as part of an August regatta, the canoe race was always held when the guides were in camp at Highland Inn. Camps Pathfinder, Tamakwa, and Tanamakoon also sent entries, but the elaborate silver "Turner Trophy" lists Pigeons as victors several times.

The Pigeon family still spends a lot of time in the park. Tom makes his living in Algonquin. Jake spends his summers at Brent, and Mary and Lorne continue to cottage at Cache Lake. "The park was quite a place," says Lorne. "There were, and still are, so many special men and women living and working in the park. It has something magical to offer anyone who visits for a day, or stays a lifetime."

The common loon seldom
stays under water longer
than three minutes, and the
average dive lasts only
about forty-five seconds.
Their streamlined bodies
and powerful webbed feet,
set at the rear of the body,
make for maximum
efficiency in their quest for
fish, which they seize with
quick thrusts of the bill.

Shallow water
at the mouth of the
Nipissing River.

Brent:

Jake Pigeon

Jake Pigeon's curly white hair and beard glow in the light cast by the single bulb above the door to the store. He leans against the tailgate of a pickup truck in muffled consultation about where to fish the next day. A train rumbles by, shaking every window in town, but he and his friend still use hushed tones, as though to avoid being overheard.

Since 1981, Jake has run the Algonquin Outfitters store at Brent, and Algonquin is in his blood. His parents are Mary and Lorne Pigeon. His grandfather, Mary's father, was Chief Ranger Tom McCormick.

Jake first visited Brent as a teenager, guiding for Camp Northway. He used to tell the girls to pack a dress for a visit to the bustling town of Brent. "As we got closer, we would start hearing the train whistles at night, and the girls would get excited about arriving." The night before, from their campsite across the lake, Jake would point out the "station lights," explaining that the main town was behind a hill. The girls would hang their dresses in the trees overnight to get all the creases out, and, in the morning, they would get dressed up and make a first stop at the store.

"We would always send them in to Gerry to ask him when the next bus went to Brent. They would ask this crusty old bugger behind the counter with a cigarette dangling from his mouth, and he would yell back, pounding his fist, 'Jesus Christ, you *are* in Brent for goddamn sakes.' Well, the front door would open and all these girls would come running out screaming, with Gerry yelling behind them."

"Smiling Gerry" McGaughie was a Brent institution. He opened the store in the late thirties and ran it until he died in 1981. Brent was a much busier town in Gerry's day. Logging, ranging, and the railway used to provide employment, but families slowly moved away during the sixties and seventies as railway cutbacks took effect. When passenger rail service was eliminated in 1978, the town became a summer-only village. The forty-kilometre drive from Highway 17 is along a twisting, dirt road; the rough, washboard surface and giant potholes take their toll on incoming vehicles. "We often wondered if we would get more people up here if the road was better, but then we wonder if we really want any more people."

Jake and Bonnie, with their two young children, Forrest and Sky, drive into Brent for weekends as soon as the road becomes passable in April. They settle in for the summer in June, but the weekend pilgrimage from their home in Penetanguishene resumes between September and November. Their summer home is attached to the rear of the store; inside, the furniture has been pushed back to create a large circle where the kids can ride their tricycle.

Working at the Brent store, Jake and Bonnie have met a lot of friendly people, and some "interesting sorts" as well. One solo tripper paddled in and said he hadn't had anything to drink in six days and that he was dehydrated. Jake asked, "Weren't you on a canoe trip?" and the canoeist said yes. Then Jake asked, "What the hell were you paddling on?" "Water," was the response. Jake starts to shake his head. "I asked, 'Did you ever think of drinking it?'

"No," he said, 'I never did think of that.'

"We've seen a lot of different people out on canoe trips," Jake continues. "Some you have to wonder how on earth they made it up this far. These two people from France decided they wanted to go on a canoe trip, and they were outfitted at the Portage Store [on Canoe Lake, about eighty kilometres away by canoe]. They left there assuming that there would be a café every few hours where they could get a bite to eat. They spent five days out in the bush with three [freeze-dried] mushroom omelettes. When they got here, they were both frightened and hungry, so we took them under our wing, and they ended up staying for another week."

The store is full of old photographs and artifacts, left from the days when Brent was a busy village. Canoe trippers enter in search of cold pop, frozen treats, and chocolate bars to satisfy cravings that a week in the bush, away from convenience stores, has only intensified. When the day's customers have been served, and Brent becomes still in the evening, Jake and Bonnie often relax on the back porch with friends. They look out over Cedar Lake, talk about the day's events, and watch the raccoons argue over the treats Bonnie has left out for them. Jake reflects, "Brent is definitely the forgotten part of the park, but that's what continues to make it special. The people who come up here now come for the uniqueness and solitude."

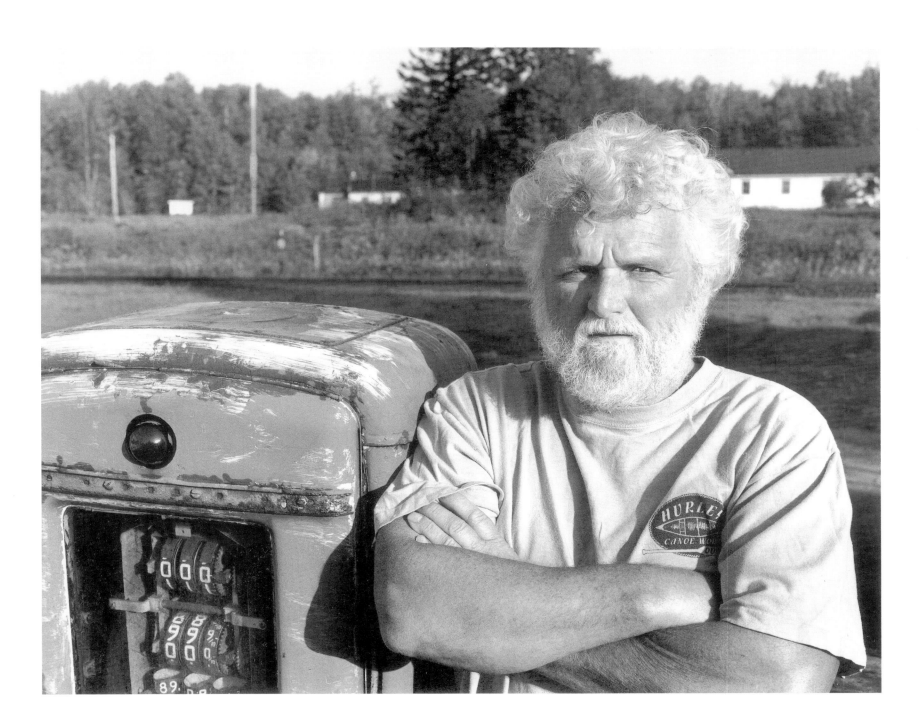

*A lone red pine in a
winter sunset.
"All you do in Brent during
the winter is just live
with it."*
– Adam Pitts

*Early-morning sun lighting
the red pines on
Molly Island, Smoke Lake.*

The Mayor of Brent:

Adam Pitts

Adam Pitts's house is across the tracks and up a slight incline from Cedar Lake. It has no electricity or running water, and the only entrance is the back door into the kitchen. Light comes from makeshift lamps – open juice cans filled with coal oil. From these lamps belch clouds of black soot. The only window is in the kitchen, and a clear patch wiped in the grimy film lets sunshine filter into the smoky room.

Adam's house consists of a kitchen, a bedroom, and a third room partitioned off for food storage. The furnishings are simple: in the bedroom there is one chair, one table, and a single bed. It's the bed in which his father was found frozen to death by a neighbour, one winter years ago, and that may explain why, even on a humid, August day, Adam keeps a fire burning in the kitchen cookstove. At seventy-seven, Adam is Brent's only occupant from November to April. He has no contact with outsiders after the last summer residents pull out; his two cats are his only companions.

He's flattered to be asked about his life in Brent, but he says modestly that he doesn't really have much to say. The people around the village call him "The Mayor of Brent," but he laughs at the title. "Ah, that doesn't mean anything; it's a kind of joke, that's all. Just kids one day said this to me, and it's stuck ever since."

He's been here for sixty-one years, though, and his father lived in Brent before him, stoking trains. Adam worked at odd jobs in the park; once he laboured in a factory in Toronto for a short time, but he was drawn back to Brent. In the boom years, he enjoyed watching the children going to school each morning, laughing and skipping down the street, throwing snowballs at each other or at the passing trains. Today, the community has all but disappeared, and he watched its slow decline. "The people have changed," he says. "Fire ranging is almost over. The railway and its purpose is almost gone. The lumbering is no longer the way it used to be, so there really isn't anyone here any more. Lots of little towns – Kiosk, Daventry, Odenback, Brent – all packed up and left because there was nothing left to do." Adam wouldn't leave and give up the unencumbered lifestyle he has in Brent, though. As sorry as he is to see the last people leave in the fall, he's fiercely independent.

About the long winters, Adam explains, "I'm busy keeping the stove going, shovelling snow off the woodpile, cooking, sleeping, talking to my cats, and listening to the radio, although I don't listen to it as much any more. It uses a lot of batteries, and every half hour tells me all the bad news going on in the world. I also play the fiddle and have been for years. It's a good feeling when I play for myself or other people." For food, he relies on home preserves, apples from his trees, and tinned goods, and he hangs loaves of bread from the rafters, where the warm air dries them, keeping them from going mouldy. "My food supply usually lasts me through the winter. I don't eat as much if I start to run low."

When the other residents come back in the spring, Adam goes on a visiting binge. Sometimes he'll ask people up for a coffee. He doesn't waste much time on housekeeping, but he's proud of what he has, and he's generous. When Jake arrives in the spring, he takes Adam some donuts, fresh vegetables, and other foods he hasn't eaten in months. Adam always wants to pay for them, and will only accept the goodies if he's told they are a late Christmas gift. If anything is offered to him the next day, or later in the summer, he is determined to pay for it.

Adam has no plans to leave Brent. "I usually get into Mattawa for a day if someone is going. I sometimes thought that I would have left Brent, but I'm still here long after everyone else has moved out. I guess I've been hoping all these years that the people would all come back again."

He will make only one prediction about Brent's future. "When I'm dead and gone, I think Jake will probably still come back summer after summer, because he really likes the place and the fishing. I think he also likes the idea that then he would become the 'Mayor of Brent.'"

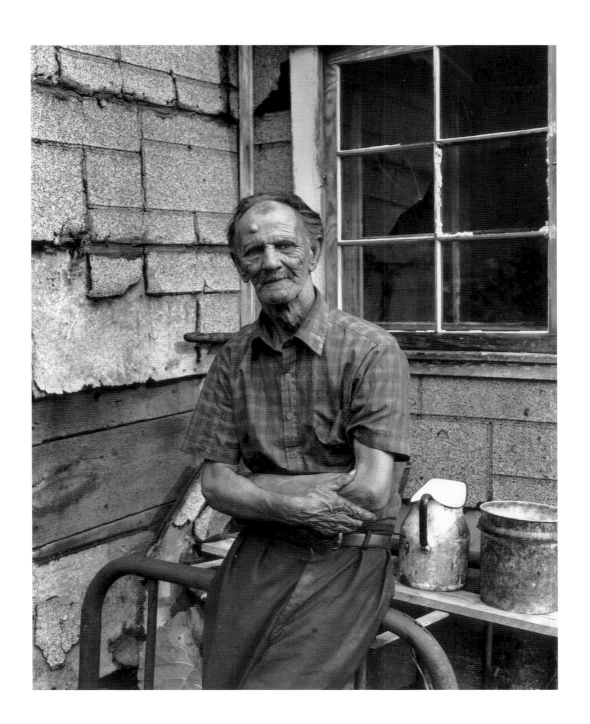

Windy Isle on Canoe Lake.
"There is certainly
something magical about
being here in the park and
feeling comfortable in
the woods."
– Jane Gray, artist and
Cache Lake resident

"A Great Old Life":

Leonard "Gibby" and Lulu Gibson

From their kitchen window, Gibby and Lu Gibson can see where Potter Creek empties into Canoe Lake. Lu has spent many an evening fixed to this window, waiting for Gibby's return. In winter, she watched for him to come round the point, back from a full day of cutting ice. In summer, she kept his dinner warm, long after dark, until she could hear his boat arrive back from one of the camps.

As they pass, canoeists often say to each other how perfect it must be to live here year-round. But Lu knows that life here was not always easy. There were times when she worried about Gibby out on the lake at night, and others when the couple was isolated for days after winter storms. Gibby, for all his stubborn strength, has been through a lot, too. Over the years, he has lost his legs to hard work and frostbite. He shrugs it off with a smile. "I get real enjoyment watching the mosquitoes in the springtime trying to get blood from my wooden legs."

Lu was fifteen in 1931 when her family moved to Algonquin. Her father, Everett Farley, took a job as lumber foreman on Canoe Lake to see the family through the Depression. Later, he ran a contracting business and took over the Canoe Lake Post Office. "It was a meeting place for the people in the area, and I knew everyone," says Lu. After Lu finished school, she worked at the post office for fifteen years.

"In the wintertime," she recalls, "I would use a horse and cutter or a dog team to go down to Smoke Lake to pick up the mail. I had four or five dogs for many years. Mikey was one of my favourites. Gibby bought him in Whitney for me for a dollar and a half. Omer Stringer gave me Belto and Tongo. The dogs had as much fun as I did. It was a real adventure, and we would take off regardless of the weather.

"In the summertime, I would go down the lake in the wooden 'mail boat.' We would get all the mail from the parents to the campers of Tamakwa, Arowhon, and The Taylor Statten Camps with the cottagers' mail. And then, of course, there would be all the letters back to the parents. I got sentimental when I saw a little kid's writing on the envelope in pencil to 'Mom and Dad.'"

Lots of the residents used to go down to the station to meet the trains, just for something to do, and Lu was there on the day Gibby arrived at Canoe Lake in 1933. "He and his friends had hopped on a train coming out of Parry Sound, and they ended up at Canoe Lake. I don't think any of them quite knew what they were doing or where they were going, but Len ended up finding work, and he stayed."

Construction on Highway 60 through Algonquin had just started as a job-creation project during the Depression, and Gibby joined the crew. In his words, "I worked on that Christly highway doing every possible job, but the one that I did the longest was delivering supplies to the [construction] camps. I always made sure I got the best of anything for our camp at Smoke Lake. The people at Joe Lake Station all knew me and would pretend to run and hide when I pulled up to the dock [for supplies]. Sometimes it took quite a while, but I would usually leave with a full load, waving to the men on shore, who would all be scratching their heads, wondering how I, once again, got what I asked for."

Gibby left Canoe Lake to serve overseas during the war, interrupting their marriage plans, but he wrote home to Lu, telling her to pick out an engagement ring. She ordered it by mail from Toronto. "There wasn't a day that went by without me checking every piece of mail that came in. Old Gibby came home on December 10, 1945, and we were married a month later. It was a very quiet wedding in Parry Sound, but we came back to Canoe Lake on the train and had a party with all our friends." The following summer, they started building their home next door to her parents' on Potter Creek.

While Lu continued running the post office, Gibby worked alternately at the Hotel Algonquin or with Lu's father, cutting ice in the winter and wood in spring and fall for camps Ahmek, Wapomeo, and Arowhon, and for the cottages.

"Lippy Lenny" always seemed to have something up his sleeve, and he figured in a few outrageous park stories. One winter day, he "borrowed" a car from the Portage Store to get his groceries home. "It was an old Buick – late thirties – with a spark advance, so it was easy enough to start. I put planks down, so that I could get it from

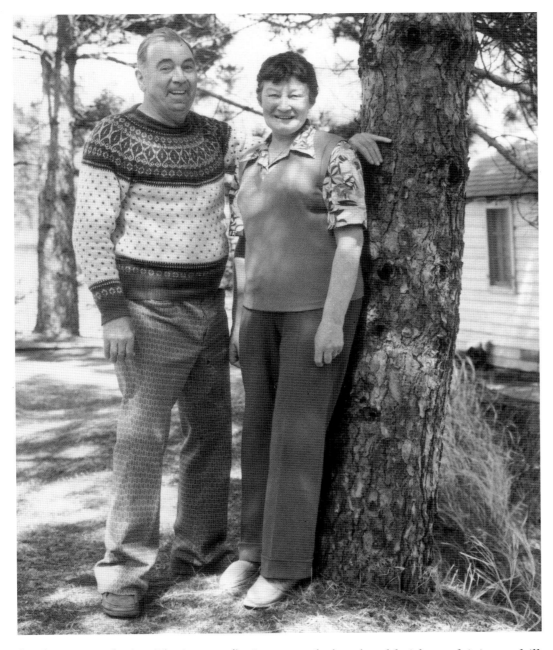

Gibby was always coming to the rescue when something on the lake needed doing. Sometimes it was coaxing a wheezing generator back into operation for The Taylor Statten Camps or magically breathing new life into an outboard motor on which everyone else had given up.

Like other long-time residents, Gibby and Lu form an important part of the park's character. They have gone about their lives with quiet strength and a deep commitment to each other and to their Algonquin home. Because of their strong attachment to the park, they have made a special mark on the place just as surely as it has left its enduring stamp on them.

the shore onto the ice. The ice was flexing enough that the old girl was driving uphill the whole way." Gibby stood on the running board, just in case the car broke through. The people at Potter Creek were all outside watching as he rounded the last point; they scrambled for cover as he plowed right up onto the safety of the shore. Of course, he realized the vehicle had to be returned right away, but he was reluctant to head back out onto Canoe Lake. He chose a bumpy trip back along the railway tracks instead; fortunately, he knew the train schedule well.

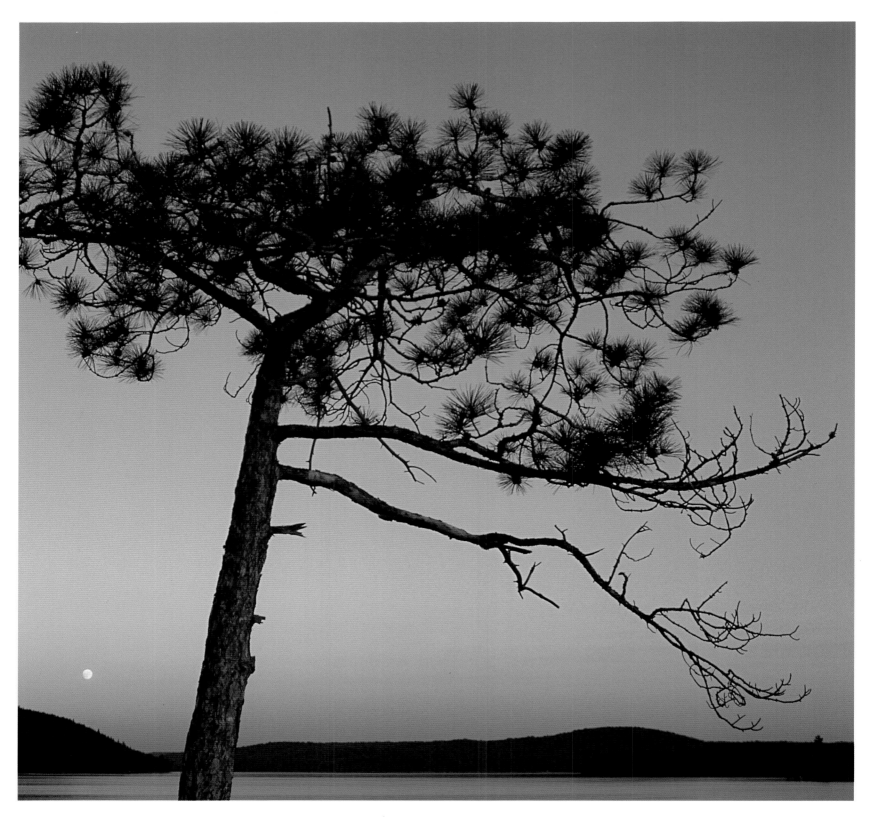

"In wildness is the preservation of the world." – Thoreau

"Seek simplicity to preserve complexity." – Arne Naess, writer and environmentalist

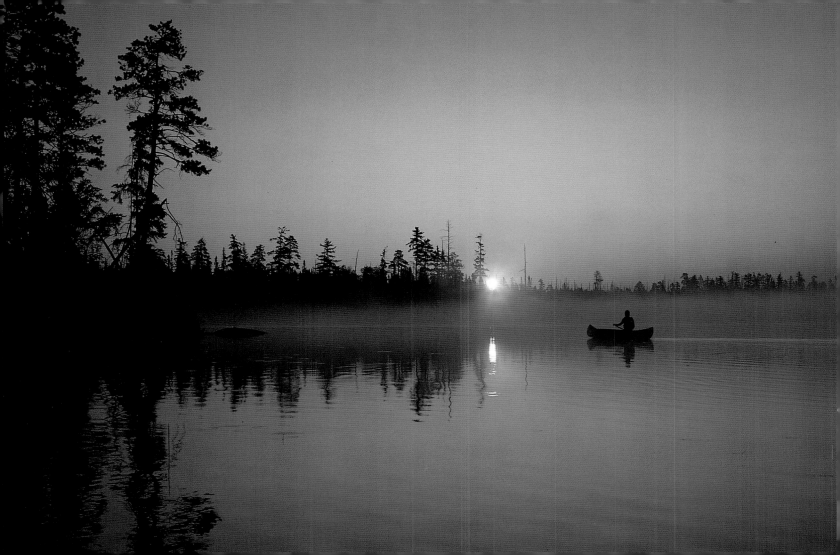

The Canoe

May every dip of your paddle lead you toward a rediscovery of yourself, of your canoeing companions, of the wonders of nature, and of the unmatched physical and spiritual rapture made possible by the humble canoe.

– Pierre Elliott Trudeau. Foreword to *Path of the Paddle* by Bill Mason, 1980

Algonquin Park sits atop a lake-covered highland, down from which flow winding rivers. Native people across North America developed watercraft suited to the topography and building materials of their region, and the Algonquin were no exception. To traverse the many watersheds of the park area, they required a light and portable craft. The highly adapted birch-bark canoe was their answer. It was not too heavy, was manoeuvrable in fast water, was small enough that one person could portage it, and was able to carry large loads on the water.

During his exploration of Algonquin territory in 1603, Samuel de Champlain praised the indigenous craft: "with the canoes of the savages one may travel freely and quickly throughout the country, as well up the little rivers as up the large ones."

Among all the modes of progression hitherto invented by restless man, there is not one that can compare in respect of comfort and luxury with travelling in a birch-bark canoe. It is the poetry of progression . . . you are propelled at a rapid rate over the smooth surface of a lake or down the swift current of some stream.

Presently the current quickens. The best man shifts from the stern to the bow, and stands ready with his long-handled paddle to twist the frail boat out of reach of hidden rocks. The men's faces glow with excitement. Quicker and quicker flows the stream, breaking into little rapids, foaming round rocks, and rising in tumbling waves over the shallows. At a word from the bowman the crew redouble their efforts, the paddle shafts crash against the gunwale, the spray flies beneath the bending blades. The canoe shakes and quivers through all its fibres, leaping boldly at every stroke.

– Windham Thomas Wyndham, 4th Earl of Dunraven, 1876. Quoted in *The Canoe* by Kenneth G. Roberts and Philip Shackleton, 1983.

Early trappers and explorers took their cue from the first people and used birch-bark canoes in the park area, but by the time David Thompson was sent to study the feasibility of a canal linking Georgian Bay to the Ottawa River in 1837, cedar-plank canoes were already in use in other regions. Government authorities suggested that Thompson take sheet-iron canoes on his expedition, but he insisted on large cedar-plank craft. As the season wore on, it became clear that there would be advantages in splitting his party into two groups. Two smaller boats would allow Thompson's party to navigate shallower waters and to complete their exploration before the lakes froze. After ascending the Oxtongue River, they stopped at a cedar grove on Tea Lake (on the present site of Camp Tamakwa) to cut and split enough cedar planks to build two eighteen-foot canoes.

Alexander Murray also built canoes in Algonquin while on his exploratory journey in 1853. While Thompson preferred cedar, Murray's party used birch bark. In fact, Murray gave the lake where he stopped to harvest materials to build his canoes its present name in honour of the event; they were built at the north end of Canoe Lake.

Bark canoes gave way gradually to plank ones in the latter half of the 1800s. They were sturdy and stable, and commercially produced. Some of the more popular models came from the Rice Lake area, where builders in the 1870s were producing a cedar-plank craft modelled on the shape of birch-bark canoes. The plank boats had a somewhat flat bottom, good carrying capacity, and a pronounced tumblehome (where the sides curved in toward the gunwales).

Canvas-covered cedar canoes made their first appearance in the mid-1800s and, by the turn of the century, were widely used by trappers, tourists, and campers. The canvas shell made the canoe slightly heavier, but it was easier to maintain. A few of the park rangers continued to make and use bark canoes, but since canvas canoes were commercially available, more durable, and more stable, they eventually supplanted the older craft. Rangers relied on the canoe for patrolling the interior when the lakes were free of ice, and reading even a few entries from ranger Stephen Waters's diary illustrates how much time the rangers spent paddling:

Oct. 3, 1893 – Thomson decides to go to McDougall's Lake and take me with him. . . . I carry the canoe across portage two miles, reach South Bay of Opeongo, after an hour and a halfs paddle we arrive at Fraser's Farm.

Nov. 9, 1893 – Left Mink Lake at six o'clock, reached Cedar at eleven left for Burnt Lake twenty miles up the Petawawa

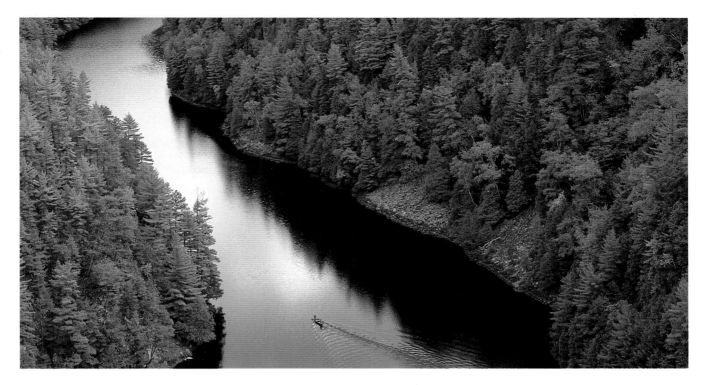

The Barron River winds between hundred-metre cliffs on the eastern side of Algonquin.

River arrived at foot of Burnt Lake at six had tea, left for Depot four miles up the Lake, got there at half past eight after paddling and portaging forty-six miles.

Nov. 12, 1893 – Left at seven, short portages small Lakes met canoe with four men in it, found out after that it was agent for American Lumber firm reached Madawaska River at nine. . . . off again to Lake of two Rivers, across it ten miles up the River to Cache Lake, up River cross Island, Smoke Lakes and Canoe Lake is reached mile and half paddle to Headquarters.

Nov. 13, 1895 – Left Canoe Lake for a short trip it will not be a very extended one I fancy on account of ice how we are to get along is a mystery to yours truly the small lakes are frozen over and the Bays of the larger ones also. Had to break ice in Portage Bay Canoe Lake for quite a long distance before we could reach the trail to Smoke Lake.

As the recreation industry blossomed across North America during the first part of the century, so too did the number of boat builders catering to the new tourist trade. Several of the children's camps founded in Algonquin during this period also employed builders and canoe repairmen. Two forty-two-foot war canoes, custom-built by Stan Murdoch of the Peterborough Canoe Company, were delivered to The Taylor Statten Camps in 1925. They are still in use today, and are the only canoes of their kind in existence.

Since the Second World War, paddlers have been able to choose from a widening selection of construction materials. Wood canoes have largely given way to those made of aluminum, fibreglass, and other synthetic materials, but travelling by canoe is still the best way to reach Algonquin's remote corners.

I would ask you, "Given the choice, what would you pick, the dome of the cathedral or the falls?" As much as I love and appreciate the great works of art, I know what my choice would be. And the thing I like best about these falls is that you can only get there by canoe – the most beautiful and functional object that humanity has ever created.
– Bill Mason, *Path of the Paddle*, 1980

The Brent Run

There is a canoe race that isn't known well outside Canoe Lake circles, and it attracts a different breed of paddler: "The Brent Run." In this race, a two-person team paddles and portages a cedar-strip canoe one hundred and sixty kilometres, from the middle of Canoe Lake to Brent and back, and times are measured to the closest hour.

Hank Laurier, a Canoe Lake cottager, once ran the race with his brother, Carl. He describes how they accepted the challenge for what became a record-setting run:

We first heard about the Brent Run when it was rumoured that two Stringer boys had gone up to Brent and back again in twenty-four hours [during the early thirties]. No one saw them leave or return, but I wouldn't doubt that they did it. Then Bill Stoqua, who was a guide with Hotel Algonquin, and Bill Little, who was a guide at Wapomeo, did it in thirty-two hours. Carl, my brother, and I were both working for The Taylor Statten Camps at the time, and Stoqua and Little dared us to try to beat their time. Both Carl and I were strong paddlers, and we knew the area well, so the next day, we packed two peanut-butter sandwiches and two cans of orange juice, threw a lantern in the canoe, and started to paddle in the direction of Brent.

We reached White Trout [now Big Trout] in four hours, had dinner on Burntroot, and made it to Brent in thirteen hours. It was a clear night, but dark, because there wasn't a full moon. Our legs and arms were starting to cramp up, but other than that, we didn't have any real problems coming back. When the sun came up, we ended up paddling into a slight headwind, but we made it back to Canoe Lake in time for dinner. We had gone to Brent and back in twenty-seven hours. That night we all got together, along with Stoqua and Little, and partied until the sun came up over the hills behind Ahmek.

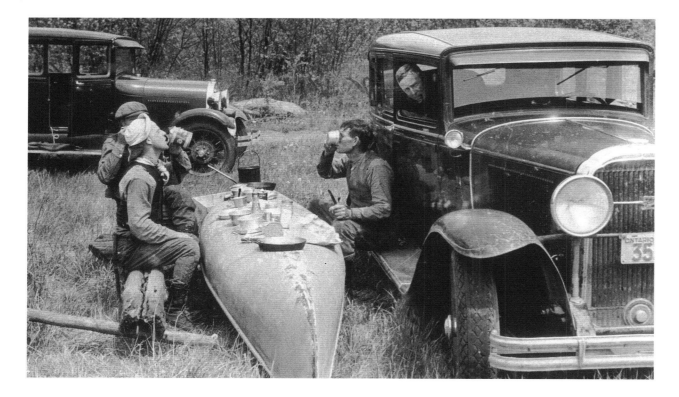

The first cars entered Algonquin Park in the late 1920s along an old railway spur line. This is a lunch stop near Lake Opeongo.

128

The present record is held by former Ahmek staff members, Chuck Beamish and Bob Anglin, who completed the run in twenty-three hours. Explains Chuck:

> The Brent Run is not done for public recognition. It's a race that you do for yourself. You only hear of a good time every eight to ten years, so it's not the type of thing that everyone talks about. The rules of the race are all unofficial. There are people who keep time at Canoe Lake, and you phone back or get verification once you arrive in Brent, but the rest is up to the paddlers. I suppose that doesn't make it a legitimate affair in a lot of people's eyes, but that's the nature of the race and that's one of its charms. We still do the race in hours and don't calculate it down to minutes or split seconds. There is no reason why you would want to take someone's twenty-seven-hour paddle and beat them by ten minutes; it's the kind of race where both teams can claim the twenty-seven-hour accomplishment. The people who paddle appreciate the rules that have been created, and they respect all the others who have attempted and completed the run.

Timeless Transportation

Every year, thousands of city-weary visitors take to the canoe, embarking on annual pilgrimages that cover far more than just physical distance. Today's portages often follow the same path as those that the native inhabitants and early explorers used, and present-day paddlers are the latest participants in a long Algonquin tradition. As Bob Henderson, Smoke Lake cottager and Professor of Outdoor Education at McMaster University, wrote in the Fall 1988 issue of *Paddler* magazine:

> Algonquin's geography is special and exciting. It offers a very demanding landscape for canoe travel and it is ironic that it is the country's premier beginner canoe trip area. When in Algonquin, few stop to realize that the creeks and swamps are the start of significant rivers that drain off the Algonquin Uplands; few make sense of the long portages as common to large headwater regions. Knowing this sense of patterns to its waterways is part of the region's

heritage. Interest in the geography helps link you to the area's exploration history. . . . [and provides] some relief in knowing why one is portaging so much.

Whether rented from outfitters or owned, made of wood, aluminum, or fibreglass, a canoe is an integral part of most overnight visitors' Algonquin experience. Properly handled, it dances responsively through tumbling rapids, or slices a lake's calm surface at dusk, silently floating across a backdrop of mauve and orange clouds. It is a vehicle exclusively associated with open spaces and the north country, a graceful antithesis to urban confinement. As wilderness traveller and environmentalist Sigurd Olson wrote in *The Singing Wilderness*, "The way of a canoe is the way of the wilderness and of a freedom almost forgotten. It is an antidote to insecurity, the open door to waterways of ages past and a way of life with profound and abiding satisfactions."

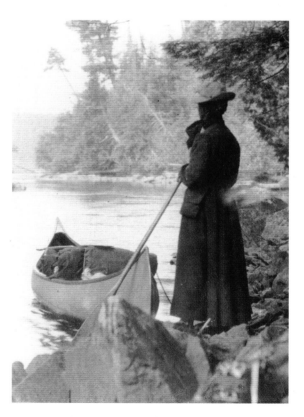

An early visitor waits at the end of a portage on the Petawawa River near Red Pine Bay.

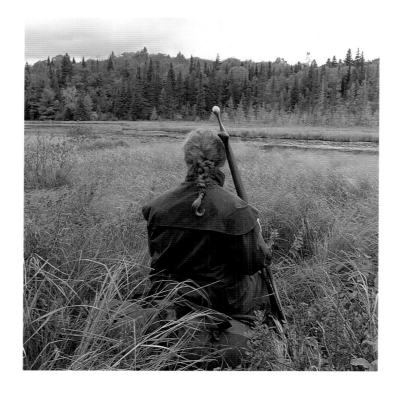

"Every canoe trip that I have done, there has always been a portage that feels like it would never end. Every hill or bend in the trail, you pray for that flash of lake between the trees."
– Linda Leckie, year-round park user

"The history of this country is canoe travel, and people like to experience the romance and wilderness lifestyle of the past. Algonquin is a place where you can get all of this."
– Lesleigh Anderson, year-round park user

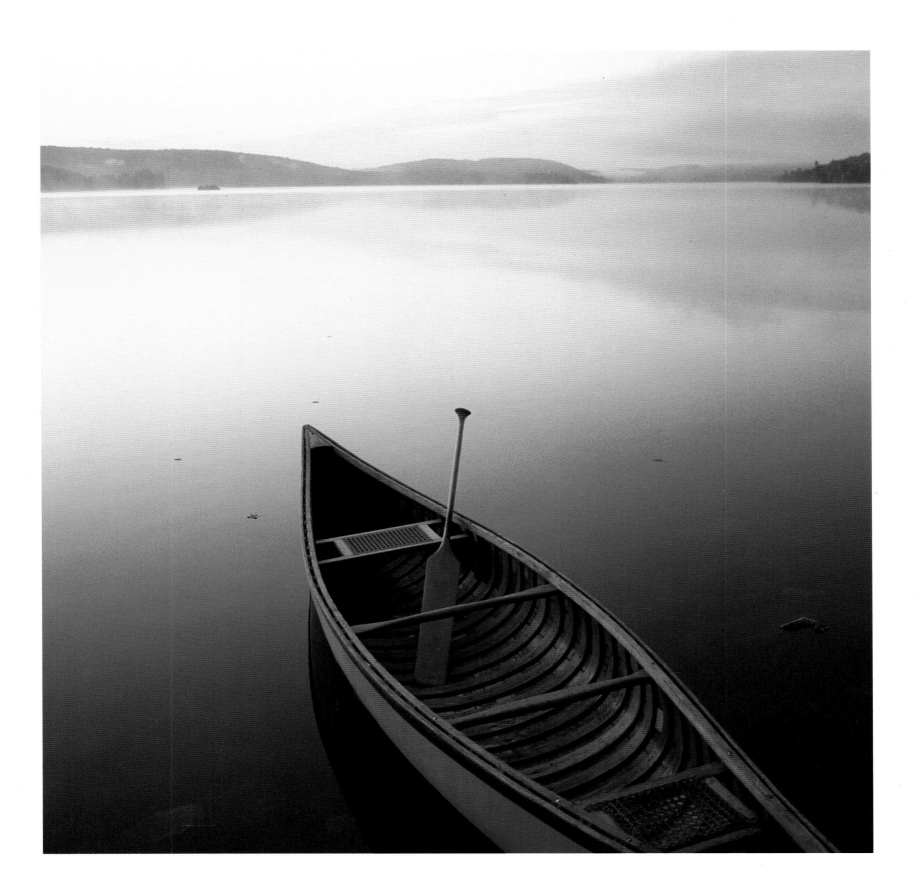

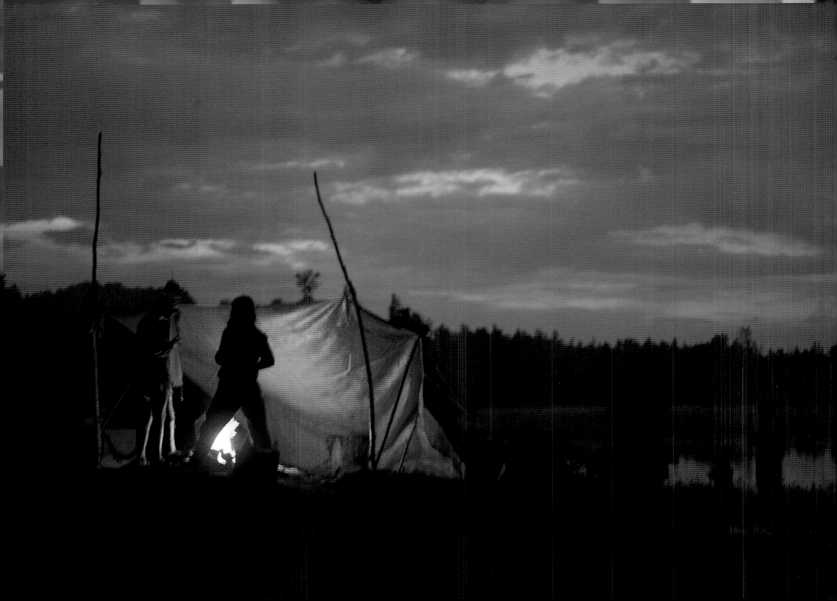

Canoe Trips and Camping

To really see the Park, you must still travel by canoe. It is the canoeist's paradise, with its myriads of little lakes and mysterious dark, twisting rivers, the forests crowding to their banks. Few pleasures can match the combination of beauty and adventure provided by slipping silently down one of these park rivers in a canoe. Something exciting or interesting seems to wait around each bend. Perhaps it will be a moose, lifting his dripping head from the water, a bunch of water plants trailing from his jaws; or a raccoon, turning over rocks after crayfish; or a bear, fishing; or a fawn with its mother.

– Richard Miller, *A Cool Curving World*, 1962

To allow you truly to drink in Algonquin's spirit, nothing beats a canoe trip. Since the arrival of the first tourists at the end of the last century, the "canoe outing" has been the quintessential Algonquin holiday.

One of the earliest regular visitors to the park was Buffalo industrialist, G. B. Hayes. With canvas tarpaulins for shelter, balsam boughs for bedding, and Indian guides, Hayes and his parties could count on excellent fishing and a relaxing vacation in the cool, lake-studded highlands of Ontario. In fact, a trip in Algonquin National Park was a fashionable destination for American sports enthusiasts years before it became popular with Canadian vacationers.

Access for American and Canadian tourists alike was by train, either Booth's line in the south or the CNR, after 1915, in the north, and railways and guiding agencies began advertising the unspoiled wilds awaiting canoe trippers in Algonquin in the early 1900s.

Until the 1930s, most vacationers didn't dream of embarking on a canoe trip without an experienced guide. The hotels, outfitters, and guiding agencies were able to outfit parties with a full kit and experienced woodsmen. The guides portaged the supplies, cooked meals, and did the chores around camp, but they also had some fun with their charges.

One story, now said to be apocryphal, concerns a Canoe Lake guide who found himself with a particularly belligerent client. On a very rough day, the demanding businessman insisted that the guide take him across a large lake to fish. He explained the dangers, given the weather, but the surly customer persisted. The guide finally gave in, but, a few yards from shore, he let a large wave crash over the gunwales. Then, as the client pleaded with him to return to shore, the canoe "accidentally" tipped. After the panicking businessman had thrashed about a few minutes, the guide told him the water was shallow enough for him to stand up and walk ashore. "Naturally," recounted the guide, "he fired me, but I had him well broken in for the next guide."

I guided a lot and I liked it mighty fine. I worked out of a couple of hotels. I knew Nominigan Camp very well; I guided there for many summers. Mostly, though, I worked out of Colsons' Hotel Algonquin, over on Joe Lake, just across from the portage out of Canoe. The train would come in to Joe Lake Station with lots of tourists, and we'd go over and hire on for the week for guiding. The wives would stay at the hotel, and we'd have a good time.

Most of the tourists who hired us came from Toronto. A lot of 'em came back year after year, and there were plenty who were hard to work for. But I'd be glad when I'd get a letter from one of the good fellows, hiring me to take them to different lakes for a couple of weeks.

No, I was never married. I was having too good a time.
– Wam Stringer, Algonquin guide and Canoe Lake Resident

Briton Bernard Wicksteed recorded a canoe trip with his Indian guide in *Joe Lavally and the Paleface*, published in 1948. He had set off for Algonquin to capture the spirit of the romantic Canadian north woods that he remembered from stories he had read as a young boy in England, and Joe Lavally was the perfect guide. Lavally was full of animal lore and outrageous stories, and the distinction between the two was often unclear. He told, for instance, about a pike he once caught that was so large all he had to do was prop open its mouth for a make-shift lean-to. Joe explained that trout bit best in a west wind, because it blew the bait right into their mouths. And he was a fine camp cook; his tea "was good, black as pitch and scalding hot, with the aroma of wood smoke curling from the cup." Wicksteed raved about the paddling, the fishing, and the daily swim:

if any worldly cares lingered unsuspected in my system they were swept away in the plunge from the rocks. Off came the sweat and grime of a hot, hard day, away went that last defiling feel of civilisation – the taint that clothing leaves on flesh. The clean clear water of that northern lake, softened by rain and warmed by the summer sun, was like Nature herself taking an errant child to her all-forgiving bosom.

The British writer marvelled at the wildlife and his surroundings. The Algonquin trip was his schoolboy's dream come true.

Self-guided trips became the norm after the Second World War, and today roughly sixty to seventy thousand visitors strike off for the interior each year. The experience has changed some-

what. Whereas earlier visitors thought nothing of clearing a new campsite, canoe trippers today use designated sites, fire pits, and privies that have been prepared by the canoe rangers. The bed of boughs has disappeared in the interest of conservation; it is illegal to cut live trees in the park. The rotting remains of ranger huts and lumber camps have vanished, but an Algonquin canoe trip still occupies a place in the fond memories of a great many people.

Every year our family goes on a canoe trip to Algonquin. We spread the map out on the dining-room table weeks before we go. Everybody gets to pick what they'd like to do for one day of the trip, and we name that day after the person. It's neat to look over the trips we did before when we're planning; all of our routes are marked on the map and I can always remember the fun things that happened at each lake and campsite.
– Leslie, aged twelve, 1991

At the close of our holiday we return to our labours among our fellow-men, invigorated and strengthened, both in mind and body.
– James Dickson, *Camping in the Muskoka Region*, 1886

"You really don't have to be miles away from civilization to enjoy the canoe-tripping experience. You can have a great time just over the first portage and on to the next lake."
– Willy, canoe tripper

Guiding:

A Fine Summer Job for a Trapper:

Ralph Bice

Finding Ralph Bice's home in Kearney, just north of Huntsville, is easy. Any person in town can direct you to the home of the town's author, former mayor, famed outdoorsman, and cribbage champ. There are weathered canoes overturned outside, and the Magnetawan River flows quietly past from its headwaters in Algonquin. Ralph lives alone now on Poplar Point – the name comes from the trees that his late wife, Edna, planted there in 1948. "She wasn't as keen on the outdoors when she first came, but she got to be, and we enjoyed many outdoor trips with our family," he says proudly.

He settles into a generous armchair, beside the doorway into the room where he has written papers on trapping, articles for the local newspaper, and his books on trapping and the outdoors. The walls are crammed with honours and with plaques recognizing his contributions to Algonquin Park, to trappers' associations, to the town council, to educational groups, to the province. He chuckles as he recounts receiving the Order of Canada for his work in humane trapping. "I was sitting at the dinner beside Pierre Trudeau. 'You're a lucky man, Pierre,' I told him. 'There's only one old trapper here, and you got to sit next to him.'"

In fact, Ralph comes from a long line of trappers. "You see all of the men in my family used to do some trapping. I was born on March 2, 1900, and I like to say I remember it well." He keeps a straight face. "It was a dirty, blustery afternoon, and they sent me out to check the rabbit snares for supper." He also likes to say that his grandfather was the first poacher arrested after Algonquin was made a park in 1893. It's not as spectacular an event as it sounds, he admits. "He went to his camp early in the season in 1893, and he wasn't there more than two hours, when Dan Ross, the ranger, came along. Dan said, 'Isaac, you know this is a park now,' and he issued a warning and told Isaac to take his equipment away. Now we just brag that our grandfather was the first poacher in Algonquin Park."

As a young boy, Ralph remembered his father leaving the family farm to guide for the Hotel Algonquin for the princely sum of three dollars a day. "I was enthralled with the idea that you could go fishing every day and get paid for it," Ralph recalls. "I decided then that some day I was going to guide in Algonquin Park."

In 1917, he made good his word, and he guided for sixty summers following – first from the Hotel Algonquin, then from the Highland, and finally for his own business. He remembers fondly the old-time guides who shared their secrets: what was the best tackle, where to find lake trout, how to cook over an open fire, where to set up camp, and how to get along with different types of customers.

There was only one time when he admits being nervous in a canoe. "It was mid-September and we were windbound on Butt Lake." During a lull, his group decided to make a run for the far shore. "We started out," recalls Ralph, "and it looked good, but all of a sudden . . . you could see it coming. There was sleet, rain . . . and wind, and the lady sitting in the centre of my canoe got out the frying pan, and she had to bail water until we finally made shore."

He talks about the canoes outside his front door. "My favourite is the seventeen-foot Chestnut. I used it until I was about seventy-six. I think that I can say that I've carried a canoe more miles than anybody living today, and maybe I've paddled more miles, too."

There was never much money to spare at home, and sometimes Ralph wondered whether a regular job might make things more comfortable, but as he says in *Along the Trail with Ralph Bice*, "I got to thinking about all the fine people I have been associated with, those wonderful canoe trips where I enjoyed the trip as much as the people paying the bill. Having all the fresh air and freedom, I realize that I am one of the few who have done what they wanted to do." It's something he's shared with his family, too. Once, he guided an Algonquin trip with his son and his father, and, on another trip, he had two grandsons working with him.

Ralph's favourite season in the park is "just any day of the year I can be there." He's said more than once that anyone who's spent time there will likely be disappointed if they go to heaven, and he wrote, "there could be no place, absolutely no place that would be as soul satisfying and tranquillizing as the finest camping and fishing area that the Almighty ever created."

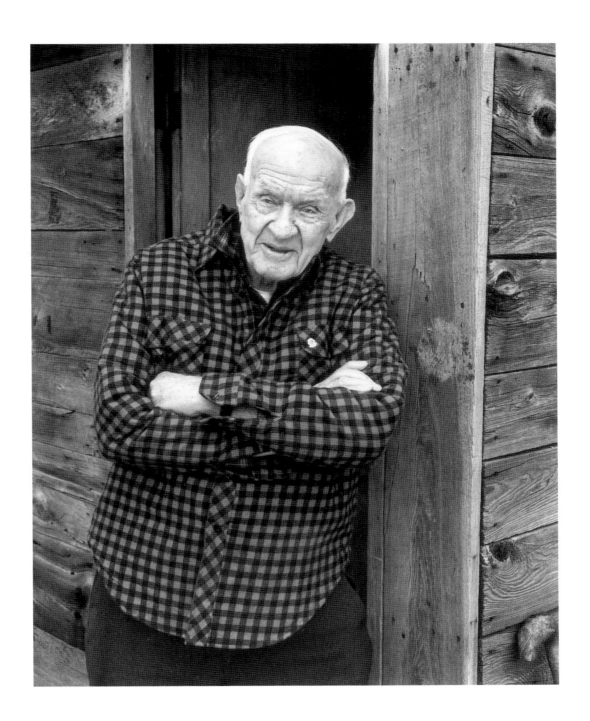

"Life in the city is so complicated and involved.
My tent has no expensive stereo system
or even a couch, and my pack provides the things I
seem to really need."

– Steven Blackwell, canoe tripper

*"I find when I come to Algonquin with my friends, it
is a place where we can be happy. There is always a
lot of laughter."*
– Mary, Wapomeo camper

Children in the Park

Thousands of people have been introduced to Algonquin through children's camping; Scouts, the YW and YMCA, churches, schools, associations for underprivileged young-sters, and boys' and girls' clubs have brought groups of young people to enjoy and learn from this special environment through camping and canoe trips. In addition, there are eight residential camps in the park, with permanent facilities that attract children from across Canada, the United States, Europe, Asia, South America, and the Middle East. Audrey Saunders in *Algonquin Story* summarizes the experience of so many of these young campers:

the Park provides opportunity for real adventures in the art of living. Stripped of the artificial amusements of the city, the camper learns to fall back on more permanent pleasures. He finds the joy that comes from the perform-ance of difficult physical feats, he learns how to make

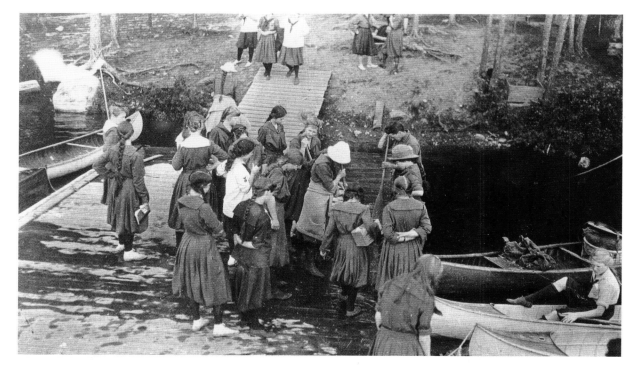

Northway campers prepare for a canoe trip. Northway Lodge for Girls on Cache Lake was started by Fannie Case in 1908.

himself warm and comfortable with the minimum equipment, he learns to be self-sufficient. At the same time, he comes to appreciate the wildlife which he discovers all about him. Birds, mammals, insects, flowers, trees, the sky above, and the rocks beneath, become real, tangible, and fascinating. The Park holiday experience in camp has provided many boys and girls with a background of friendship and interest that has been carried on through life.

Whether the children come on an agency-sponsored canoe trip, or are based at one of the residential camps, Algonquin provides them with the ideal surroundings in which to learn new skills, develop self-reliance, and acquire a sense of the wonder and excitement natural places instil. Most of the camps offer programs for children aged eight to sixteen, and campers stay for periods ranging from two weeks to two months.

Algonquin's oldest camp, and Canada's oldest camp for girls, is Northway, founded in 1908 by Fanny Case, a Rochester educator who was ahead of her time in believing that young women would benefit from healthy exercise in the outdoors. Northway's Cache Lake campsite remains simple; it has no electricity

or running water. As with all of the Algonquin camps, canoe trips play an important part in the program for the fifty or so campers. On the same Cache Lake shore is Wendigo, an affiliated camp, founded in 1965 as a canoe-tripping outpost for boys. Because so little time is spent in camp, campers must be slightly older to be accepted at Wendigo than at other camps; they range from twelve to sixteen years of age.

Other camps followed Northway. Camp Pathfinder for boys, on Source Lake, was founded in 1914 by two other Rochester teachers, and, in 1921, Taylor Statten, who was active in the YMCA camping movement, created Camp Ahmek for boys on Canoe Lake. It is now the oldest Canadian-owned and operated camp in Algonquin. A sister-camp, Wapomeo, was opened on an island three years later by Statten's wife, Ethel. Mary G. Hamilton established Camp Tanamakoon in 1925 to provide an active program for girls and a leadership training ground for young women studying Physical Education at the Margaret Eaton School in Toronto.

Lillian Kates, a feisty entrepreneur, purchased the site of the failing Camp of the Red Gods on Teepee Lake in 1934, and opened her Camp Arowhon during the Depression. The name came from Samuel Butler's utopian *Erewhon*, and the camp

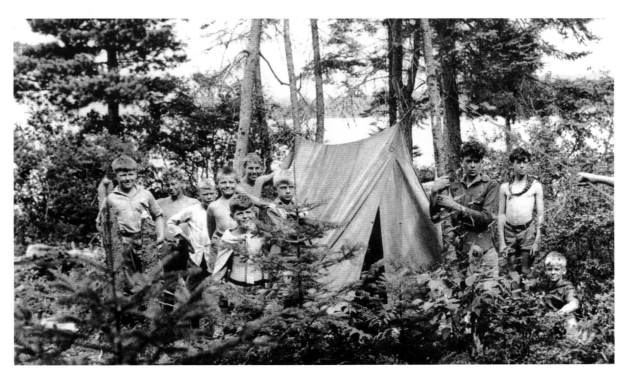

Pathfinder boys setting up camp while on a canoe trip. Camp Pathfinder for boys on Source Lake was founded in 1914.

introduced Canada's first large co-educational program. Camp Tamakwa on Tea Lake was founded in 1937 by Lou Handler, a former Arowhon counsellor from Michigan.

During the Second World War, when rangers were scarce, some of the children's camps helped out in the park. Many of the young people cleared portages and campsites, while older campers pitched in to help fight fires. When male staff went overseas, some of the boys''camps hired female counsellors for the youngest cabin groups.

Some camps were less successful and operated for only a few years: Camp Waubuno on Cache Lake, which operated briefly, beginning in 1908; Long Trail Camp on Joe, which ran around the time of the First World War; Ahmeek on Lady Joe, which ran from 1911 to 1922; Minnewawa at Lake of Two Rivers, from 1911 to 1930; and Algonquin Experience Youth Camp on Whitefish Lake, from 1974 to 1982.

Each of the surviving camps has its special traditions: Tanamakoon's trip songs, Northway's skilled "Voyageurs," The Taylor Statten Camps' Indian council rings. But they also share many of the same activities and philosophies. Archery, swimming, canoeing, and campcraft are available at all, while the larger camps offer riding, tennis, windsurfing, arts, drama, and sailing. However, canoe trips remain the focal point of each child's camp experience.

In addition to skills development, the camp staff try to encourage each camper to develop as an individual, at the same time as they foster a spirit of cooperation and leadership within each cabin group. The aim is a balance of self-sufficiency and team work. Individual creativity is stressed through drama, pottery, and arts and crafts. The more skilled or senior campers are encouraged to help novices during canoeing and sailing lessons. On a canoe trip, each child learns how important it is to work together – whether putting up a tent, gathering wood and making a fire, or unloading a canoe at the beginning of a portage. Most of all, these children grow up with an appreciation of a special wild place and of valued friendships.

It has been thirty years since I left camp, but my ties with the people I knew there are still strong. And when we get together in a group and we sing our favourite old camp songs and we recall those happy, laughing days, we know that we shared something special.

– Miki Spring, quoted in *A History of the Taylor Statten Camps,* unpublished thesis by D. A. Burry.

Seventy Years of Children's Camping:

Adele "Couchie" Ebbs

Four weathered wooden chairs sit on the dock, their bright colours bleached to soft pastels by warm summer sun. White pines shade the log cottage, and red squirrels leap from the nodding branches onto the roof. Inside, the kitchen wall is covered with coats and caps for all sorts of weather. In the living room, natural artifacts adorn windowsills and tables. In the corner rests a ceramic pot filled with tree branches, each holding a bird's nest, next to a stack of well-used bird books, wildlife magazines, and nature guides. Sunlight plays on paddle blades, each decorated with names or sunny pictures. There are a lot of other handcrafted treasures, too, all gifts from campers at The Taylor Statten Camps and from older Algonquin friends.

Couchie Ebbs first came to Canoe Lake at the age of four, in September 1913, when her parents, Taylor and Ethel Statten, brought her on a canoe trip. They decided to lease this small island north of Big Wapomeo Island for a summer home following that visit. Couchie hasn't missed a summer on "Little Wap" since then.

Her family has had a long association with children's camping. Her father was active in the YMCA camping movement, and he ran a "Y" camp for boys at Lake Couchiching for several summers, beginning in 1905. The campers and staff gave Couchie her nickname the year she was born. "They started to call me 'Couchie' [after Lake Couchiching]." After Couchie, the Stattens had two sons: Taylor "Tay," and Page.

In 1920, Taylor Statten directed a leadership-training camp at Canoe Lake. The next summer, "The Chief," as he was known because of his interest in native lore, opened Camp Ahmek, a private camp for boys at the northeast end of Canoe Lake.

When Couchie expressed interest in attending camp herself, her parents decided that they should start a girls' camp. Wapomeo opened in 1924 on Little Wapomeo Island; the family cottage became the camp lodge for the first few years, and the girls slept in tents. "My mother, Ethel – her Algonquin name was 'Tonakela' [which means 'you first'] – was an ardent outdoors person. Tonakela was head of Camp Wapomeo in title. She always had a program director who ran things day to day, but she made a lot of the decisions." Wapomeo subsequently expanded and was moved to two larger islands, a short paddle to the south. Thousands of young people have been introduced to Algonquin and camping through Ahmek, Wapomeo, and the other camps in the park.

"Algonquin Park has so much to offer. The children who are given the opportunity to spend time on a canoe trip in an environment like Algonquin will benefit greatly and never forget the experience. I think it's one that you can't get anywhere else. Teamwork is the key to a successful trip, and cooperation is necessary when you are living so close to each other for twenty-four hours a day."

The Chief shared his innovative ideas about programming and leadership training informally, and, along with the directors of five other Ontario camps, the Stattens were founding members of the Ontario Camping Association in 1930. In fact, the Chief was the association's first president, later becoming the first president of the Canadian Camping Association. In 1942, he was elected president of the American Camping Association, the only Canadian ever to hold that distinction.

The camp has remained a family-run affair. Couchie shared her love of camp and of Canoe Lake with her late husband, Dr. Harry Ebbs. He first came to camp as a counsellor-in-training at age sixteen, and theirs is one of the many camp romances that led to happy marriages. From 1931 to 1975, Couchie directed Camp Wapomeo; Harry was directly involved, as were their two daughters in later years. One of Couchie's brothers, "Dr. Tay," gradually took over the operation of Ahmek from the Chief during the early fifties, and the other, Dr. Page Statten, became involved as well, running a September Camp for families and camp alumni each fall. Today, Taylor "Tike" Statten III is director of The Taylor Statten Camps.

In 1989, to recognize the role of the Algonquin camps in enhancing appreciation of the park, The Friends of Algonquin Park honoured Couchie with their Directors Award for her contribution to the camping experience of so many people

Couchie believes that camp instils strong feelings of self-reliance. As always, though, she emphasizes the teamwork and companionship. She describes the

flurry of embraces, tears, and promises about next year at the end of each summer. "It's emotional to see them crying and hugging each other when it's time to leave their old and new friends, and their summer home." That magic feeling that summer camp casts is captured eloquently in an inscription carved into the mantelpiece above the fireplace of the Statten's first summer home at Little Wap: "Here let the Northwoods' spirit kindle fires of friendship."

left

*Camp Ahmek boys go for
an evening paddle
in one of the camp's
two war canoes.*

below

*Smoke Lake hockey on New Year's Day.
``I can't think of any place better to be than tucked
away in your cabin on a cold windy winter night,
with the woodstove crackling, listening to a hockey
game on the radio.''*
– Dave Standfield, Canoe Lake resident

Father and son catching sunfish on Lake of Two Rivers.

Water dancers at Joe Lake dam

Young cottagers enjoy the park in all seasons.

''It would have to be leeches. Everything else out there I can deal with, but leeches on a swampy portage make me cringe.'' – Lisa and Gillian

"When Moose drop their
antlers they must feel like
they could fly."
– Blythe, young cottager

The bay cabin at
Camp Ahmek
on Wigwam Bay.

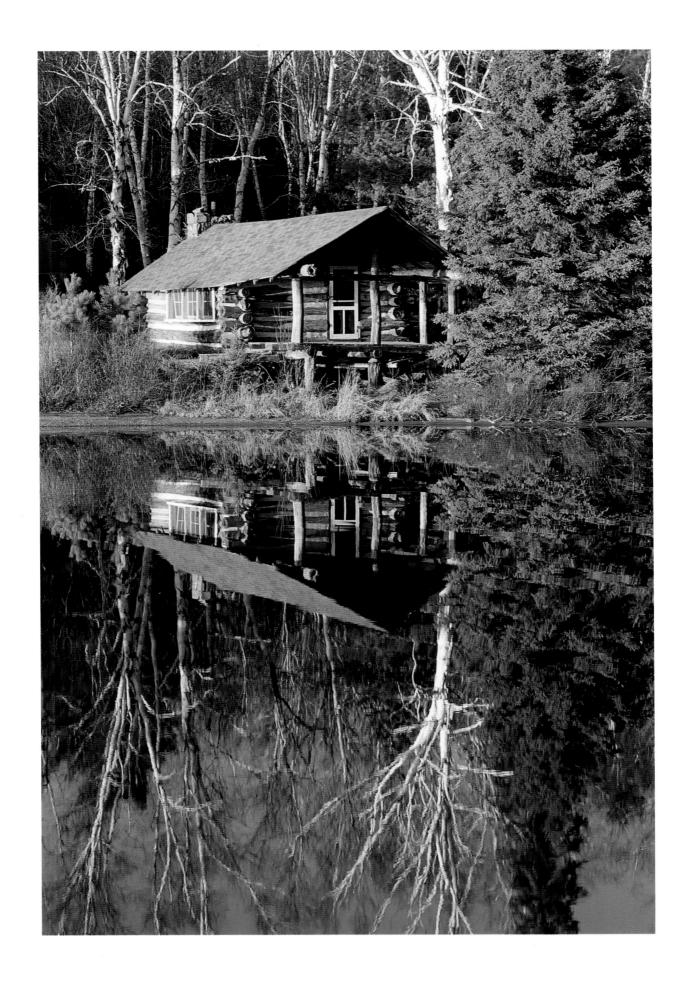

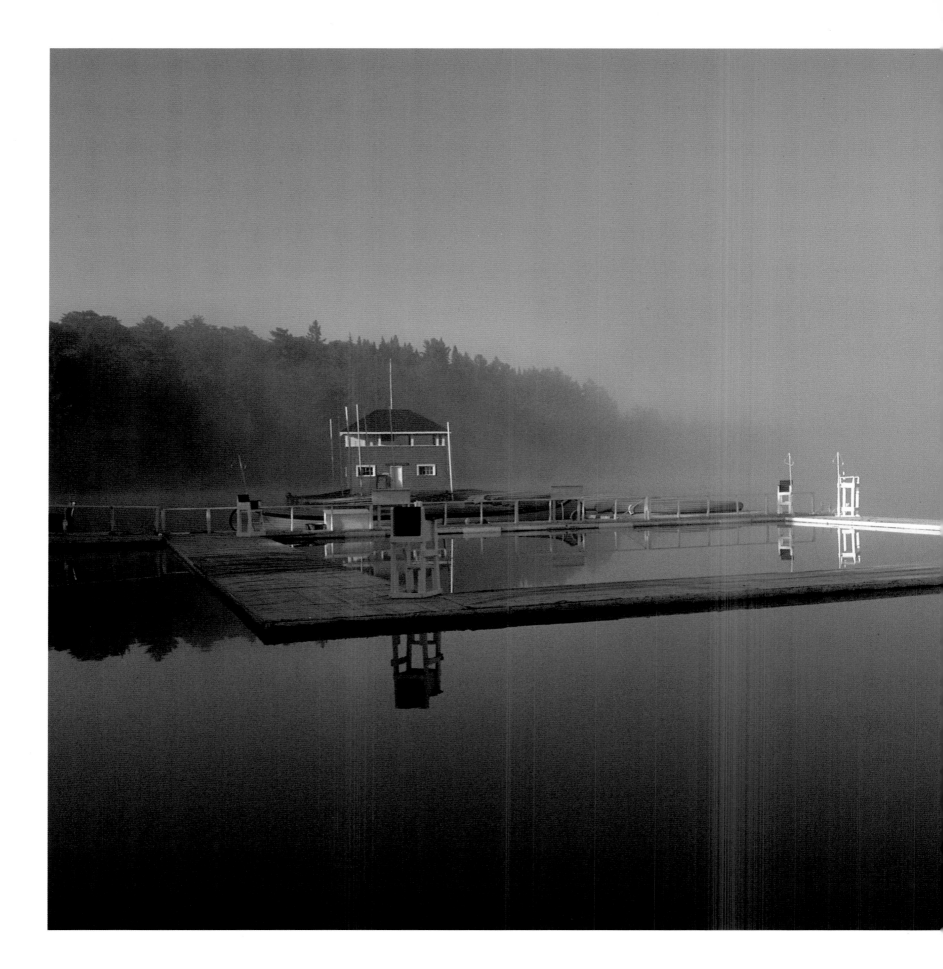

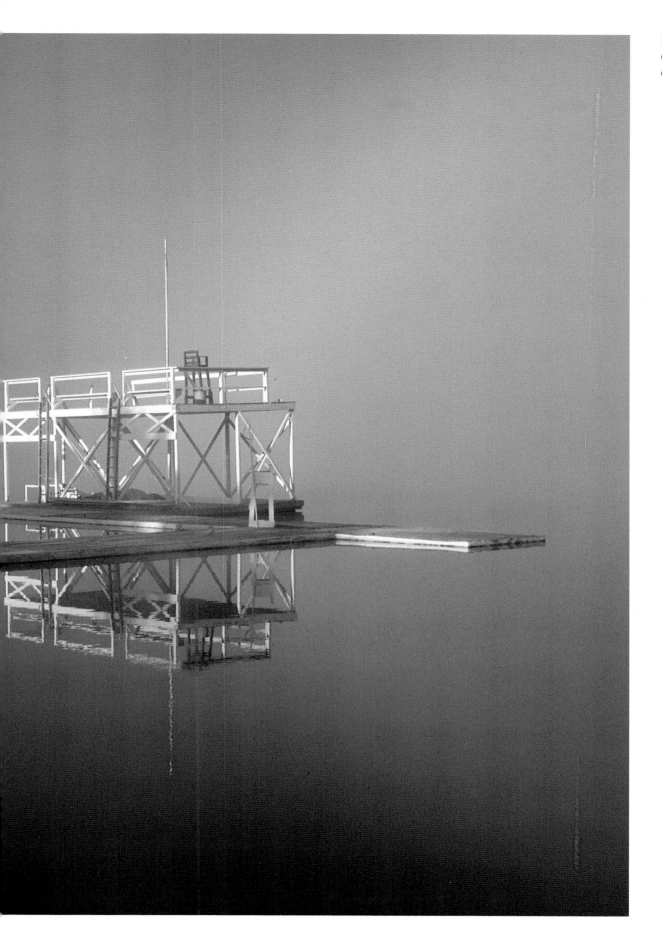

Early morning on
Camp Ahmek waterfront,
Canoe Lake.

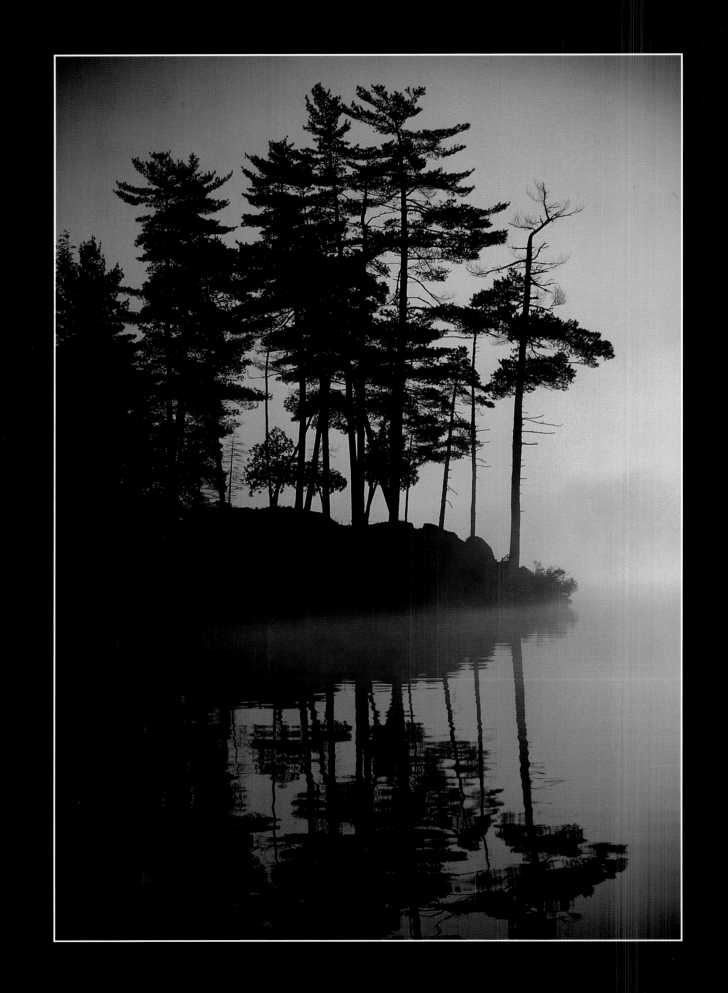

Algonquin Arts

Over the years, painters, photographers, film makers, and even composers have been inspired by the varied moods of Algonquin's forests and lakes. In fact, the park played a central role in the emergence of Canada's most significant art movement in the early part of this century.

The Toronto Arts Students' League, a sketching club that encouraged Canadian landscape painting, first organized trips to the park in 1902. Robert Holmes, W. W. Alexander, and David Thomson were among the earliest painters to take canoe trips through Algonquin. They were enchanted by its scenery, plants, wildlife, and fast water, and they returned to Toronto describing Algonquin as excellent painting country. Tom McLean followed, along with his friend painter J. William Beatty, and through this pioneering group, an influential band of Toronto painters was introduced to the park.

Tom Thomson

Without question, the title of "Algonquin's artist" must belong to Tom Thomson. Thomson was born in Claremont, Ontario, in 1877, but he was raised on a farm in Leith, near Owen Sound. After trying a few jobs, including a short stint with a Seattle photo-engraving firm, Thomson found himself in Toronto, where he began working for engraving houses in 1905.

Around 1909, a number of artists who were to form the Group of Seven were employed at Grip Limited, a Toronto illustration and design firm. Here Tom Thomson met Beatty, Franklin Carmichael, Ben Jackson, Frank Johnston, Arthur Lismer, J. E. H. MacDonald, McLean, and Frederick H. Varley. In their free time, this circle set aside their commercial work and took to Ontario's countryside to pursue landscape painting.

Thomson first ventured to Algonquin with Ben Jackson in 1912. Like the other painters of this movement, Tom painted what he saw, depicting the rugged scenes in all their haunting beauty. His view of the north woods was unlike the sombre, dark canvasses of earlier European landscapes; the brilliant colours of Canada's untamed wilds leapt from his paintings. Without formal training, he developed his own style, taking his inspiration from the country he loved and gradually incorporating some of his companions' suggestions.

From sketches he did during his first Algonquin summer, Thomson completed *A Northern Lake* in 1913. Purchased by the Ontario government, it was his first commercially successful painting, and he was encouraged by art patron Dr. James MacCallum to abandon design work and devote himself entirely to painting. The next summer, Thomson established a pattern that he was to follow until his death in 1917: painting in the early spring at Canoe Lake, guiding or ranging during the summer, sketching again in the fall, and then developing full-sized canvases from the previous summer's work in a Toronto studio during the winter. His summer base was Shannon Fraser's Mowat Lodge.

Thomson persuaded many of his Toronto associates to join him in Algonquin. A. Y. Jackson, Lismer, Varley, Harris, and MacDonald were all infected by Tom's enthusiasm for the park's scenery and, as R. P. Little wrote in "Some Recollections of Tom Thomson and Canoe Lake" in the June 1955 issue of *Culture*, "[by 1914] the woods seemed full of artists." Thomson's work had an inestimable influence on this circle of painters; collectively, they became known as the "Algonquin Park School."

Tragically, Thomson died before the Group of Seven's first

Tom Thomson tying a fly.

exhibit – the occasion on which its formation was recognized – in 1920. He was last seen setting out on a fishing trip from Mowat on July 8, 1917. A week later, his body was found floating near Wapomeo Island by Dr. G. W. Howland. The district coroner was delayed, and because the body was badly decomposed, Dr. Howland performed the autopsy. Mark Robinson, Chief Park Ranger, was present. He noted a bruise on the left temple, and fishing line wrapped many times around Thomson's leg. Although there was no water in the lungs, the cause of death was attributed to accidental drowning.

The body was buried hastily at the little plot behind Mowat. Mystery still surrounds Thomson's death and his eventual resting site. Questions persisted as to how such an experienced outdoorsman could have drowned. Two nights after the burial, an undertaker arrived to exhume the body and transport it to the Leith cemetery. Shannon Fraser, who drove the undertaker to the grave site, maintained that the casket he subsequently loaded on the train was not heavy enough to hold a body. In 1956, a skeleton was discovered in the Canoe Lake grave site. Some clues suggested it might have been Thomson, but a forensic investigation concluded that it was the body of an Indian. Rumours of a love affair with Mowat cottager, Winifred Trainor; an angry encounter between Tom and Martin Bletcher, Jr., the night before his disappearance; ideas that the bruise and fishing line indicate murder and cover-up – all are part of the speculation that still survives in Canoe Lake circles. There are even some who say his ghost haunts Canoe Lake. But it is not for his death that Thomson is most significant. As his friend and patron Dr. MacCallum wrote, his paintings are "a complete encyclopedia of all the glories of Algonquin Park."

> To the memory of Tom Thomson, Artist, Woodsman, and Guide
> who was drowned in Canoe Lake, July 8, 1917
> He lived humbly but passionately with the wild. It made him brother to all untamed things of nature. It drew him apart and revealed itself wonderfully to him. It sent him out from the woods only to show these revelations through his art and it took him to itself at last.

– inscription written by J. E. H. MacDonald for the Tom Thomson memorial cairn at Canoe Lake

The Group of Seven and Others

Most of the members of the original Group of Seven – Carmichael, Lawren Harris, Jackson, Johnston, Lismer, MacDonald, and Varley – painted in the park at some point. Jackson's *Frozen Lake*, *A Winter's Day*, and *The Red Maple* were painted from sketches he made in Algonquin in 1914. Lismer's *Guides' Home, Algonquin*, and MacDonald's *Moonlight, Algonquin Park* are other works in which the park influence is obvious. A. J. Casson, who became a member of the Group in 1926, also sketched in the park. In 1987, he accepted the Friends of Algonquin Park Directors Award on behalf of the Group of Seven for their enormous contribution to Canadian art and their stirring studies of the Algonquin landscape. Park lakes have been named after MacDonald, Harris, Lismer, Varley, and Tom Thomson to recognize the unique relationship between Algonquin and this influential group of artists.

The park continued to inspire visual artists after the Group of Seven disbanded in 1933. Among later artists to depict Algonquin scenes were Thoreau MacDonald and Robert Bateman, and the park still moves artists – both amateur and professional – today.

Canoe Lake Cemetery, Mowat.

*Early morning on
Smoke Lake.*

Managing the Resource

No other park in Ontario is comparable to Algonquin for its diversity of uses. The 1893 Act stipulated that the park be "reserved and set apart as a public park and forest reservation, fish and game preserve, health resort and pleasure ground for the benefit, advantage and enjoyment of the people of the Province." Contradictory roles were inherent: public playground vs. forest reserve, industry vs. preservation, wildlife protection vs. sport and recreation.

A park may not be all things to all people, but in 1966 work was begun to formulate a multiple-use mandate for Algonquin that would meet as many needs of its varied users as possible. After a series of public hearings, a blueprint was drafted, and in 1974, the twenty-year Master Plan, complete with provisions for regular reviews, was released.

Ontario parks fall into one of six classes: wilderness parks, waterway parks, recreation parks, natural-environment parks,

historical parks, or nature reserves. The Master Plan designated Algonquin as a natural-environment park. Each designation determines different uses; "Natural Environment Parks provide a variety of low-intensity recreational opportunities within an environment of educational, recreational and scientific significance."

To accommodate the variety of activities, the park has been divided into management zones, each with its own purposes and permissable types of use. These zones fall into five categories, and they range in degree of wilderness preservation from development zones (the only areas where organized campgrounds and high-intensity activities are permitted – for example, the Highway 60 corridor) to wilderness zones, which presently comprise 9 per cent of the park's area. An additional east-side wilderness zone is currently under consideration. Some 75 per cent of the park falls within a recreation/utilization classification, which allows for low-intensity recreation and timber harvesting. Algonquin and Lake Superior are the only two Ontario parks with this type of zone, although logging was put on hold in Lake Superior in 1989 when a master-plan review, that is still under way, was begun. In Algonquin, preserving a high-quality recreational experience for some six hundred thousand visitors annually is still the first priority of administrators.

Historic zones protect sites such as camboose camps, depot farms, old ranger cabins, and other historic structures. Seventy nature-reserve zones protect ecosystems within the park in an attempt to preserve its biological diversity. The first pine reserves were established in 1940, and hardwood forest, wetlands, hemlock stands, and areas of natural disturbance (including fires and blow-downs) are just some of the habitats currently protected in nature-reserve zones.

The Issues

Recreational visitors seem to fall into two groups, each with its own requirements; interior users seek an undeveloped wilderness experience, while corridor visitors enjoy the self-guided interpretive trails, campgrounds, and lodges adjacent to Highway 60. The challenge is to enhance services to both groups in the face of budgetary cutbacks.

Major Master Plan reviews occurred in 1979 and 1989, and other problems have been addressed through the review process. Crowded lakes, especially during peak season, led to a quota system for interior access in 1976. Each park access point was given a limit, which set the maximum number of parties that could be allowed to start out each day on busy weekends and during the summer. Canoeists who wish to go into the interior may now write or phone to reserve access and to obtain an Interior Camping Permit. A second improvement was the ban on cans and bottles in the interior, instituted in 1978, which has reduced litter.

One of the most recent controversies involves hunting and trapping. Licensed trapping has been permitted in the eastern section of Algonquin since 1958. Hunting and trapping have also been allowed in the two southern townships – Clyde and Bruton – since they were added to the park in 1961.

Current developments concern the native people of the Golden Lake First Nation, southeast of Algonquin. In 1991, the Ontario government began negotiations with the band regarding their claim to thirty-six-thousand square kilometres on the Ontario side of the Ottawa River. Most of the park is included in that claim.

By October of 1991, an interim agreement had been drafted regarding the band's hunting and trapping rights in the claim area. The Golden Lake band is able to hunt in the eastern half of the park between October 15 and January 15. Species that may be taken have been determined, and annual bag limits set: one hundred moose and one hundred and seventy-five deer per year. The arrangement will be reviewed each year as long as the land-claim negotiations continue, but various lobby groups have registered their disappointment at the expansion of hunting and trapping activities in the park.

Others argue that Algonquin does an admirable job of balancing all of these needs, but they wonder whether it can survive as an island, surrounded by increasing development. The area may already be too small to preserve some mammal populations, such as the fisher, which hunts over territories up to one hundred kilometres long and fifteen kilometres wide. The feasibility of buffer zones, limiting development in areas surrounding the park, is under investigation.

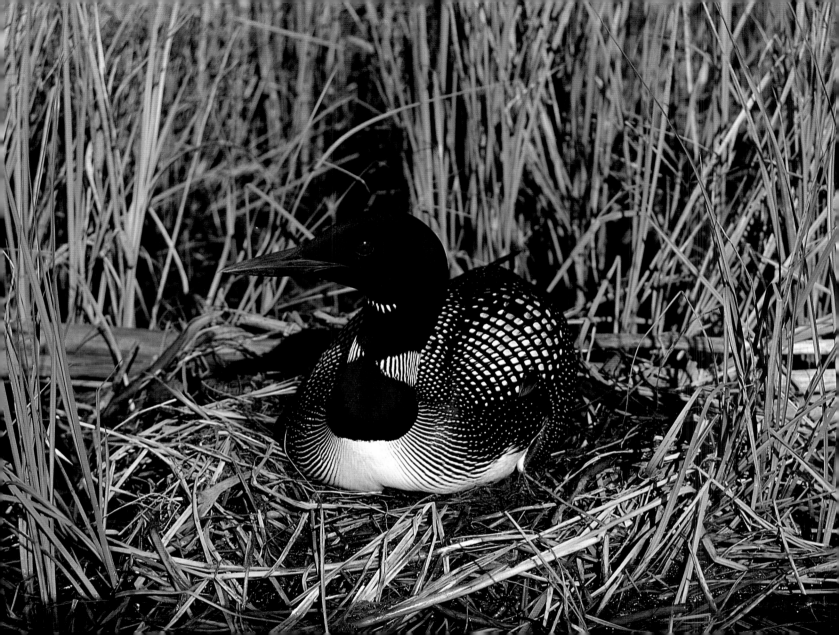

Research and Nature Interpretation

Since the early 1900s, Algonquin has provided an outdoor laboratory for research into botany, ecology, fish, mammals, birds, and other wildlife. Biologists working for government agencies, students and faculty from universities, and scientists from other public institutions have carried out studies within the park that have had national and international significance. Over one thousand scientific papers have been published based on research conducted there, "making Algonquin the most important single area in Canada for biological research," wrote superintendent Ernie Martelle in a 1991 park publication.

The first area of scientific study was forestry; a group from the University of Toronto set up a field camp at Burntroot Lake in 1908 to study logging and silvicultural practices. Between 1924 and 1935, a more permanent research base was established at Achray, where scientists worked out of Ontario Forestry Branch

buildings. In 1950 the Timber Management Research Station was established at Swan Lake on the west side of the park, and research continues today. Areas of investigation in more recent years include forest regeneration, effects of fire control on species distribution, maple die-back, and the effects of disease and insects on forests.

Fisheries research had its genesis in concerns that there would be overfishing once the highway improved access to many interior lakes. Under the direction of Dr. W. J. K. Harkness, a research lab was established at Lake Opeongo in 1936, and the facility was named the Harkness Laboratory of Fisheries Research in his honour in 1961. Studies have directly affected the regulation of fishing in Algonquin. Early investigations indicated that Algonquin lakes are relatively unproductive as compared to warmer, more nutrient-rich lakes to the south. To protect fish stocks, ice fishing was banned beginning in 1954, fishing limits have been changed, use of live bait-fish is prohibited, and fishing seasons have been adjusted. More recent studies have considered the growth rates and the reproduction of lake and brook trout, and the effects of water quality, acid precipitation, and fluctuations in water levels on aquatic biology and fish reproduction.

Wildlife management has undergone a shift over the last hundred years. At the turn of the century, there was greater concern about maintaining sport species than in preserving the natural order. In the early years, administrators recommended killing loons and gulls to protect fish stocks. Bartlett's rangers were encouraged to destroy as many wolves as possible under the mistaken impression that this would lead to an increase in the deer population. Since that time, scientists have illustrated the importance of predators in maintaining equilibrium within ecosystems like Algonquin. If, however, systems become unbalanced, so that an abundance of prey starts to dwindle, the decline can be speeded up by controlling factors such as wolf predation.

In 1944, the Algonquin Wildlife Research Station was established at Lake Sasajewan. Over the years, scientists based at the station and in the field have investigated subjects including: parasitology; marten ecology; the behaviour and nesting habits of various bird species; and interrelationships among larger mammals.

One of the subjects of long-term studies has been the wolf.

Between 1958 and 1965, an intensive wolf-research program was undertaken by a team of scientists including the late Douglas H. Pimlott for the Department of Lands and Forests [now the Ontario Ministry of Natural Resources]. The Algonquin researchers applied totally new techniques to the study, and their findings were instrumental in debunking many myths about the wolf.

Highly social animals, wolves howl to communicate with each other. The scientists found that Algonquin wolves would answer to taped calls, and, in time, it was discovered that the animals responded just as well to human imitations of wolf howls. The technique was used to conduct censuses and to locate dens with a degree of accuracy that had been unimaginable up until that time.

The wolf-research team examined distribution, breeding and eating habits, and the wolves' impact on the species on which they prey. Along with studies that ran from 1970 to 1975 and from 1986 to 1992, the research made it clear that, rather than causing the decline of deer in the park, wolves play an important part in maintaining the health of herds. The findings also led to the cancellation of the wolf bounty in 1972. Today, according to University of Waterloo professor John Theberge, there are somewhere between 200 and 240 wolves (after the pups are born in spring and before winter fatalities) in the park, giving Algonquin one of the highest wolf densities in North America.

Another significant area of wildlife study is the relationship among white-tailed deer populations, their habitat, the climate, and competing species. The white-tailed deer is actually a southern species, and it was very rare in Algonquin before the early logging days, when deep snow and widely scattered food made survival difficult. During the 1800s, logging and fires removed many original mature trees, and low, shrubby plants – ideal food for deer – sprang up. Because of the abundant food supply, the deer were able to survive the severe winters and thrive in Algonquin. Prior to 1960, visitors used to see a lot of deer, usually browsing on young plants next to the highway or in clearings around the campgrounds and hotels, but during the sixties and seventies, the deer declined, while moose numbers rose. It has become clear that there are complex interrelationships between the numbers of deer and moose, the severity of winters, and the effects of fire control and logging.

One of the factors that limits the number of deer is forest

cover. Hemlock and other coniferous trees provide winter shelter. When large numbers of conifers were logged during the forties and fifties, the number of suitable winter deer yards were reduced. Logging and forest regeneration have also had a major impact in a second area. The harvesting of deciduous trees helps deer by promoting the new growth on which they feed, but present forest management encourages the rapid growth of young trees, which quickly puts the tender buds beyond the reach of browsing deer. In addition the fire towers and the air patrol, which began during the thirties, drastically reduced the size of fires; the maturing forests offered less low-growing vegetation. Finally, harsh winters from 1958 to 1960 and during the seventies caused major deer die-offs.

It was widely known for many years that where there were large numbers of deer, moose were rare. During the early sixties, research carried out in the park by the Ontario Research Foundation eventually provided the answer to the inverse relationship between the two populations. Dr. Roy C. Anderson discovered that white-tailed deer carry a parasite (*Parelaphostrongylus tenuis*) that does not harm them. However, when moose ingest this nematode worm, it fatally attacks the brain and spinal cord. In "How the Moose Came to Algonquin" (*Alces*, 1987), District Wildlife Biologist Mike Wilton explains the increase in moose:

> Since it appears that the prevalence of *P. tenuis* in moose is directly related to deer density, then it is probable that the decline in the Algonquin Park deer population which took place between 1959 and 1974 reduced the incidence of *P. tenuis* to the point where the moose population could expand toward its present level.

The deer declined because the forests were maturing, providing less food for them; therefore, the moose were less likely to become infected with the parasite, and numbers increased.

However, the winter tick is placing further stress on the moose population. Ed Addison's winter tick research project in the early eighties highlighted the speed with which the tick could have a major effect on the population of moose. Says Wilton:

> Right now there is a tremendous upswing in the tick pop-

ulation. We know that some of our animals are suffering, and it looks as if we may get a major die-off in the spring of 1992. [The moose try to rub off the ticks, causing hair loss during late winter when temperatures still plummet.] So what we will probably see is a decline in the moose population.

The relationship between deer and moose is still in flux, but because of research conducted in the park, much of it done with the aid of radio-collaring and tracking, more informed predictions about animal populations and effects of habitat change can be made. As Wilton points out,

> The past research in the park, such as the wolf-research program, were landmark studies. It was fascinating stuff because it was on the cutting edge at that time, but things have progressed with the research that Dale Garner is doing on the moose and Graham Forbes is conducting on the wolf now. They are not just going out and gathering anecdotal information the way it was done thirty years ago. They are doing genetic fingerprinting and sophisticated radio tracking, and then they are plugging this information into dynamic models and working with computers. With this kind of information at our fingertips, maybe we will be able to predict what will happen in the future with wildlife with a greater degree of accuracy.

Interpretation

Interpretation in Algonquin began in 1942 when Smoke Lake cottager J. R. Dymond started leading informal nature walks. Organized hikes were initiated in 1944, and lectures on various aspects of biology, soil, and fire control followed. Nature trails were the next development. As the number of programs grew, the need for a nature centre became apparent, and in 1953, a park museum with stuffed mammals and birds, fish tanks, and other displays was opened at Found Lake. Since that time, park naturalists have expanded the range of activities to include children's programs, evening films, and slide shows.

One of the most popular programs over the years has been the public wolf howls. They began in 1963, and, on the first

171

evening, over six hundred visitors turned out. The howls are still conducted much as they were in the sixties. After a short presentation, the group heads out in a stream of cars that can stretch for ten kilometres, and the thousand or so participants drive to a spot where naturalists elicited a response from wolves the evening before. The staff will howl, and haunting, wavering cries come back over the still night air. Wolves have been heard on over 60 per cent of the outings and, to date, over 70,000 people have participated in the program.

As Dan Strickland, Chief Park Naturalist explains:

The wolf howls are immensely popular because there is that prospect that people will have their own personal experience with an almost mythical, elusive wilderness carnivore that they only dream about. It starts off with a talk, a slide show, and then we all go out. There is a sort of bonding that goes on out there in the dark, with everyone hoping they will hear the wolves.

They usually aren't disappointed. Those who have heard it agree that the eerie chorus is profoundly moving, and that it is a stirring symbol of the wild character of Algonquin.

Naturalists are also available to answer questions and to correct misconceptions about the balance of species in the park. Ron Tozer, Park Naturalist, outlines the role of the interpretive staff in explaining the broad concepts of how ecological systems work.

Our job is to increase understanding and awareness of the park, its human and natural history, so that people's experience here will be enhanced. People are so urbanized now, they don't have an ecologically-based view of the world. We think that if they become sufficiently excited about the resources that are available to them, they'll want to preserve them.

The staff point out how important habitat protection is. They provide the facts on both sides of many wildlife and environmental issues, and then they encourage visitors to make their own decisions. Services include a weekly park newsletter, *The Raven*, that delves into research about the interrelationships among animals, habitat, and human action. In addition, staff produce a large number of publications, including booklets for fourteen self-guiding interpretive trails spread throughout the park, all of which emphasize various aspects of ecology or human history.

As Dan Strickland summarizes,

I think all of these programs in Algonquin Park are a very useful way of entertaining visitors and providing environmental education. Interpretation provides a very important link between the basically urban existence of most of our visitors and this part of our natural and cultural heritage. Through education comes appreciation.

The Visitor Centre

Opened in 1993, the new visitor centre on Sunday Creek has been designed to work as a springboard to the visitor's own experiences in the park. Says Strickland:

> An interpretive visitor centre should introduce people to the landscape to which it pertains. The exhibits should do their best, but they're just an introduction. The real thing is outside. From the visitor centre's viewing deck, you are able to see 180 degrees of wild landscape, representing four of the five major habitats of the park, and you can see what a rugged environment it must have been for the first people who pushed their way into it. We are really trying to invite people to go out and explore the park on their own.

In addition to the visitor centre, there is a newly constructed logging museum, complete with an alligator, a recreated camboose camp, and a working log chute.

The Friends of Algonquin Park

Founded in 1983, The Friends of Algonquin Park is a charitable organization that has two main goals: to assist with interpretive and educational programs and to produce publications about the park. In addition to operating two bookstores and a mail-order service that distributes a wide variety of materials about the park, the Friends commission and print trail guides, canoe maps, and lengthier works on the flora and fauna of Algonquin. Most of the nearly two thousand members are from Canada, but there are others from thirty American states and from France, Germany, England, and Switzerland. Revenues from the various publications are used to develop new products and facilities, and to hire additional summer interpretive staff.

In a related initiative, each year the organization presents their Directors Award to people who have made a significant contribution to the appreciation of Algonquin Park. Past recipients were Ottelyn Addison, author of *Early Days in Algonquin Park* and *Tom Thomson: The Algonquin Years*; Dr. Roy C. Ander-

son, noted for his Algonquin research into parasitology, particularly moose brainworm; Ralph Bice; A. J. Casson; Aubrey Dunne, long-time Algonquin ranger and former District Forester; Adele "Couchie" Ebbs; Dr. J. Bruce Falls, in recognition of his ornithological research in Algonquin; Jim Fraser, brook-trout and splake researcher; Dr. Alan Gordon, for his research into Algonquin's forests; Dr. Edmund Kase, Jr.; Nigel V. "Nick" Martin, world-renowned lake-trout authority and former director of the Harkness Laboratory of Fisheries Research; Audrey Saunders Miller, author of *The Algonquin Story* and a pioneer in the use of oral history; Omer Stringer; and Pierre Elliott Trudeau, in recognition of his canoe tripping and work in wilderness preservation.

Established at Lake Travers in 1960, the National Research Council's radio telescope provided information about continental drift, the earth's magnetic field, radio waves in distant galaxies, and star formation.

How to Catch Big Fish, and Where Loons Go in Winter:

Thoughts from David Christine, Matthew, and Other Young Visitors

David, aged seven, has been coming to Algonquin since he was two months old. His yellow raincoat flaps as he makes the big step from the dock onto the boat seat, juggling a tackle box, fishing rod, and a slightly sticky juice box. The gentle drizzle has him excited; he knows that fish bite best in this type of weather. "The more you fish in Canoe Lake, the better the chances are that you will catch one of the big ones," he explains with a wide smile. "We use worms; you can catch lots of fish in the park with just a little worm. I try right off the dock, or we go along the shoreline looking for bass and maybe even a lake trout. I guess the biggest fish I ever caught was a bass down at Ghost Walk Creek. I usually let them go, but when my brother catches them, he eats them for breakfast.

"My grandpa's dad came here to Algonquin Park a long time ago. I think it was because of the fish and the loons, and he liked to paddle canoes, too. I have three sisters and a brother, and we all like it here. We have beavers, turtles, fish, moose, and sometimes a bear will come around. One time, we saw a loon come up right beside our boat with a fish in its beak, and then it swallowed it.

"One thing I would really like to do is take a long canoe trip through the park. There must be hundreds of fish out in the other lakes that would be easy to catch, because not many people would know where to look for them. The older you get, the better you will be as a fisherman. Some of the old guys on this lake – you know, some are even older than my dad – can catch a fish almost every night. I hope they leave enough so there will be lots of fish in the lakes to catch when I grow up. I don't think those old guys could catch all the fish, but you never know."

Jeff, a six-year-old camper at Kearney Lake, has some advice: "The woods are really dark in the night time, but you can always see the animals because their eyes light up when you shine the flashlight at them. It's sometimes scary when you're in the tent and you hear them outside eating your crumbs, but they will never come in if you keep the zipper closed on the doorway."

Christine, aged ten, went to a public wolf howl with her family while they were staying at Lake of Two Rivers campground. "We didn't hear anything there, but when we were driving back to the campsite, my dad started to howl, and my brother said he was turning into a werewolf. All that night, I kept waking up and making sure that my dad was still in his sleeping bag and snoring away."

When nine-year-old Karen arrived back at the Canoe Lake Portage Store, she was dying to tell someone about her family's canoe trip. "We stayed overnight on an island, and the next morning we found out that our canoe had floated away. We had to wait for someone to paddle by and help us look for it. My sisters and I were kind of scared, but my mom just kept laughing at my dad, and my dad kept trying to blame it on my mom."

Some of the children are budding naturalists, like five-year-old David, whose eyes grew wider as he pressed his nose up against the glass of the fish tank at the park museum. "Every time we come here and camp after the wintertime, the animals at the campground still know us," he asserts. "I know because I have been feeding the same chipmunk every summer, and he likes the same food as last year. When I grow up, I'm going to live here and work with the bears and the moose and feed the chipmunks my lunch."

At Kearney Lake, Matthew, also five, shared his own theory. "I think the loons from the lakes here turn into penguins when the wintertime comes."

Some children see that Algonquin appeals to each member of their family for a different reason. Ten-year-old Rebecca puzzles, "Every time we come here, my dad is lucky to catch one fish, but when we get back to the city, he always tells the neighbours what great fishing we had in Algonquin."

Says Billy at the Lake of Two Rivers campground, "My dad likes it here, 'cause he can sit and relax. My mom likes it because she can walk through the woods and look at the little plants. My two sisters like to go swimming and cook the meals over the fire. I like it here 'cause I can buy pop and french fries at the store."

At the Beaver Pond Trail, nine-year-old Roger let others in on a secret. "My mom and dad are always relaxed when we are here, but you can tell when it's almost time to go back to the city because my dad starts to get crabby."

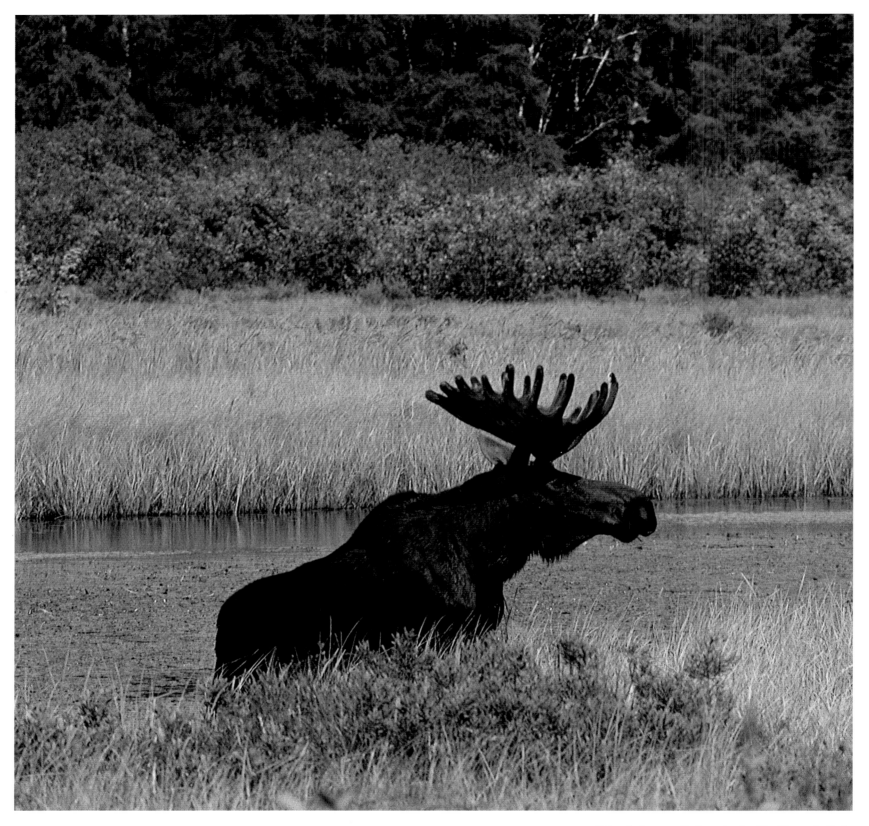

Prime bull moose, the largest animal in Algonquin Park.

Dale Garner, moose research biologist. Radio collars for tracking are placed on newborn calves to help determine specific mortality causes.

On a misty morning in the late fall, a bull moose has just finished rubbing around its eyes and the base of its antlers (where glands that secrete pheramones are located) on a small tree. This is believed to be for marking and scent communication.

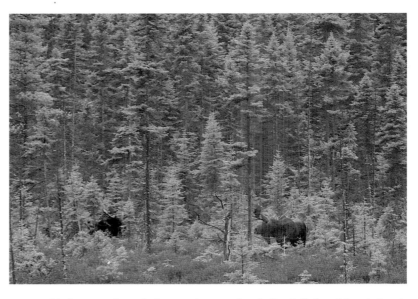

A second bull emerges from the forest and approaches the first bull, but although there is eye contact, neither shows aggression.

Two bulls of equal size standing this close together at this time of year may indicate that both have finished the rut. They are no threat to each other, and therefore no confrontation takes place.

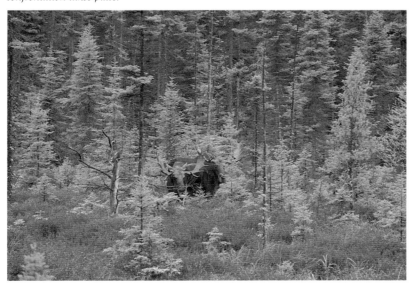

The tree has become a "scent post," and after the first bull has finished and leaves, the second bull begins to rub around its eyes and antlers on the same tree. His scent will communicate with the next bull (or cow) that walks through this particular bog.

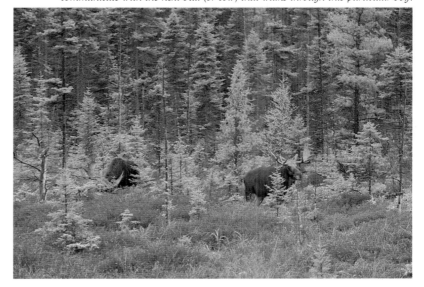

An old bull moose in early winter gives back to the forest and its animals.

The tracks in the snow are evidence that several wolves have been scavenging on this carcass. The small size of Algonquin wolves makes it difficult for them to actually kill an adult moose, so scavenging may be important for their survival.

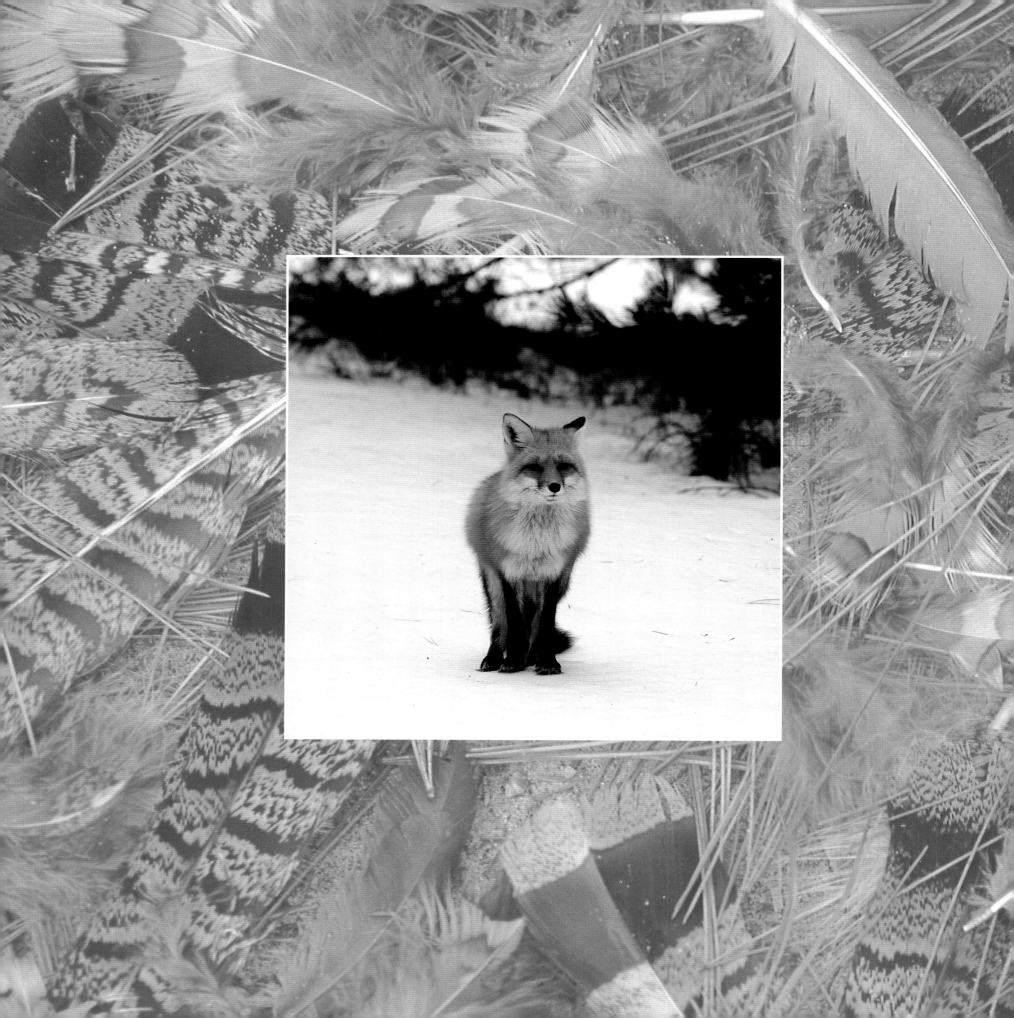

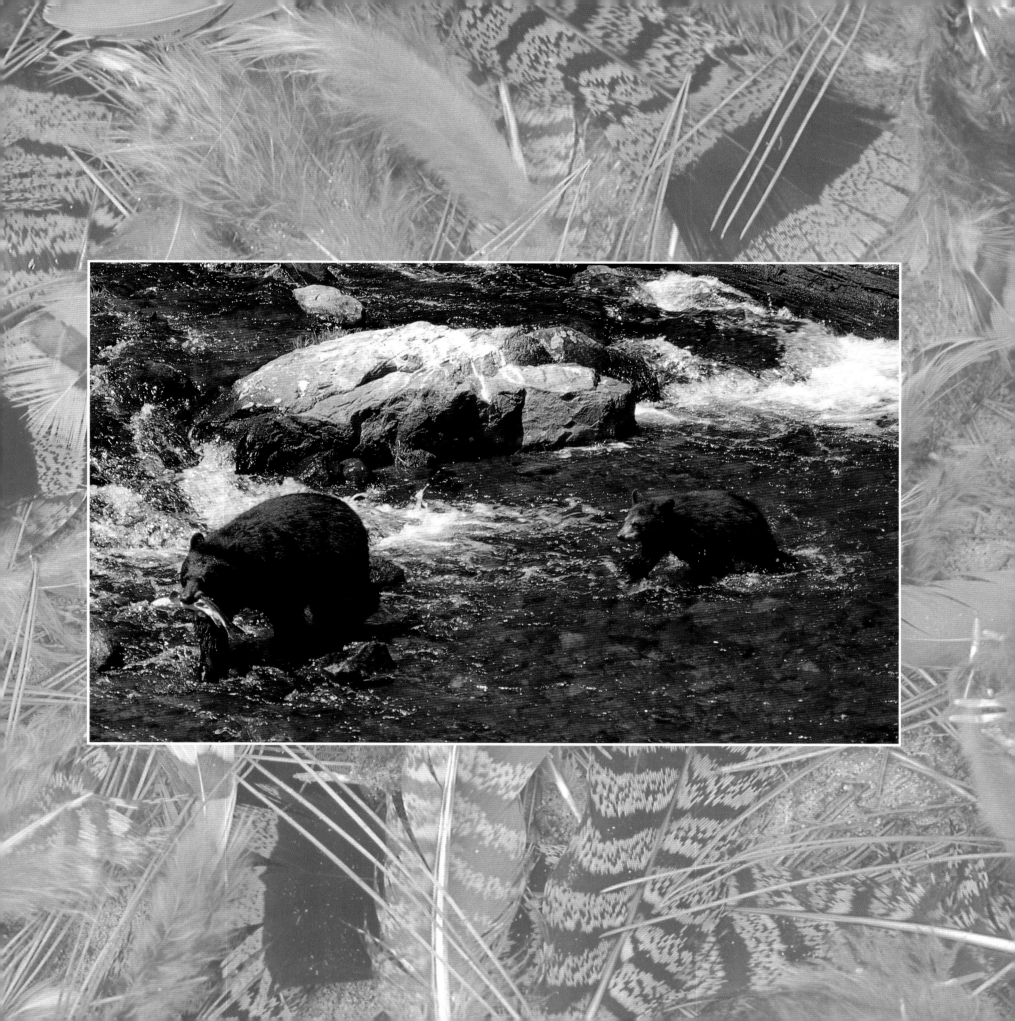

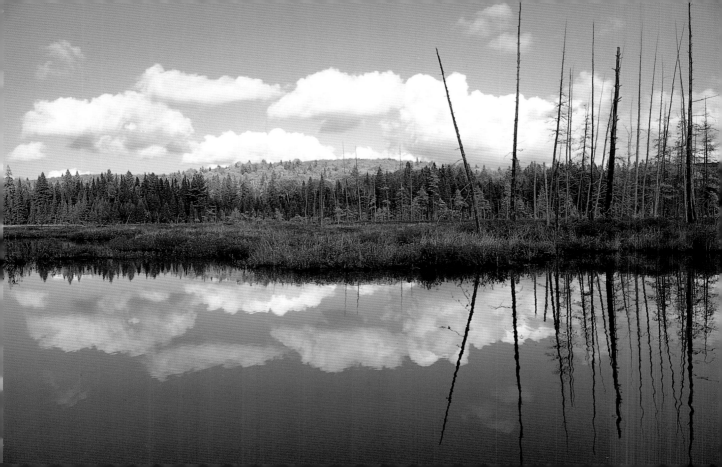

The Next Hundred Years

"The Commissioner of Crown Lands who establishes Algonkin Forest and Park raises a monument that will not crumble nor decay, and his memory will be cherished in the warmest corner of many hearts."

– Alexander Kirkwood, *Algonkin, Forest and Park, Ontario*, 1886

Alexander Kirkwood saw the lasting value in preserving the Algonquin landscape from settlement. In his words, "it is in wandering through such scenes that the mind drinks deep but quiet draughts of inspiration and becomes intensely sensible of the beauty and majesty of nature." We owe much to Kirkwood and to the people of his era who helped set aside this natural refuge for the enjoyment of later generations.

What is their achievement? Certainly, the park preserves a mosaic of stunning natural images. Algonquin is the loon's mournful strain at sunset. It is the inviting smell of wood smoke reaching out from an island campsite. It is morning mist dissolving in a golden haze to expose a quiet lake. It is that hush in the forest when aspen leaves grow still just before a summer storm; the first trilliums poking up through dried maple leaves; stars blazing in a summer sky; geese honking overhead as they head south; and northern lights shimmering above a frozen landscape. Season after season, the park offers scenes of subtle beauty.

Over the years, Algonquin has supported many uses: logging, research, cottaging, fishing, and hunting. It has also drawn recreational users from across this continent, from Europe, and even from Asia. They came to savour the park's world-renowned landscapes, and their increasing numbers also placed demands on the park. Yet, for all the pressures, many aspects of the Algonquin experience remain constant. In *Along the Trail*, Ralph Bice describes the enduring qualities:

> The Park has changed so, but then so has everything else. There are so few of us left who can recall the days during the First War. Naturally we would prefer things as they were in the olden days, but we would be a very small minority. . . . Then there are times I get to wondering what Dickson and Kirkwood would say if they saw the way their pet project was going. . . . But while the highway is busy, some of the lakes crowded, and the fishing far from what we remember, there are still many places where you can feel you are back in the woods. The loons and other birds sound just as nice, the breezes just the same, and the woods and waters still give one that contented, peaceful feeling.

George Garland, Smoke Lake cottager and Algonquin author, sums up the eternal qualities of the place as well:

> Algonquin has seen the canoes of Indians who hunted and camped on its shores. It has seen the present-day trippers cross its portages and leave garbage at one end and it has seen other present-day trippers cross its portages and pick up the garbage. Algonquin has laughed as we try to protect ourselves from its rainstorms, and has rewarded us with bright sunshine as we pass its unexpected tests.

Algonquin provides a sense of timelessness, a link to the landscape and the people of its past. Some of the campsites on sandy beaches and rocky points have been used for hundreds of years. Today's portages follow routes that the first native

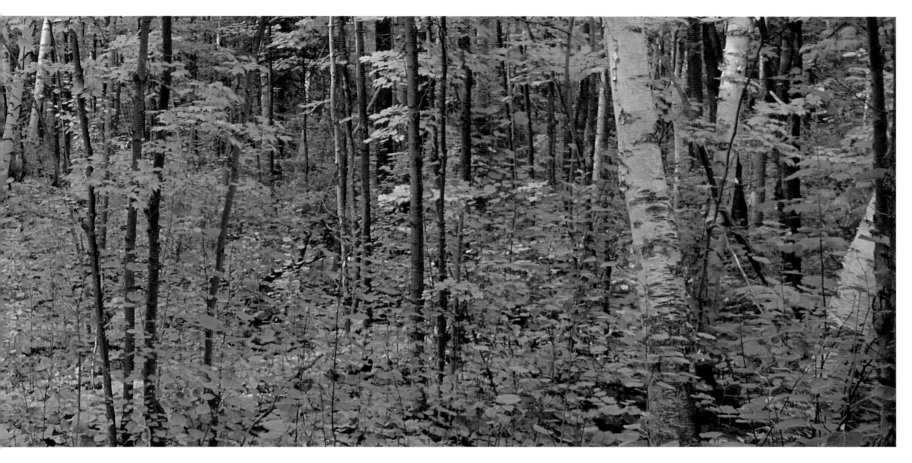

people used. When one paddles a winding river, with spruce emerging on either bank from a shifting fog, the imagination is propelled back through the mists of time. There is a sense of wild expanse and continuity with the past that appeals to urban dwellers seeking an antidote to the city's constant constraints of time and space.

Another of Algonquin's enduring joys is the element of companionship, of sharing experiences with family and friends. It may have followed a miserable day's paddle in the rain, but the friendly joking over a hot drink around the campfire becomes the lasting memory. The deserted lake at the end of a long, hot portage is doubly enjoyed because of the companions to help recall it in later years, and for so many who have known Algonquin well, its people have become an important element of the place. Algonquin has had a lasting influence on them; their personalities have become part of the park's unique character.

"It's such a simple, beautiful life out in the woods and away from the city."
– Heather Stowe, canoe tripper

It is hard to predict what changes the next hundred years will bring to the park. Algonquin does not exist as an island, and it, too, falls prey to pressures that arise outside its boundaries. Given the number of changes that have occurred over the centuries, more are likely to follow. Two things are certain, though. Visitors today still enjoy the natural legacy that the park's creators bequeathed one hundred years ago, and, as difficult as it is to foretell the park's future, it is clear that the lives of many people would be quite different had they not been touched by Algonquin's wild spirit.

Spider webs in young larch,
early morning

*Fall colours against sheer
cliff, Rock Lake.*

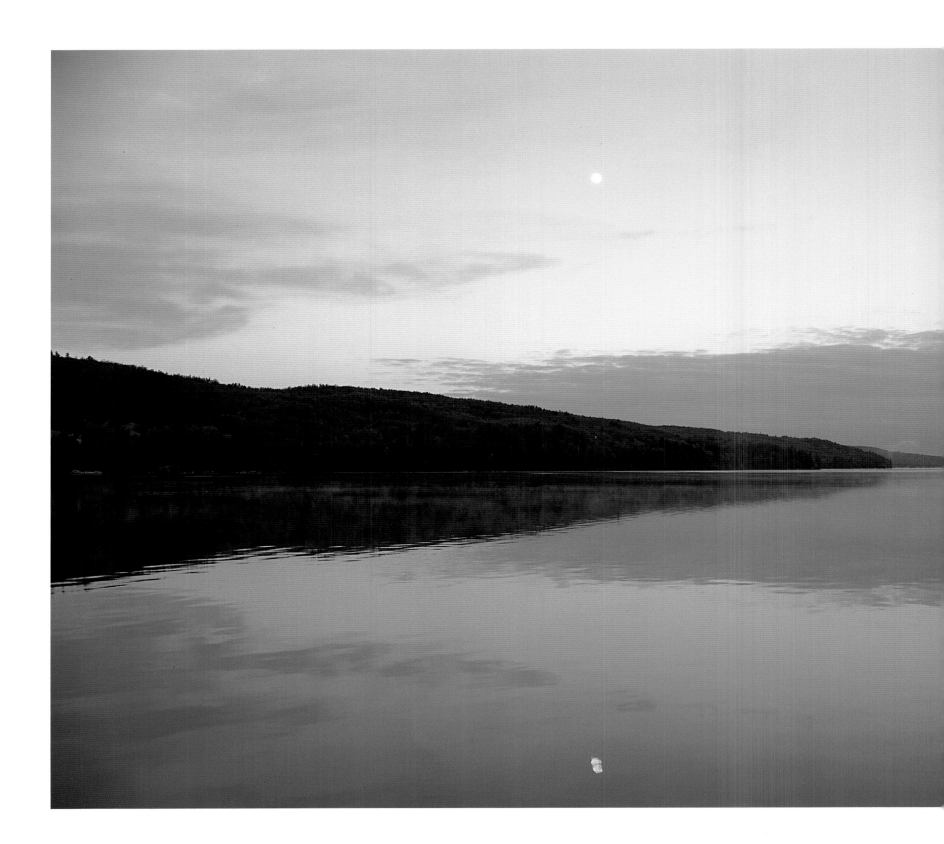

Grand Lake, early morning, with smoke coming from a distant campsite.

"The feeling is good and bad when you're out tripping in the off season and you haven't seen anybody all day, only to spot a campfire at the other end of the lake."
— Gord Carl

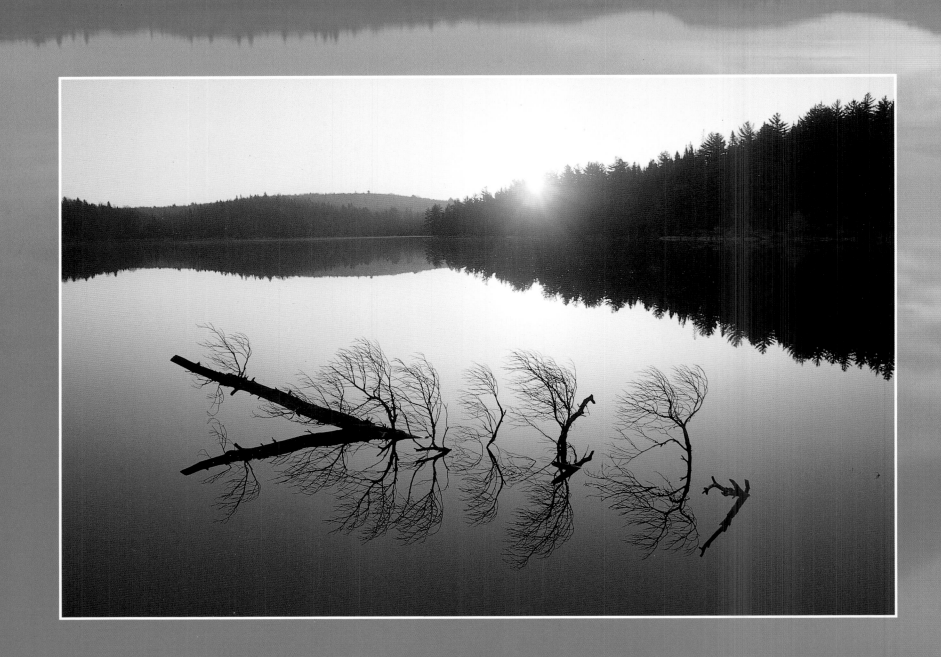

Sources

Books

Adams, Joseph. *Ten Thousand Miles Through Canada*. Toronto: McClelland and Goodchild, 1912.

Addison, Ottelyn. *Early Days in Algonquin Park*. Toronto: McGraw-Hill-Ryerson, 1974.

_____, and Elizabeth Harwood. *Tom Thompson: The Algonquin Years*. Toronto: Ryerson Press, 1969.

Avery, Sidney. "Outdoor Life in Muskoka Bushland." *Heritage Muskoka*. Parry Sound: Algonquin Library System, 1975.

Bice, Ralph. *Along the Trail with Ralph Bice*. Scarborough: Natural Heritage/Natural History Inc., 1980.

Brown, Ron. *Ghost Towns of Ontario*. Langley, B.C.: Stagecoach Publishing, 1983.

Cummings, H. R. *Early Days in Haliburton*. Ontario Department of Lands and Forests, 1962. Reprinted 1963.

Dickson, James. *Camping in the Muskoka Region: A Story about Algonquin Park*. Ontario Department of Lands and Forests, 1959. First printed in 1886.

Dickson, Lovat. *Wilderness Man*. Toronto: Macmillan, 1973.

Fowke, Edith. *Lumbering Songs from the Northern Woods*. Toronto: NC Press, 1985.

_____, and Alan Mills. *Singing our History: Canada's Story in Song*. Toronto: Doubleday, 1984.

Gage, Sandy R. *A Few Rustic Huts: Ranger Cabins and Logging Camp Buildings of Algonquin Park*. Oakville: Mosaic Press, 1985.

Glimpses of Algonquin: Thirty Personal Impressions from Earliest Times to the Present. Compiled by G. D. Garland. Whitney, Ontario: The Friends of Algonquin Park, 1989.

Grey Owl. *Tales of an Empty Cabin*. Toronto: Macmillan, 1936.

Hamilton, Mary G. *The Call of Algonquin: A Biography of a Summer Camp*. Toronto: Ryerson Press, 1958.

Harper, J. Russell. *Painting in Canada: A History*. Toronto: University of Toronto Press, 1966.

Hessell, Peter. *The Algonkin Tribe: The Algonkins of the Ottawa Valley*. Arnprior: Kichesippi, 1987.

Hughson, John W., and Courtney C. J. Bond. *Hurling Down the Pine*. Old Chelsea, Quebec: The Historical Society of the Gatineau, 1964.

Jenness, Diamond. *Indians of Canada*. Toronto: University of Toronto Press, 1977.

Kates, Joanne. *Exploring Algonquin Park*. Toronto: Douglas and MacIntyre, 1983.

Kennedy, Clyde C. *The Upper Ottawa Valley*. Pembroke: Renfrew County Council, 1970.

MacKay, Niall. *Over the Hills to Georgian Bay*. Erin, Ontario: The Boston Mills Press, 1981.

Mason, Bill. *Path of the Paddle: An Illustrated Guide to the Art of Canoeing*. Toronto: Van Nostrand Reinhold, 1980.

Miller, Jeff. *Rambling through Algonquin Park: Paintings, Sketches, Thoughts by Jeff Miller*. Huntsville, Ontario: A Limberlost Studio Publication, 1990.

Miller, Richard. *A Cool Curving World*. Toronto: Longmans, 1962.

Moore, W. F. *Indian Place Names in Ontario*. Toronto: Macmillan, 1930.

Murray, Florence B. *Muskoka and Haliburton, 1615-1875*. Toronto: The Champlain Society and University of Toronto Press, 1963.

Murray, Joan. *The Art of Tom Thomson*. Toronto: Art Gallery of Ontario, 1971.

Olson, Sigurd F. *Reflections from the North Country*. New York: Alfred A. Knopf, 1980.

Reid, Dennis. *A Concise History of Canadian Painting*. Second Edition. Toronto: Oxford University Press, 1988.

Reynolds, William, and Ted VanDyke. *Algonquin*. Toronto: Oxford University Press, 1983.

Roberts, Kenneth G., and Philip Shackleton. *The Canoe*. Toronto: Macmillan, 1983.

Robins, John D. *The Incomplete Anglers*. Toronto: Collins, 1943.

Saunders, Audrey. *Algonquin Story*. Ontario Department of Lands and Forests, 1963.

Speck, F. G. *Myths and Folk-lore of the Timiskaming Algonquin and Timagami Ojibwa*. Ottawa: Department of Mines, Geological Survey, 1915.

Town, Harold, and David P. Silcox. *Tom Thomson: The Silence and the Storm*. Toronto: McClelland & Stewart, 1982.

Whitton, Charlotte. *A Hundred Years A-Fellin'*. Ottawa: Printed for Gillies Brothers Company, 1943.

Wicksteed, Bernard. *Joe Lavally and the Paleface*. Toronto: Collins, 1948.

Wright, James Vallière. *Ontario Prehistory*. National Museum of Man: National Museum of Canada, 1972.

Reports and Miscellaneous Written Material

Algonquin Forestry Authority. *Annual Report, 1988-89*. Huntsville, Ontario.

Algonquin Park: A Place for People. Algonquin Park Leaseholders' Association, 1969.

Artifact Catalogue: Algonquin Park. Algonquin Park Museum.

Avery, Sidney. "Outdoor Life in Muskoka Bushland" *Heritage Muskoka*. Parry Sound: Algonquin Library System, 1975.

Bignell, Jan and Bob. *Pringrove: The Later Years*. Private printing, 1988.

Boultbee, R., A. P. Leslie, and J. B. Matthews. *Report on Operations of the Canoe Lake Lumber Company*. Undergraduate paper for the Faculty of Forestry, University of Toronto, 1928.

Brown, William J. *Forest Management for the Algonquin Park Management Unit for the Period April 1, 1980, to March 31, 2000*. Huntsville: Algonquin Forestry Authority, 1980.

Brunton, D. F. *The Algonquin Provincial Park Natural Zone System: Final Summary*. 1975.

Burry, Donald Alexander. *A History of the Taylor Statten Camps*. University of Saskatchewan, unpublished Master's thesis, 1985.

Case, Fanny L. *Her Own Story of Northway Lodge*, and *A Tribute to Her Memory* by Joyce Plumptre Tyrrell. Private printing. New York.

Economic Impact Study of Algonquin Provincial Park, prepared for Department of Lands and Forests by Kaplan Consulting Associates. Montreal: November, 1969.

The Friends of Algonquin Park. Members' Newsletters. Nos. 2-7, 1986-1991.

Hueston, T. W. Algonquin Park History. Unpublished notes, Algonquin Park Task Force, 1967.

Hurley, W. M., I. T. Kenyon, F. W. Lange, and B.M. Mitchell. *Algonquin Park Archaeology 1971*. Toronto: Department of Anthropology, University of Toronto, 1972.

Kase, Edmund H., Jr. *Pringrove Through the Years*. Private printing, 1975.

_____. *Jack Gervais, Ranger and Friend*. Private printing, 1970.

Nightingale, Thomas. *The Diary of Thomas Nightingale, Farmer and Miner, 1867-1871*, pp. 70-74. Published by his descendant Malcolm Wallbridge. Picton: *Picton Gazette*, 1967.

Northway, Mary L. *Nominigan: A Casual History*. Toronto: Private printing, 1969.

_____. *Nominigan: The Early Years*. Toronto: Private printing, 1970.

Ontario. *Report of the Commission on Forest Reservation and National Park*. Toronto: Warwick and Sons, 1893.

Ontario. Department of Crown Lands. *Reports on the Algonquin National Park for the Year 1893*. Toronto: Warwick, 1894.

Ontario. Department of Lands and Forests. *Algonquin Park Background Papers*, 1968.

_____. *Algonquin Provincial Park Provisional Master Plan*. 1968.

_____. *Summary of Briefs: Public Hearings on the Provisional Master Plan*. 1969.

Ontario. Ministry of Natural Resources. *Algonquin Park Master Plan*. 1974.

_____. *Algonquin Provincial Park: The Park Interior*. Interior Users' Information tabloid, 1991.

_____. *Algonquin Park Master Plan First Five-Year Review*. 1979.

_____. *Ontario Provincial Park Statistics*. 1988, 1989.

_____. *The Raven*. Park News, Algonquin. Vol. 26, No. 10; Vol. 30, No. 10; Vol. 31, Nos. 4 and 5.

Theberge, John, and Mary Theberge. *Wolves and Wolf Research in Algonquin Park*. Waterloo, Ontario: Faculty of Environmental Studies, University of Waterloo, June 1990.

Tozer, Ron. *Historical Resources in Algonquin Provincial Park, Background Paper*, 1973. (Algonquin Park Museum)

Wilton, Mike L., and Dale L. Garner. "Preliminary Findings Regarding Elevation as a Factor in Moose Calving Site Selection in South Central Ontario." Scientific report, 18 March, 1991.

Wyatt, D. *A History of the Origins and Development of Algonquin Park*. Algonquin Park Task Force. Unpublished background paper, 1971.

Archival Material

Unless otherwise noted, all archival material is from the Algonquin Park Archives. Numbers are cited where used.

An Act To Establish the Algonquin National Park of Ontario. 1893. 56 Victoria – Cap. 8.

Bartlett, G. W. *Algonquin National Park*. The Report of the Crown Lands Department, Appendix 22. Mowat: 13 January, 1902. (#4085)

_____. Superintendent's Reports – Algonquin Park. Ontario Sessional Papers. 1902.

Kirkwood, Alexander. *Algonkin, Forest and Park, Ontario*. Published letter to the Honourable T. B. Pardee. Toronto: Warwick, 1886. (University of Toronto Archives, cap. RBSC 1-2.)

Ontario. Department of Lands and Forests. *Algonquin Park Background Papers*. 1968.

Tayler, G. E. *Indians of Algonquin Park at the Time of Contact, 1600 A.D.* Undated manuscript.

Thomson, Peter. *Reports on the Algonquin National Park for the Year 1893*. Chief Ranger Thomson's report. Sessional Papers, No. 22. (Algonquin Park Archives #1159)

Waters, Stephen. Diary entries for 1893-94, 1895, 1897, 1908, and 1911.

Articles

"Algonquin Park and the Golden Lake Band." Editorial. *Seasons*, Vol. 31, No. 2 (Summer 1991): 46.

"Algonquin Park: Ontario's Great Game Preserve." *Rod and Gun in Canada*, Vol. 1, (October 1899): 90.

Bartlett, G. W. "A Winter's Trip through the Algonquin National Park." *Rod and Gun in Canada*, Vol. 11 (1911): 502-507.

Brickenden, Jack. "Ghost Town Country." *Canadian Living*, Vol. 13, No. 4 (1988): 013-016

Buchanan, Donald W. "Tom Thomson, Painter of the True North." *Canadian Geographical Journal*, Vol. 33, No. 2 (August 1946): 98-100.

Cundiff, Brad. "Bargaining Away Algonquin." *Seasons*, Vol. 32, No. 1 (Spring 1992): 16-19, 34.

Fuchs, Terry. "Brent, Ontario: Isolation Can Be Alluring, but Also Reveals Neuroses." *The Kingston Whig-Standard*, 5 October 1989: 7.

Henderson, Bob. "Serendipity in Algonquin Park." *Paddler*, Vol. 3, No. 2 (Fall 1988): 28, 38.

Jones, Donald. "Many Felt Algonquin Park Should be Named Hardy Park." *Toronto Star*, 30 September 1989: M4.

Kemsley, William, Sr. "Elder of the Tribe: Tom Thomson." *Backpacker*, Oct./Nov. 1979: 56-61.

Kidd, Kenneth. "A Prehistoric Camp Site at Rock Lake, Algonquin Park, Ontario." *Journal of Southwestern Anthropology*, Vol. 1, No. 1. (Spring 1948): 98-106.

Lee-Whiting, B. "The Alligator." *Canadian Geographical Journal*, Vol. 76, No. 1 (January 1968): 30-33.

_____. "Auction Sale at a Stopping Place." *Canadian Collector*, Vol. 16, No. 2 (March-April 1981): 61-64.

_____. "The Opeongo Road: An Early Colonization Scheme." *Canadian Geographical Journal*, Vol. 74, No. 3 (March 1967): 76-83.

_____. "The Pointer Boat." *Canadian Geographical Journal*, Vol. 80, No. 2 (February 1970): 46-51.

Little, Dr. R. P. "Some Recollections of Tom Thomson and Canoe Lake." *Culture*, Vol. 16, (June 1955): 200-208.

MacDougall, Frank A. "A History of Algonquin Park." *Timber of Canada*, Vol. 1, No. 9 (May 1941): 29-34.

Noble, William C. "'Vision Pits,' Cairns and Petroglyphs at Rock Lake, Algonquin Provincial Park, Ontario." *Ontario Archaeology*, Vol. 11 (1968): 47-64.

Platiel, Rudy. "Death of Algonquin Park Hamlet Only Postponed." *Globe and Mail*, 6 February 1979: 8.

Roberts, Lloyd. "Algonquin Calling." *Canadian Geographical Journal*, Vol. 15, No. 1 (July 1937): 34-39.

Robinson, Mark. "On Wolves." *Forest and Outdoors*, June 1934: 539-40.

_____. "Wildlife in Algonquin Park." *Forest and Outdoors*, October, 1933: 263-264.

Stefaniuk, Walter. "Cutbacks Close Vital Algonquin Telescope." *Toronto Star*, 2 November 1986: A1.

Strickland, Dan. "Wolf Howling in Parks: The Algonquin Experience in Interpretation." In *Wolves in Canada and Alaska: Their Status, Biology, and Management*. Edited by Ludwig N. Carbyn. Proceedings of the Wolf Symposium held in Edmonton, Alberta, 12-14 May, 1981: 93-95.

Taylor, Robert J. "Logging in the Valley, 75 Years Ago." *Your Forests* (Ministry of Natural Resources), Vol. 8, No. 3 (Winter 1975): 8-12.

Thomson, Stuart L. "A Spring Holiday in Algonquin." *Canadian Geographical Journal*, Vol. 12, No. 4 (April 1936): 175-82.

Todd, Irene. "The Land of White Magic." *National Life*, December, 1923: 29-30.

Truman, Ron. "Not Intruders, Part of History of the Park, Couple Say." *Globe and Mail*, 8 August 1980: 35.

Wilton, M. L. "How the Moose Came to Algonquin." *Alces*, Volume 23, 1987.

Interviews

Addison, Ottelyn. June 28, 1991.

Anderson, Lesleigh. January 1, 1992.

Beamish, Chuck. March 22, 1992.

Bice, Ralph. March 19, 1990.

Borrowman, Jack. March 12, 1992.

Campbell, George. October 5, 1991.

Carl, Gord. January 1, 1992.

Choglan, Jimmy. November 15, 1992.

Clare, Mary Colson. February 13, 1992.

Dunne, Jim. January 15, 1992

Eady, Art. July 12, 1991.

Ebbs, Adele "Couchie." February 12, 1992.

English, Sam. March 20, 1990.

Gamble, Rob and Lela. August 5, 1991.

Garland, George. February 4, 1992.

Garner, Dale. January 17, 1992.

Gibson, Dan. August 12, 1992.

Gibson, Leonard "Gibby" and Lulu. March 21, 1992.

Graham, K.M. (Kate). August 12, 1991.
Gray, Jane. August 5, 1991.
Kase, Edmund H., Jr. September 3, 1989.
Laurier, Hank. February 1, 1992.
Leckie, Linda. January 1, 1992.
Miller, Jeff. March 6, 1992.
Montgomery, Ernie. January 20, 1992.
Pigeon, Jake. August 10, 1991.
Pigeon, Mary and Lorne. December 15, 1991.
Pitts, Adam. August 10, 1991.
Quinby, Peter. February 13, 1990.
Schmanda, Jerry. January 1, 1992.
Standfield, David. January 1, 1992.
Statten, Dr. Taylor "Tay." July 12, 1991.
Strickland, Dan. February 20, 1992.
Stringer, David. August 26, 1991.
Stringer, Wilmar "Wam." March 19, 1990.
Taylor, Mike. August 14, 1991.
Townsend, E. R. March 21, 1990.
Tozer, Pat. Telephone interview. 9 April 1992.
Tozer, Ron. February 20, 1992.
Voldock, Felix. January 27, 1992.
Wilton, Mike. April 13, 1992.
Wingfield, Kevin. July 23, 1991.

Algonquin Park Publications

(Published by The Friends of Algonquin Park in cooperation with the Ontario Ministry of Natural Resources.)

"Barron Canyon Trail: History of the Canyon." Guide for Barron Canyon Trail. Text by Dan Strickland, drawings by Howard Coneybeare. Whitney, Ontario, 1989.

"A Chronology of Algonquin Provincial Park." By Rory MacKay. Algonquin Park Technical Bulletin No. 8. Whitney, Ontario, 1988.

Fishing in Algonquin Park. Text by Dan Strickland. Whitney, Ontario, 1988.

"Hemlock Bluff Trail: Research in Algonquin." Guide for Hemlock Bluff Trail. Text by Dan Strickland, drawings by Howard Coneybeare. Whitney, Ontario, 1991.

"Lookout Trail: Algonquin Geology." Guide for Lookout Trail. Text by Dan Strickland, drawings by Howard Coneybeare. Whitney, Ontario, 1989.

Mammals of Algonquin Provincial Park. Text by Dan Strickland and Russell J. Rutter, drawings by Howard Coneybeare. Whitney, Ontario, 1987.

"Mizzy Lake Trail: Wildlife in Algonquin." Guide for Mizzy Lake Trail. Text by Dan Strickland, drawings by Howard Coneybeare. Whitney, Ontario, 1988.

"Names of Algonquin: Stories Behind the Lake and Place Names of Algonquin Provincial Park." By G. D. Garland. Algonquin Park Technical Bulletin No. 10. Whitney, Ontario, 1991.

A Pictorial History of Algonquin Provincial Park. By Ron Tozer and Dan Strickland. Whitney, Ontario, 1980.

Trees of Algonquin Park. By Dan Strickland. Whitney, Ontario, 1989.

"Wolf Howling in Algonquin Provincial Park." By Dan Strickland. Algonquin Park Technical Bulletin No. 3. Whitney, Ontario, 1988.

Maps

Brown, Arthur. *Map of Algonquin National Park of Ontario*. Toronto: 1925.

Canadian National Railways. *Map of Algonquin Provincial (Ontario) Park: Highlands of Ontario*. Chicago: Poole Brothers, 1922.

The Friends of Algonquin Park. *Canoe Routes of Algonquin Provincial Park*. 1990.

Highland Inn. *Algonquin Provincial Park Map*. Toronto: 1944.

Ontario, Department of Lands and Forests. *Algonquin Provincial Park: General Information, Canoe Routes*. Rene Brunelle, Minister. Undated map and brochure.

_____. *Map Showing the Colonization Roads Built and Maintained Under the Supervision of the Commissioner of Crown Lands from 1857 to 1910 in and around Algonquin Provincial Park*. F. W. Beatty, Surveyor General, 1946.

Ontario, Province of. *Map showing Original Area of the Algonquin Provincial Park and Subsequent Additions Made Since 1893*. Chief Geographer's Office, Surveys and Engineering Division, 1946.

Index